America's Wetland

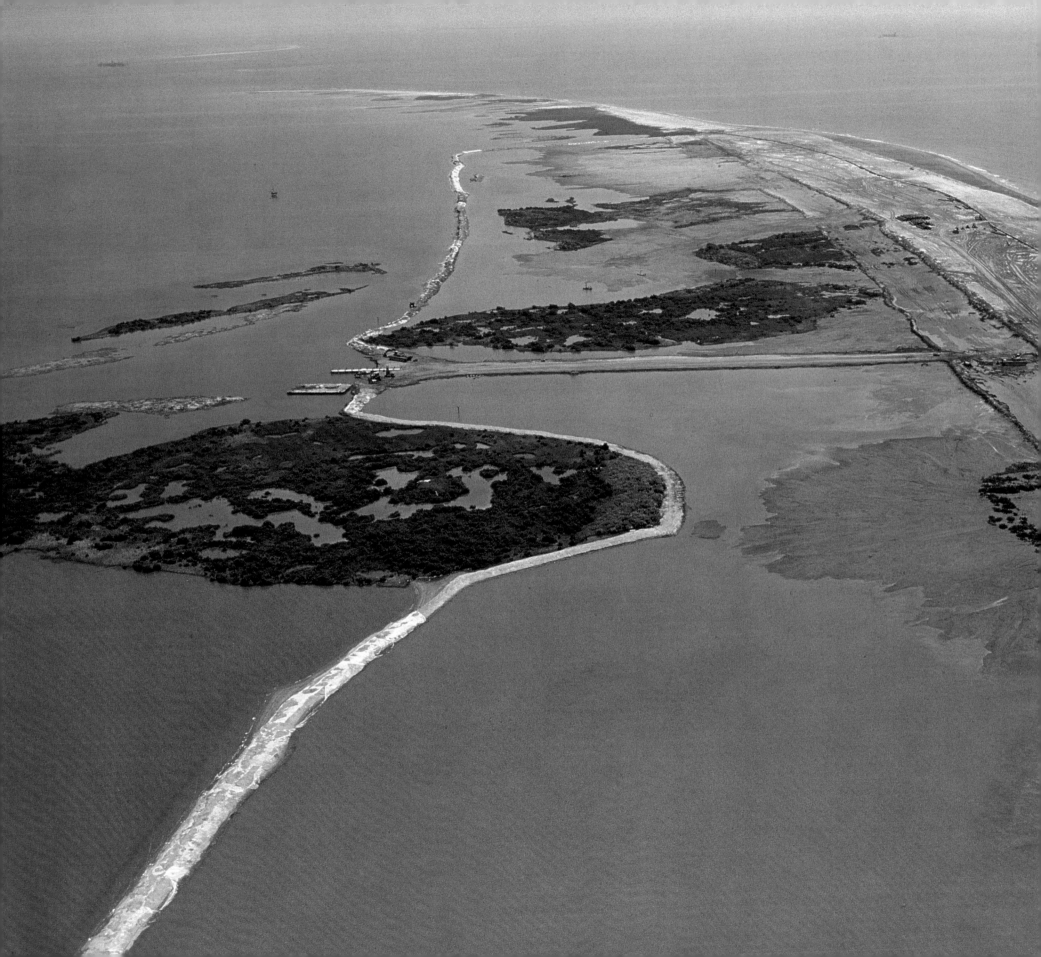

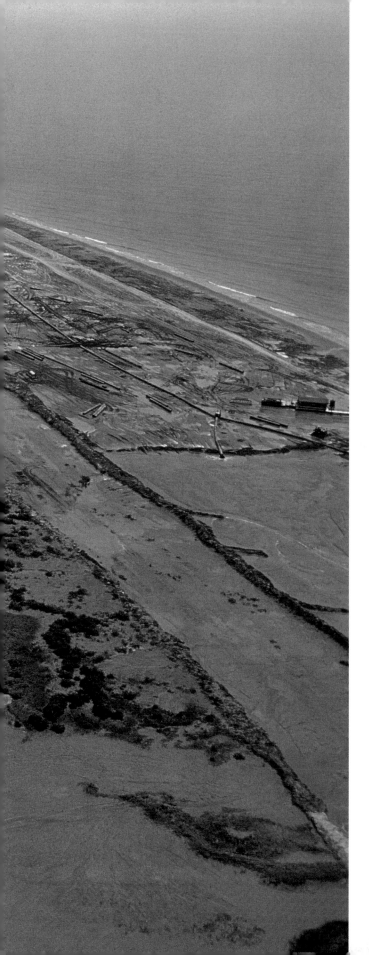

America's Wetland

Louisiana's Vanishing Coast

Photographs by BEVIL KNAPP *Text by* MIKE DUNNE

LOUISIANA STATE UNIVERSITY PRESS
Baton Rouge

Designer: *Laura Roubique Gleason*
Typeface: *Minion*
Printer and binder: *Kings Time Printing Press, Ltd.*

LIBRARY OF CONGRESS CATALOGING-IN-PUBLICATION DATA
Dunne, Mike.
 America's wetland : Louisiana's vanishing coast / text by Mike Dunne ; photographs by Bevil Knapp.
 p. cm.
 ISBN 0-8071-3115-6 (cloth : alk. paper)
 1. Coast changes—Louisiana. 2. Coasts—Louisiana. 3. Coastal zone management—Louisiana.
4. Wetlands—Louisiana. 5. Wetland conservation—Louisiana. I. Knapp, Bevil, 1949– II. Title.
GB459.4D86 2005
333.91'8'09763—dc22

 2005009329

"La Valse de la Mèche Perdue," translated as "The Lost Marsh Waltz," quoted with
permission of Flat Town Music Company.

 This publication was made possible by the generous support
of BG North America, LLC.

America's Wetland: Louisiana's Vanishing Coast was produced in cooperation
with America's WETLAND: Campaign to Save Coastal Louisiana.

The paper in this book meets the guidelines for permanence and durability of the
Committee on Production Guidelines for Book Longevity of the Council on Library
Resources.♾

To our parents
Dr. John and Lucile Bettis Munson
and
William and Gerry Dunne

When one tugs at a single thing in nature, he finds it attached to the rest of the world.

—John Muir

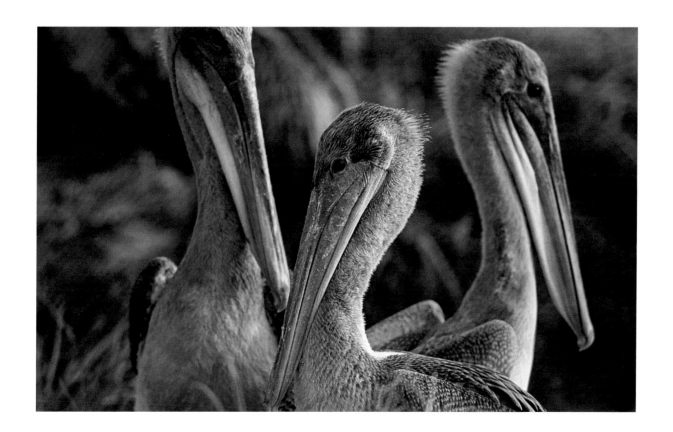

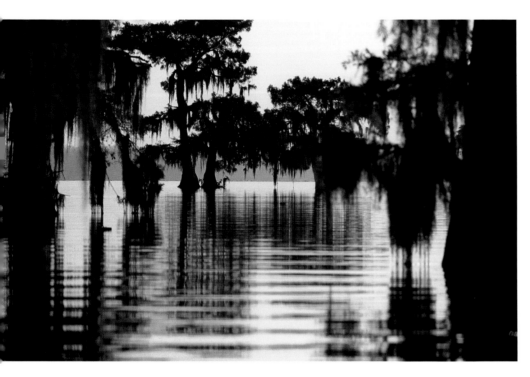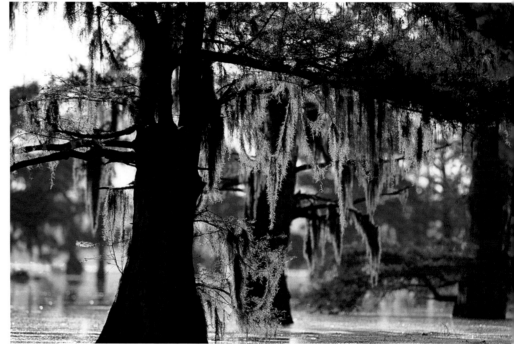

CONTENTS

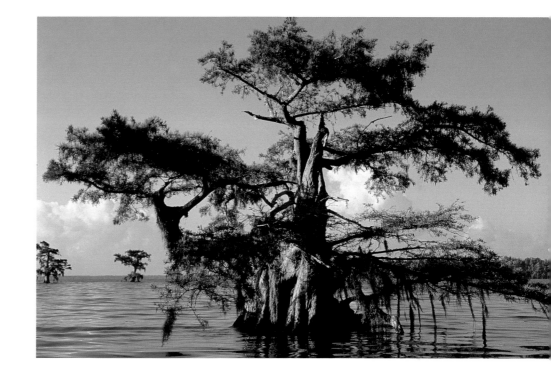

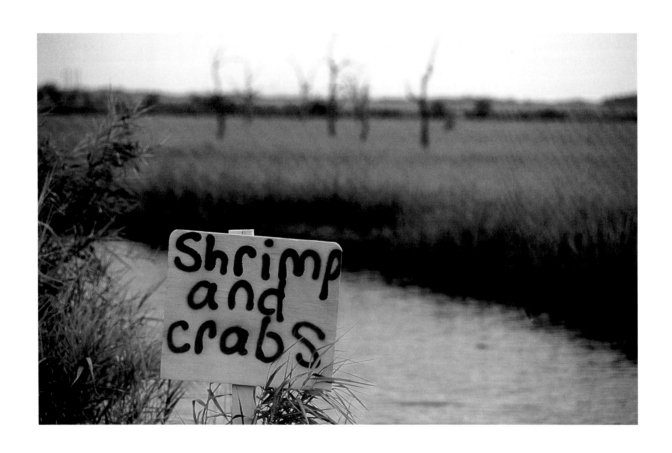

ACKNOWLEDGMENTS

The authors are extremely grateful to so many people who helped make this book possible. Thanks to BG North America, LLC, for its corporate citizenship and to the America's Wetland Foundation and Sidney Coffee, Valsin A. Marmillion, Lisa L. Noble, and Rannah Gray.

Thanks to LSU Press for giving this book life. Thank you for believing in it as much as we do.

A special thanks to Bevil's husband, Ellis Lucia. His photographs for the *Times-Picayune* inspired her to undertake this project. Many thanks to Mike's wife, Freda Yarbrough, for her editing skills and support. To the *Times-Picayune*'s Mark Schleifstien, thank you for always sharing your time, energy, and information on a subject you know so much about.

The authors wish to thank a long list of people who helped in some way. We know it will be an incomplete list: Shea and Cathy Norman Penland, Dinah Maygarden, the Pontchartrain Basin Institute, the University of New Orleans and Louisiana State University, Julie Gourgues and Carol Fox at Design III in New Orleans, Lawton Rogers for advice and counsel, the people of Isle de Jean Charles, Albert Naquin (Chief White Buffalo), Father Roch Naquin, Chris Brunet, the Billiots, Theresa and Donald Dardar, Blackie Campo and his extended family in Shell Beach, Windell Curole, Rodney and "Jimbeaux" Guilbeaux, the Coalition to Restore Coastal Louisiana, Lowell Ford, Bobby Schrieber, the Lake Pontchartrain Basin Maritime Museum, Jack Bohannan, Phyllis Darensbourg of the Louisiana Department of Natural Resources, Bob Owen and his boat *Tugly,* Bill Dietrich, Captains Dan Hendrick and Lisle Posey, Ellen Kennon, Kenwood Kennon, Joe Medina, Jeb Linscombe and everyone at the Rockefeller Wildlife Refuge, Chris Wells, Mark Shirley, Chris Swarzenski and Pat O'Neil, Brandy and Ronald Winch and their families, Tommy Michot and his clan, Lynn Hymel, Bob Marshall, Richard Vallon and Dr. William Knight and staff, Greg Linscombe for sharing his love and knowledge of the Brown Pelican, Quin Kinler and Dale Garber, the Roy Blanchard family, the Collettes, Savoie's Alligator Farm, Tony Fernandez and Billy Stander in Hopedale, Michael Fitzpatrick and Howard Boudreaux, whose hospitality is legendary.

Thanks also to the coastal scientists at LSU and elsewhere who patiently explained complex ideas in simple English, including John Day, Paul Kemp, Greg Stone, Rob Lane, Jason Day, Jim Coleman, Ivor van Heerden, and Robert Twilley, Denise Reed at the University of New Orleans, and the folks at the National Wetlands Research Center in Lafayette, specifically Jimmy Johnston, Scott Wilson, and Gabrielle Bodin and John Barras and Christina Saltus for maps and graphics.

We'd also like to acknowledge the agencies that helped us get to remote places: the U.S. Environmental Protection Agency, the U.S. Department of Agriculture's Natural Resource Conservation Service, the U.S. Army Corps of Engineers, the National Marine Fisheries Service, the U.S. Geological Survey, and the Louisiana Department of Wildlife and Fisheries and Department of Natural Resources.

A special recognition to Bevil's assistant, Anne Finney, for the endless hours of carrying gear, scanning, and laughing at her jokes.

Thanks to the families, Bettis, Knapp, Munson, Florsheim, and Dunne.

And last but never least, thanks to Bevil's aunt Tiddle, who still admits publicly that they are related.

—Bevil Knapp and Mike Dunne

The America's WETLAND Campaign gratefully acknowledges the participation of BG North America in the development of this book. BG North America, Caribbean and Global LNG executive vice president and managing director Martin Houston has made the following statement:

Corporate responsibility is key to our company's operations in twenty countries worldwide. This is the reason why in the state of Louisiana, BG North America, LLC, is committed to protecting and enhancing the environment in which we operate. In 2005, we are pleased to have had the opportunity to participate in the development of this book, America's Wetland: Louisiana's Vanishing Coast. *It is envisaged that funds raised from the sale of this beautiful publication will support the public education campaign with its goal to preserve and restore coastal Louisiana and to rebuild the wintering habitat for over five million waterfowl and migratory birds as well as other endangered animals. We would urge each and every one of you to join us in supporting this worthwhile effort.*

America's Wetland

Louisiana's coastline is a unique place where the Mississippi and Atchafalaya Rivers have been filling in the Gulf of Mexico for thousands of years. The intersection of land and sea is a swirl of bluish waters and greenish patches of mud and marsh grass.

Introduction

AMERICA'S WETLAND

Imagine what would happen if the state of Delaware disappeared—some enemy took control of it. Or New York, Chicago, Los Angeles, and Houston all disappeared. The nation would be incensed if someone took away our second smallest state or any one of those large cities. Action would be demanded.

Since 1932, Louisiana has lost enough coastal wetlands to equal the state of Delaware or all of those major metropolitan areas combined—1,900 square miles. A tennis court every thirteen seconds slips under the water or is nibbled off the edge of one of the most ecologically sensitive regions of the nation and the world. If nothing is done, another five hundred square miles will be lost in the next fifty years— the equivalent of losing seven to ten Districts of Columbia. Seawater could be lapping against the hurricane protection levees that protect the greater New Orleans area or other cities and towns that are built on the ridges of land formed by the Mississippi River as it changed course over the ages.

Since 1990, a federal task force of agencies has spent or committed more than $504 million for coastal restoration efforts. While that's a lot of money, it is simply not enough. An early Louisiana study says the nation needs to spend $14 billion

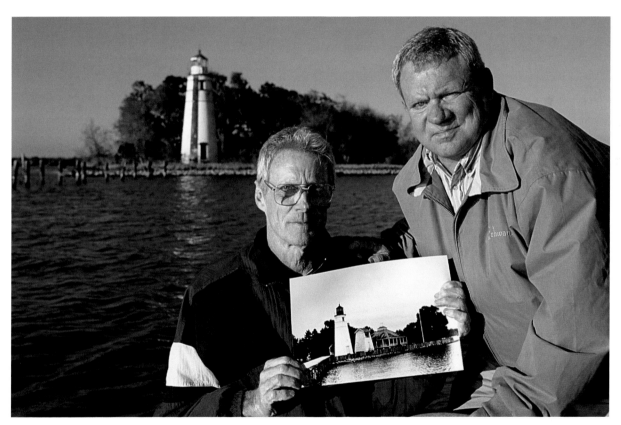

Bobby (left) and Benjamin Schrieber (right) are descendants of the last lighthouse keeper at the mouth of the Tchefuncte River on Lake Pontchartrain. Their grandfather Fredric A. Schrieber manned the lighthouse until 1935. It was automated in 1952. While the land around the lighthouse has been protected by a bulkhead, experts at the University of New Orleans say erosion along the unprotected shorelines can be three to five feet per year. The lighthouse is no longer accessible from land, as erosion and subsidence have cut it off from the mainland.

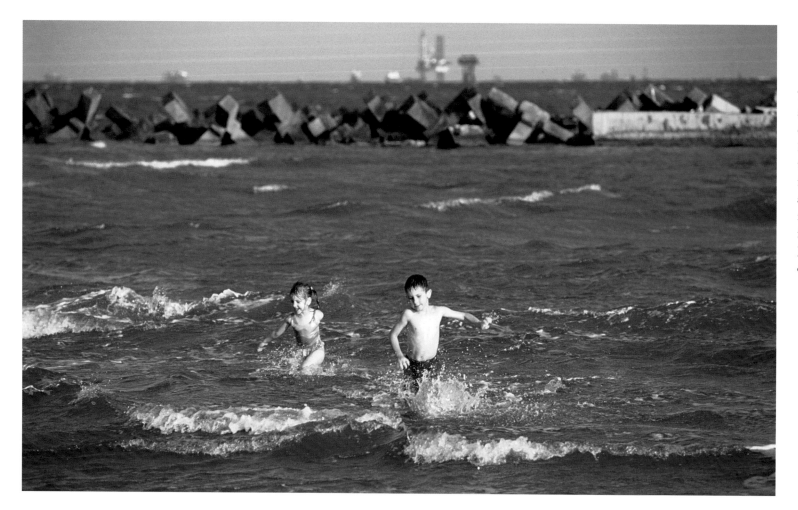

Two children splash back to shore at Fourchon Beach, one of the few spots on the Louisiana Coast accessible to the public for swimming and fishing. In the background are sunken barges filled with rock—part of an earlier effort to stem coastal erosion. Just off shore, oil and gas rigs dot the seascape.

over the next twenty years to achieve "no net loss" of coastal wetlands. Such spending is not without precedent. Congress has authorized $8.4 billion to restore the Everglades, which is substantially smaller than the Louisiana coastal marsh. While the Everglades may be better known, coastal Louisiana, an area called America's Wetland, is a living and working wetland, home to nearly 2 million residents who depend on a vanishing landscape.

In the small community of Constance Beach in Cameron Parish, two of the four blocks that existed in 1956 are today under the muddy brown waters of the Gulf of Mexico and a new beach built as part of a $20 million restoration effort. In Lafitte, south of New Orleans, bayous have become as wide as lakes. Wind-formed waves easily erode the remaining wetlands, which fall off in big chunks. In Lafourche Parish, wetlands around Port Fourchon, which supplies more than 80 percent of the offshore oil and gas activity in the Gulf of Mexico, slowly disappear,

making the port and the two-lane highway that serves it more vulnerable to storm tides and hurricanes. These are just three small examples of the land being lost in Louisiana.

The biggest threat is to the city of New Orleans and its suburbs. Most of New Orleans is actually below sea level, and it is protected from hurricane storm flooding by protective levees and walls. That system is designed to stave off a Category 3 hurricane, one with winds of 111–130 miles per hour. Computer models show that a stronger or slower-moving hurricane could put New Orleans—the home of Mardi Gras, Creole cooking, the world's largest port system, and a national economic engine—under as much as seventeen feet of water. Imagine Wall Street's reaction to losing a city like New Orleans.

What else is at stake if we lose the wetlands? Habitat for fish and wildlife. Protection for some of the nation's busiest inland waterways. Protection of the infra-

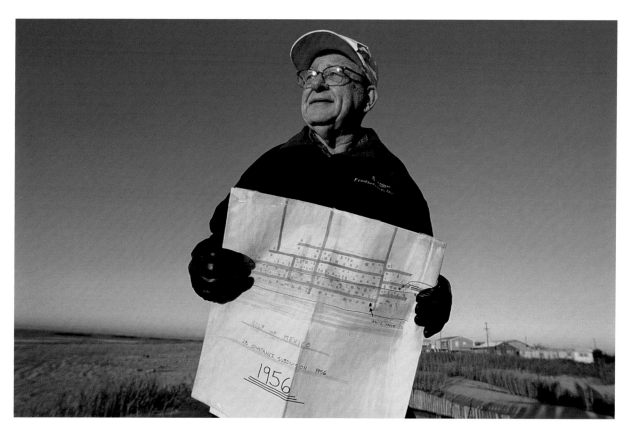

Rodney Guilbeaux slowly watched his Cameron Parish community of Constance Beach wash away. The site of his first home now sits in the Gulf of Mexico. Today, a new $20 million beach restoration sits atop his second home site. Like other residents of the small community, he kept retreating inland, and his third home is now a block away from the new beach.

Guilbeaux recalled a storm in the winter of 1978 when he had to move his house the first time: "I woke up one morning and I had lost twenty feet. The next day, another eighteen feet of land. My back steps were in the Gulf of Mexico and my back bedroom was over the Gulf." That land loss was not from a powerful hurricane that chewed up one of the few sandy beaches on the Louisiana coast. It was just a winter storm.

Guilbeaux has been an evangelist for coastal restoration and a board member of the Coalition to Restore Coastal Louisiana.

In 2002, a partnership of federal and state agencies pumped about 1.7 million cubic yards of sand onto the existing beach in an attempt to restore a semblance of the historic shoreline—a program Guilbeaux sought for years. Offshore breakwaters were also augmented. Constance Beach is again "the best beach in Louisiana," he said.

structure delivering 80 percent of the domestic production of oil and gas. Hurricane buffer for 2 million people, including the city of New Orleans, one of the country's most unique cultures, based originally on living off the bounty of the wetlands and synonymous with good food and good times.

All those losses won't happen tomorrow. These things won't disappear next week or even next year. But in less than fifty years—before today's toddler become a retiree—the open waters of the Gulf of Mexico could be lapping near the base of hurricane protection levees. A $3 billion fishery could be on the brink of collapse. The nation's energy security could be threatened.

To understand how Louisiana is disappearing, you have to understand how it appeared. For thousands of years, there has been a battle between the

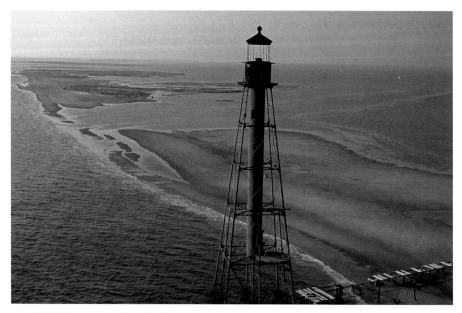

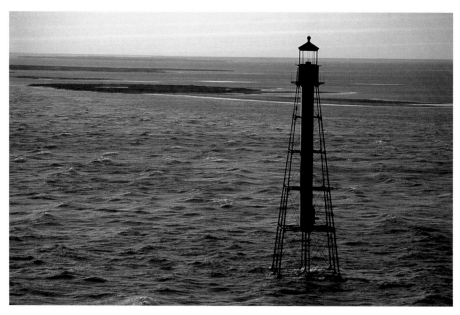

An old lighthouse stands on the largest portion of the Chandeleur Islands, a barrier island chain southwest of New Orleans. The lighthouse is one of the few reference points officials and scientists have for determining what damage is done to the important fishery habitat by passing hurricanes. Hurricane Ivan in 2004 severely damaged the island chain as witnessed by the photo above.

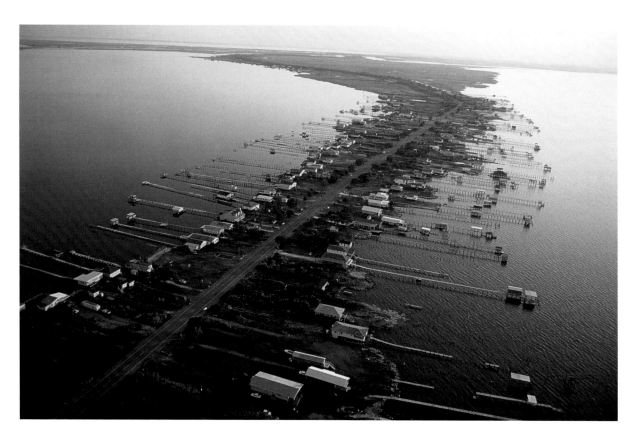

forces of the Mississippi River and the sea, the Gulf of Mexico. The Mississippi drains 41 percent of the nation, becoming a monster of a stream full of freshwater and sediment eroded from the Black Hills of South Dakota to the coal mining areas of Pennsylvania. As the river dumps its load, it pushes farther and farther into the Gulf of Mexico.

But the Gulf does not sit back and take it. Its waves nibble at the shoreline, and its currents move

Left: A "land bridge," or small strip of land, often separates two bodies of water in South Louisiana. Roads and residences are usually built on the high land. To the right is Lake Pontchartrain and to the left is Lake St. Catherine. The roadway is U.S. Highway 90. Many of the buildings are weekend camps with fishing piers and boathouses.

Right: Louisiana Highway 1 which links the fishing community of Grand Isle and the oil industry service port in Fourchon to the rest of the state and nation, slips like a snake through the marshes. The highway is very susceptible to flooding, even days before a hurricane arrives.

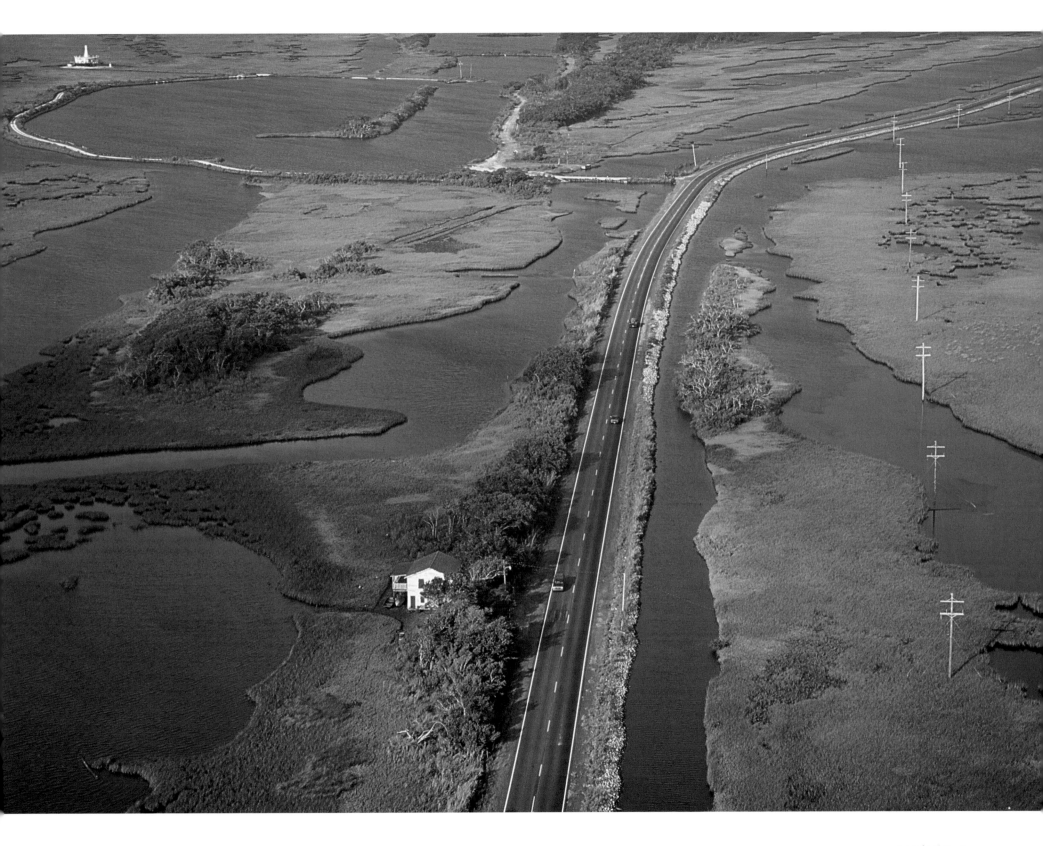

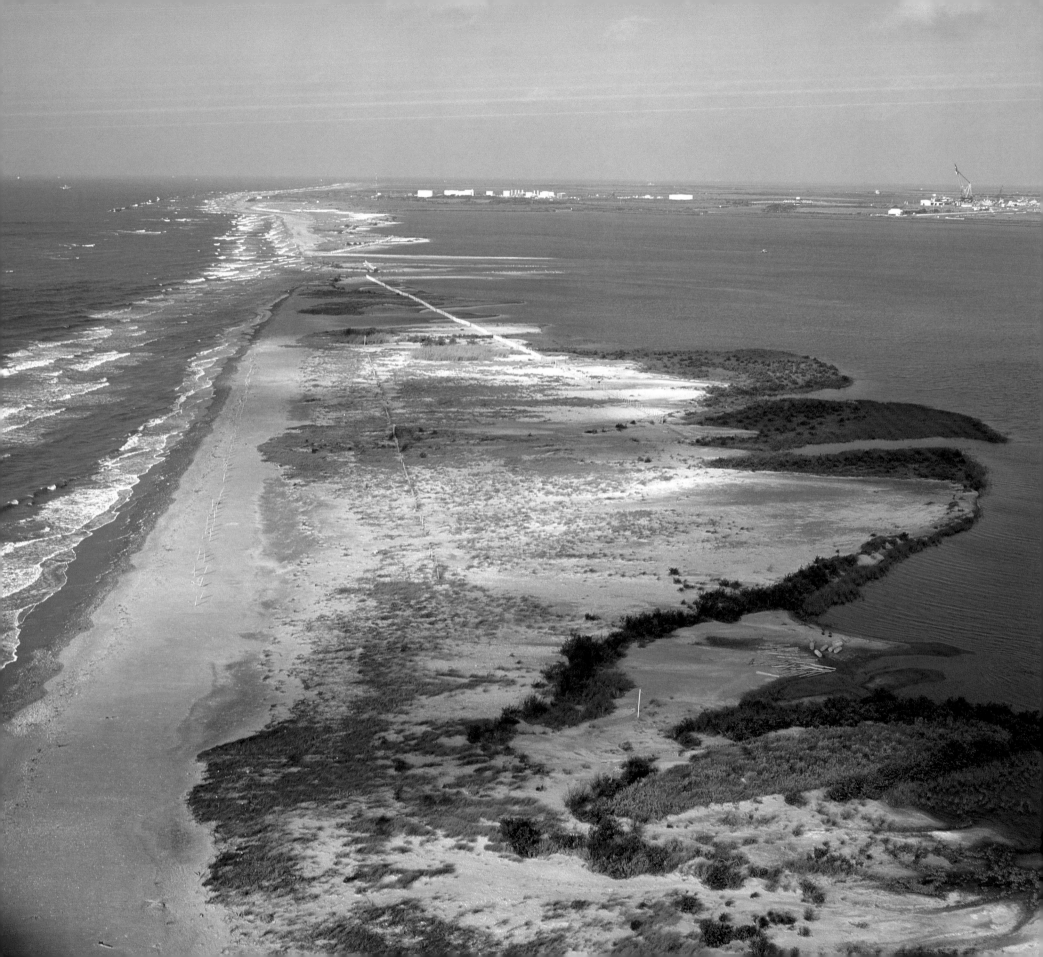

imperceptibly compacting. Until the levees stopped the cycle, the river's natural flooding process built the land and replenished the sinking areas. The Gulf is also getting stronger. Sea level is rising one to two centimeters a century, faster than the plants can build up year by year. When the marsh plants stay under water too long, they drown, and the whole system collapses a bit more.

This battleground between Gulf and river is ironically rich in life. The river delivers nutrients into the Gulf, spurring the growth of tiny algae called phytoplankton. These little plants are the bottom of the sea's food chain, with tiny organisms eating the phytoplankton, bigger fish eating smaller fish. That's why Louisiana's fishery is worth $3 billion annually and accounts for 25 percent of all seafood consumed in the United States.

But harnessing the river is not the only reason Louisiana's land has been lost. Fingers can be pointed in many directions. Although legally permitted, oil

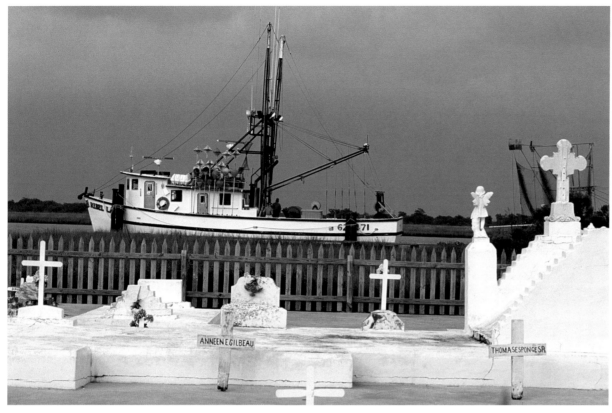

Above: While there was enough solid land for farmers to plant and raise cotton in Leeville in Lafourche Parish in the early 1900s, today there is only a small strip of land left on both sides of Louisiana Highway 1. The fact that the community's cemetery has been cemented over to armor it against rising water seems a fitting symbol of what is happening in South Louisiana.

Left: Only a fragile strip of sand beach and shallow marshland protects Port Fourchon in Lafourche Parish. Eighty percent of Gulf of Mexico oil drilling activity is supplied from Port Fourchon, and 1.7 million barrels of oil flow in pipelines under the port each day.

the sediment from place to place. For seven thousand years, the river has been stronger than the Gulf, building the series of deltas that are now South Louisiana. But the Gulf has had a strong ally in the past century—just a blink in geologic time. Man has unwittingly weakened the river and strengthened the Gulf. Man has confined the river and its fresh water and sediments with levees. Floodwaters no longer flow over the land and bring the nutrients that help build marsh plants, that key element in land-building. Man has opened the marshes with oil canals and navigation channels and allowed the Gulf's salt water to creep in and kill the freshwater marshes the river built.

The Gulf has another ally, gravity. The land the river created is slowly sinking,

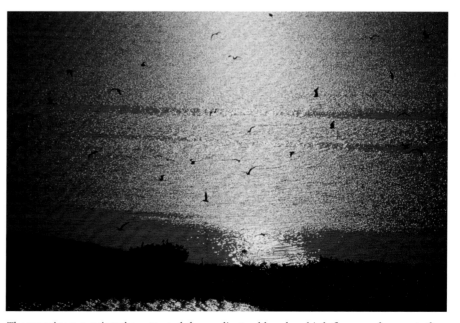

The morning sun paints the water and sky a radiant gold as shorebirds fly over a fragment of the Chandeleur Islands, part of the Breton National Wildlife Refuge.

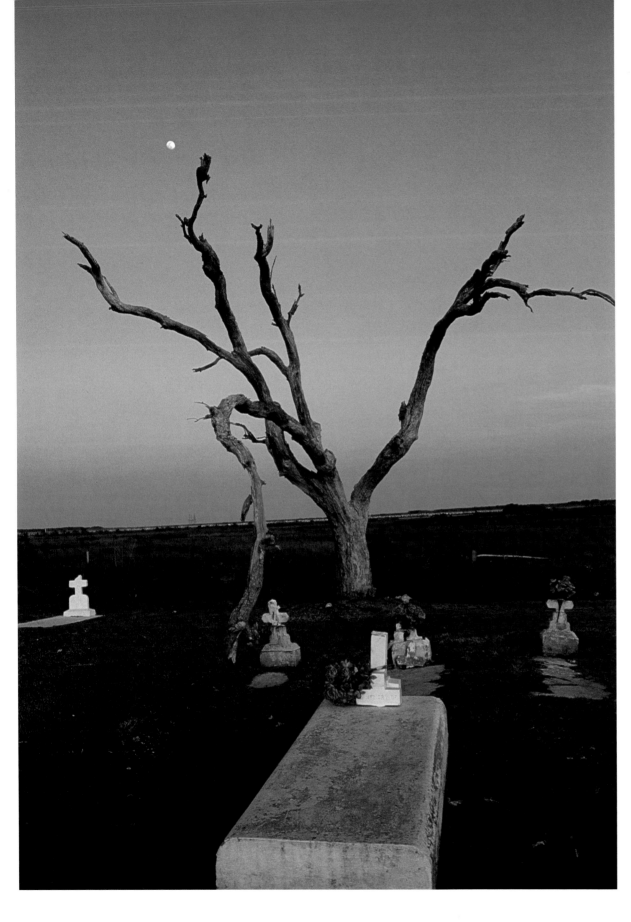

and gas exploration caused unintended consequences as the process carved up the marshes with canals to get rigs into place. Some research indicates that as oil and gas were pumped from the ground, geologic faults were activated and caused a rapid sinking of the land. Shipping channels were also sliced through the wetlands, like the Mississippi River Gulf Outlet south of New Orleans.

Nearly one-third of the oil and gas consumed in the United States passes through the ports and pipelines of South Louisiana. Pipelines were laid by cutting more canals in the marshes and swamps, and waterways were deepened and straightened for shipping. The wetlands provide storm protection for ports that move more than 500 million tons of goods each year, according to the U.S. Army Corps of Engineers. That's about one in five tons of the total waterborne commodities moved in the United States. Four of the nation's top ten ports by tonnage are in South Louisiana. Unfortunately, shipping channels not only helped improve navigation in the wetlands, but they also become highways for salt water to creep into freshwater marshes, killing the plants that hold the

Left: Only a graveyard marks the former fishing town of Chenier Caminada in lower Lafourche Parish. The community was destroyed by a hurricane in 1893. Survivors moved further up Bayou Lafourche to Leeville and, after another storm, into Golden Meadow and Galliano. "We have already begun to retreat," says Windell Curole, manager of the South Lafourche Levee District and a vocal supporter of coastal restoration.

Right: The morning sun breaks through the trees in the Atchafalaya Swamp, the nation's largest freshwater swamp. The Atchafalaya River, which carries about one-third of the Mississippi River's load, has created a gigantic swamp in the middle of the Louisiana Coast. The Atchafalaya River delta, where it runs into the Gulf of Mexico, is one of the few places where land building exceeds land loss. It is only a tiny percentage of the whole coast.

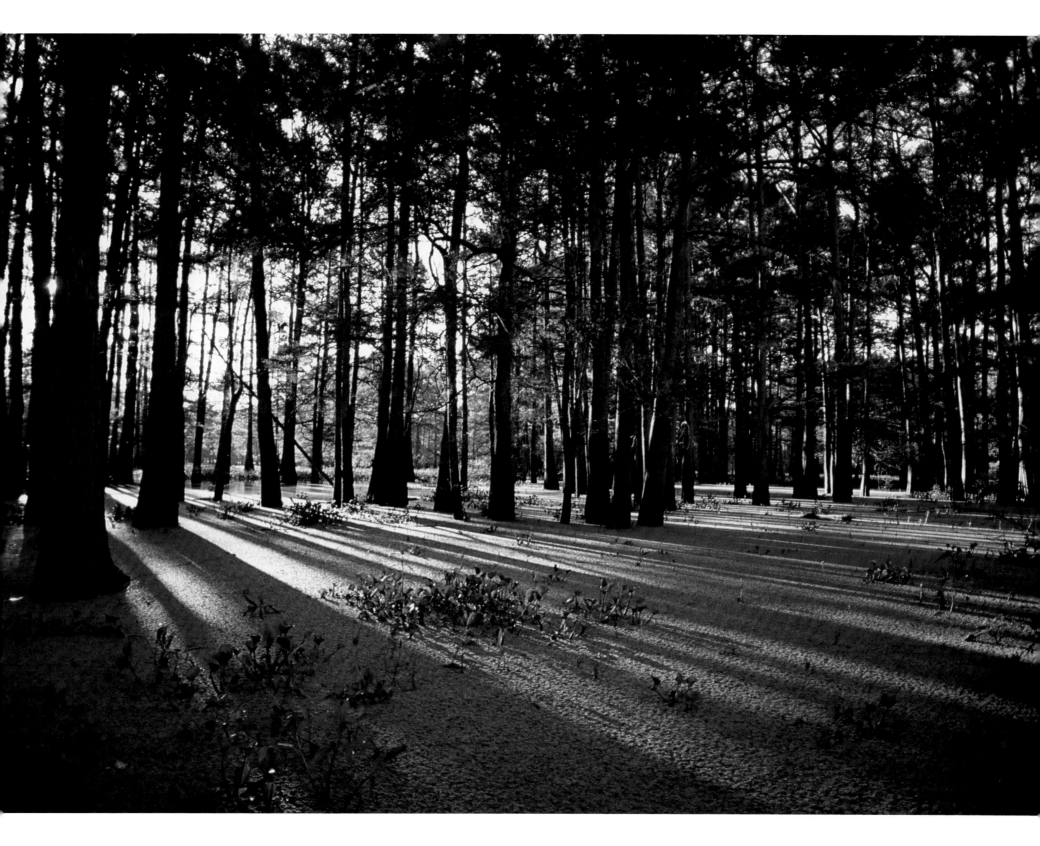

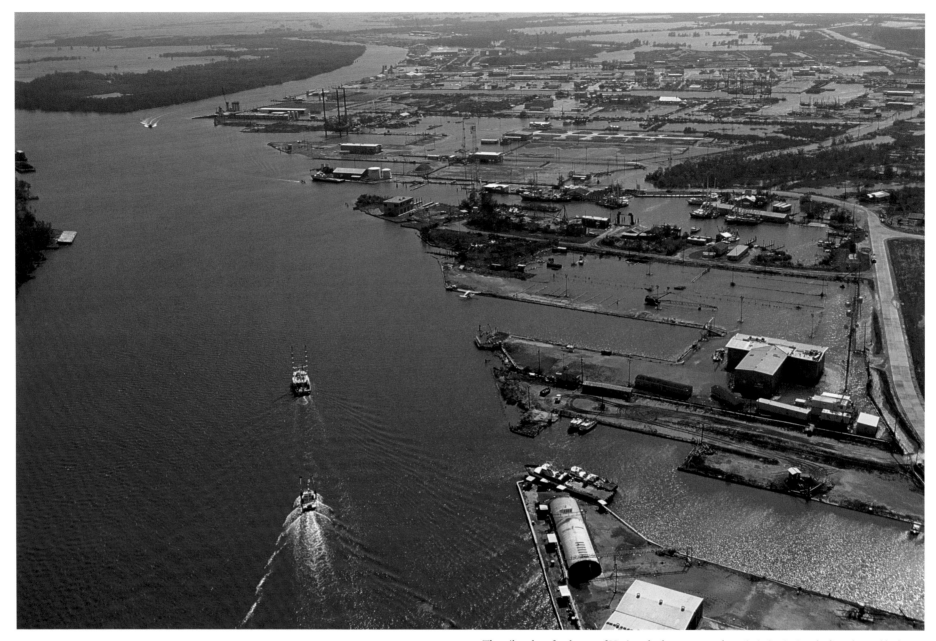

The oil and seafood port of Venice, the last port on the Mississippi River before the Gulf of Mexico, was easily flooded by a hurricane that struck the Alabama and Florida Gulf Coast, hundreds of miles away. South Louisiana's ports, which primarily service the offshore oil and gas industry, become more vulnerable each year as the land around them erodes.

fragile land together. Saltwater intrusion has also killed off stands of cypress, creating "ghost swamps" and "cypress cemeteries" that dot the South Louisiana landscape. Deforestation by man, primarily in the late nineteenth and early twentieth centuries, also changed the geography. When Europeans arrived, much of South Louisiana's freshwater marshes were filled with gigantic cypress trees. Another cause of wetland loss is a South American import, the nutria, brought to Louisi-

ana to be raised for its fur. A wild population of millions of nutria now roams the coast, gnawing plants down to their roots and killing the vegetation that holds together the organic soils.

Generally, man has undone in a few lifetimes what nature took centuries to build. It is estimated that land loss in the delta plain of Louisiana (from the Mississippi Sound to western Vermilion Bay) was about seven square miles per year in 1913. By 1940, that loss was about fifteen square miles per year. During the 1940 and 1950s, as man's imprint really began to reshape the landscape, the loss rate increased to as high as about thirty-nine square miles per year. It is now down to about 29.9 square miles per year, according to the U.S. Geological Survey. The reduction is because the land most easily lost to erosion is now gone.

If nothing is done to reverse or control the current trend, by the year 2050, one-third of the entire coast of Louisiana will be lost. Can the nation afford such a loss?

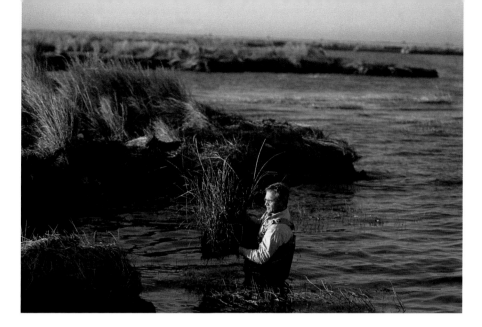

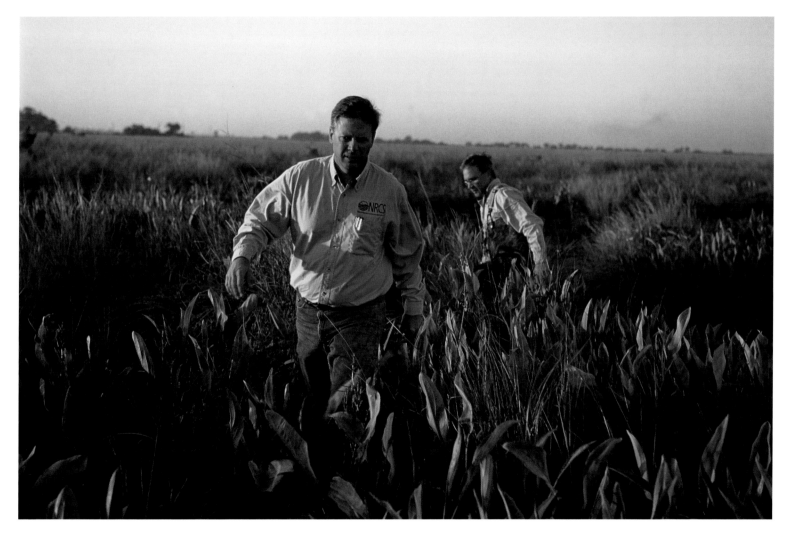

Dale Garber walks through bull tongue, one of the plants that help keep the marsh together, as Quin Kinler follows. Both are from the Department of Agriculture's Natural Resource Conservation Service and are working on restoring marsh south of the fishing and oil service village of Lafitte. Kinler walks on a stone dike placed in the marsh to slow down wave erosion.

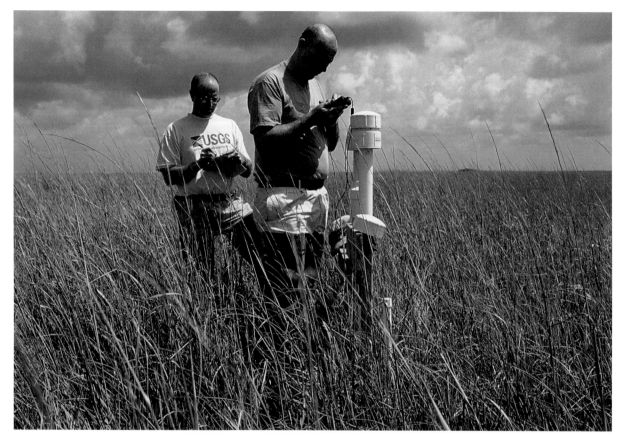

Researchers Tommy Michot and Chris Swarzenski of the U.S. Geological Survey monitor a floatant, or floating, marsh. Such floating marshes can easily erode if exposed to open-water waves. The researchers wear hip boots because one can easily sink ankle- or knee-deep in the muck upon which the grass and other plants grow.

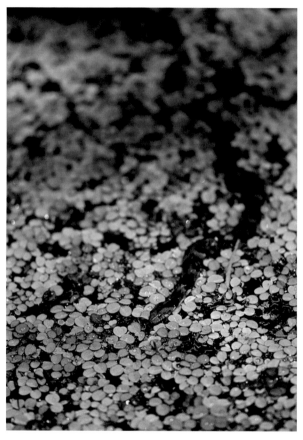

A water snake blends into his environment in Jean Lafitte National Park.

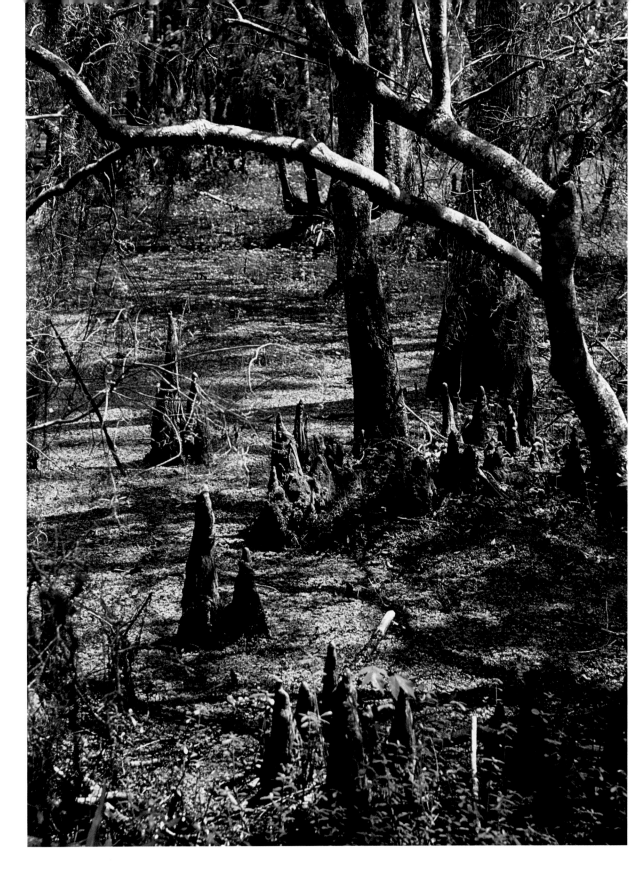

Left: Cypress tree roots, called "knees," often stick up above the water. Cypress trees need a dry period for seeds to germinate and for seedlings to grow tall enough to live in flooded conditions. As the wetlands subside and are cut off from fresh water and silt by Mississippi River levees, cypress forests often don't regenerate.

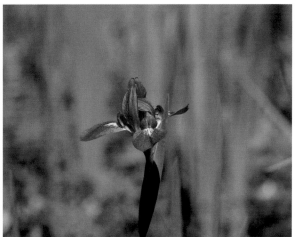

Louisiana iris dots the marsh in Jean Lafitte National Park, a freshwater marsh at the upper end of the Barataria Estuary, near New Orleans.

This U.S. Geological Survey map illustrates land changes over time across the Louisiana coastal zone and projects what will be left as of 2050.

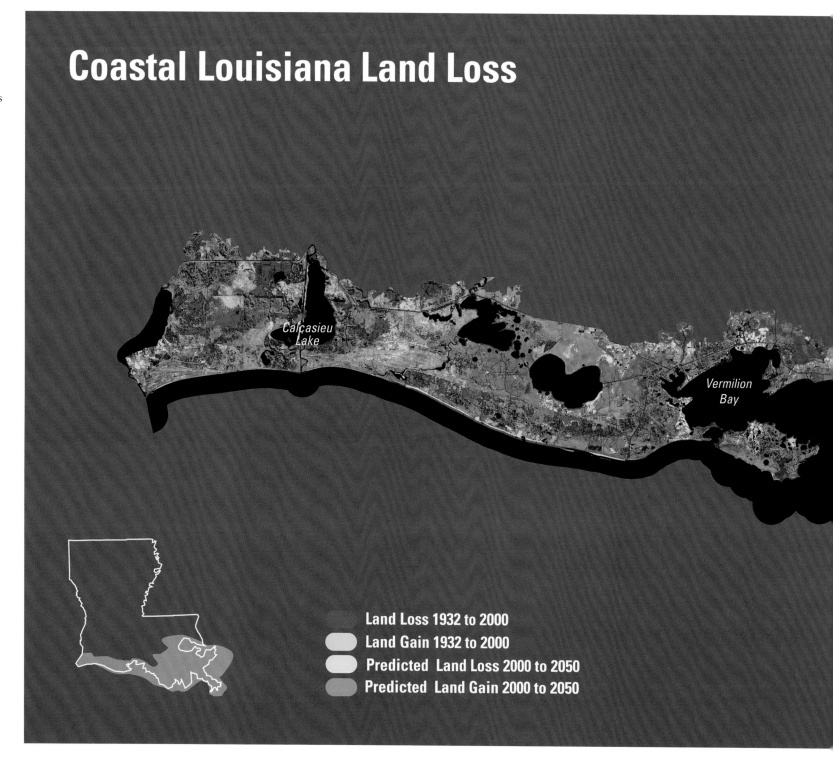

Coastal Louisiana Land Loss

Calcasieu Lake

Vermilion Bay

Land Loss 1932 to 2000
Land Gain 1932 to 2000
Predicted Land Loss 2000 to 2050
Predicted Land Gain 2000 to 2050

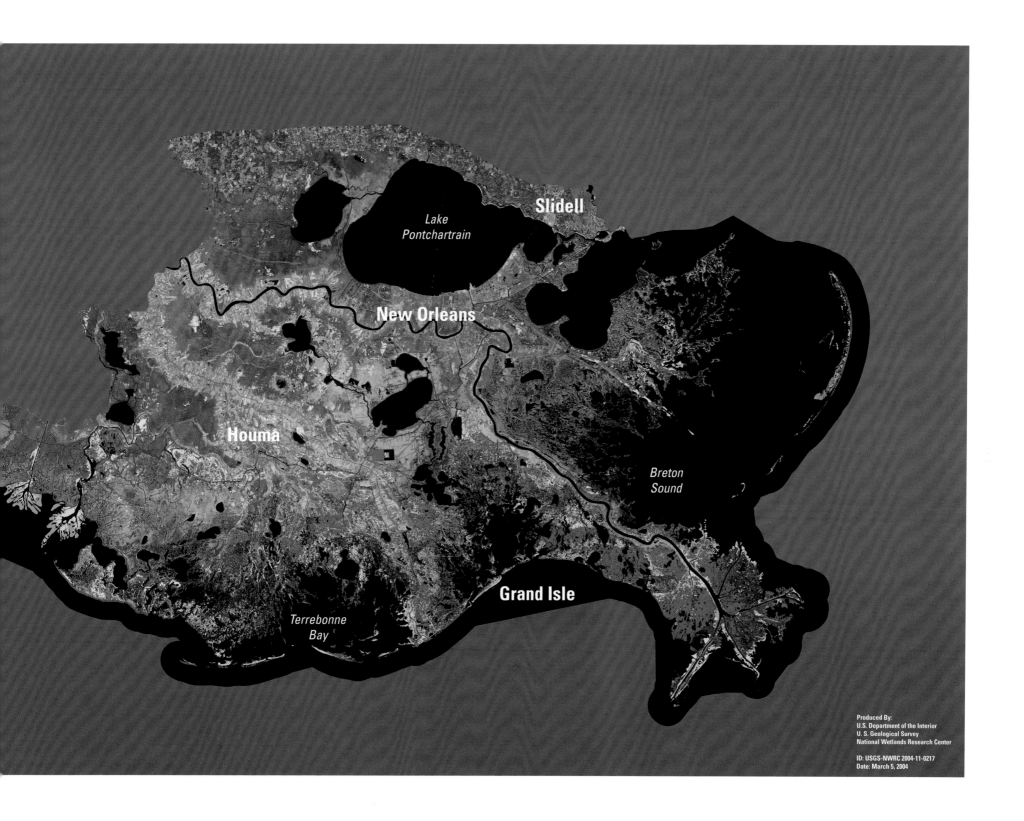

Slidell

Lake
Pontchartrain

New Orleans

Houma

Breton
Sound

Grand Isle

Terrebonne
Bay

Produced By:
U.S. Department of the Interior
U.S. Geological Survey
National Wetlands Research Center

ID: USGS-NWRC 2004-11-0217
Date: March 5, 2004

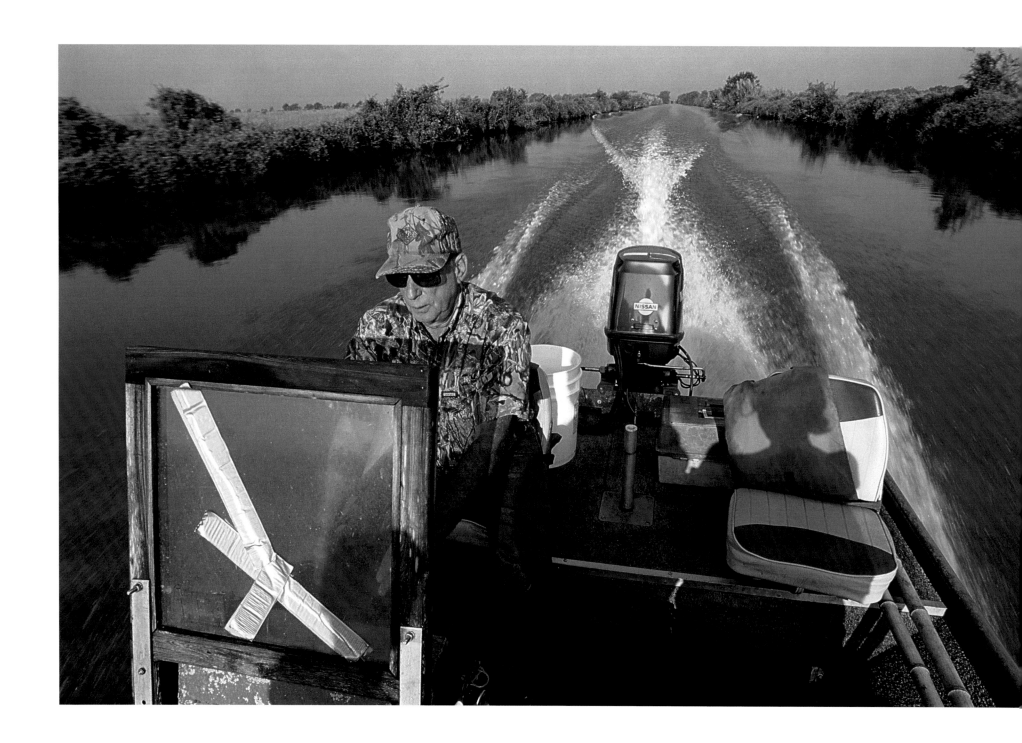

1

PEOPLE OF THE WORKING WETLAND

Coastal Louisiana is home to about 2 million people who live and work in the wetlands created by the Mississippi River over the centuries. They are fishermen and oyster farmers making their living from the bounty of the marshes, bays, and bayous. They are oil industry workers delivering the nation's energy and ship-builders and tugboat captains and deckhands who move the country's goods. They are farmers and ranchers who work the land as little as a mile from the Gulf of Mexico.

In New Orleans, they run businesses and do every kind of job that might be found in any other city. But this city has some differences. It is a place with more sites on the National Historic Register than any other city in the nation, and it is surrounded by wetlands and water. The National Hurricane Center has dubbed it the nation's most threatened city because of the loss of its surrounding wetlands and its vulnerability to hurricanes.

Suire's Grocery and Restaurant in Kaplan in Southwest Louisiana pays homage to the alligator as king of the freshwater marshes, which also act as nursery grounds for fish, shrimp, crabs, and other critters in South Louisiana. Cajun food often centers on the bounty found in the marshes and bays of South Louisiana and the nearby Gulf of Mexico.

Left: Howard Boudreaux of Avery Island cruises a canal in Vermilion Parish in the southwestern part of the state. He manages a large hunting club in Pecan Island called Les Deux Ponts, or the Two Bridges. Boat wakes, storm surges, and sinking land have all combined to allow salt water to move farther inland and taint freshwater marshes once filled with migrating ducks and other animals, Boudreaux said. Ducks like to eat the plants found in freshwater marshes. Once a marsh becomes saltier, the ducks lose habitat and important food for their migrations.

Les Deux Ponts is "losing about twenty feet a year" of fresh marsh along some of its bor-ders, Boudreaux said. The loss was at first gradual, but has become more noticeable each year in the last decade. Boudreaux, who once worked for the company that makes Tabasco sauce, said the wetlands between Avery Island and Pecan Island are slowly disappearing, and he sees fewer ducks, deer, and other wildlife that once flourished.

Oak trees that once marked ridges in the marsh are dying because of saltwater intrusion, and "canals are filling up, keeping us from fishing spots," said Mike Fitzpatrick, one of the members of the hunting club.

From the urban "City That Care Forgot" to the Cajun bayous where the motto is "laissez les bon temps rouler," or "let the good times roll," the culture is intimately tied to the disappearing landscape. Here are just a few of the people who live, work, and play in America's Wetland.

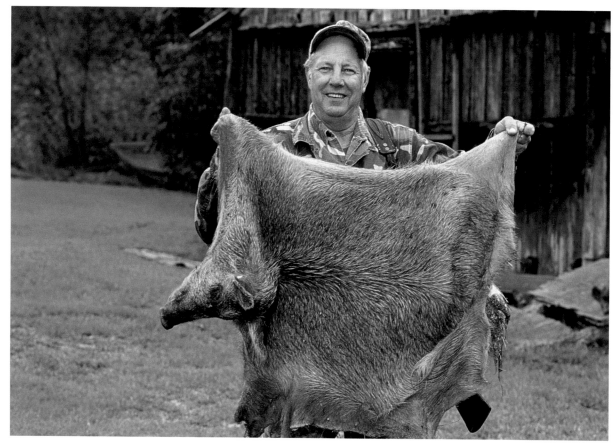

Above: Roy Blanchard of Bayou Benoit in St. Martin Parish represents the twelfth generation of his French family to live in Louisiana since his ancestors came to the swamps after fleeing first France and then Nova Scotia. Like many of his ancestors, Blanchard has lived off the land, fishing and hunting. Here he holds the skin of a wild pig.

For thirty-five years, he caught crawfish and catfish in the Atchafalaya Basin. "It's gotten so bad you really can't depend on crawfish any more," Blanchard said, blaming changing markets and poor water quality due to waterways filling with silt that should be working its ways to the coast.

Only a few of his generation made their living as fishermen. His sons both left the fishing business to pursue other jobs, one building boats and the other working for a seismographic company that looks for oil in South Louisiana's marshlands. Blanchard and his two sons will occasionally fish when the market is up, but no one can keep up the business full time. Roy now conducts swamp tours and does maintenance work for a local hotel. He misses fishing, though: "You get out there in the peace and quiet. You see all kinds of animals and birds."

Right: Roy Blanchard and his wife, Annie, travel through one of the many waterways in the Atchafalaya Basin.

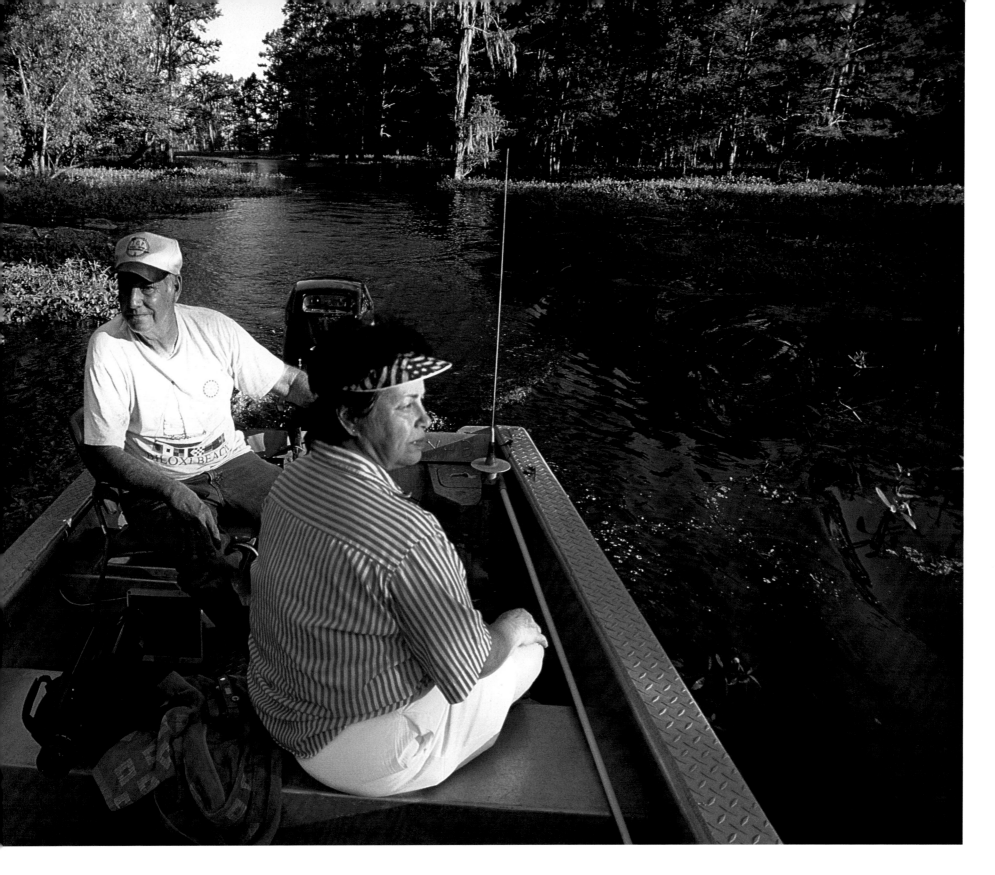

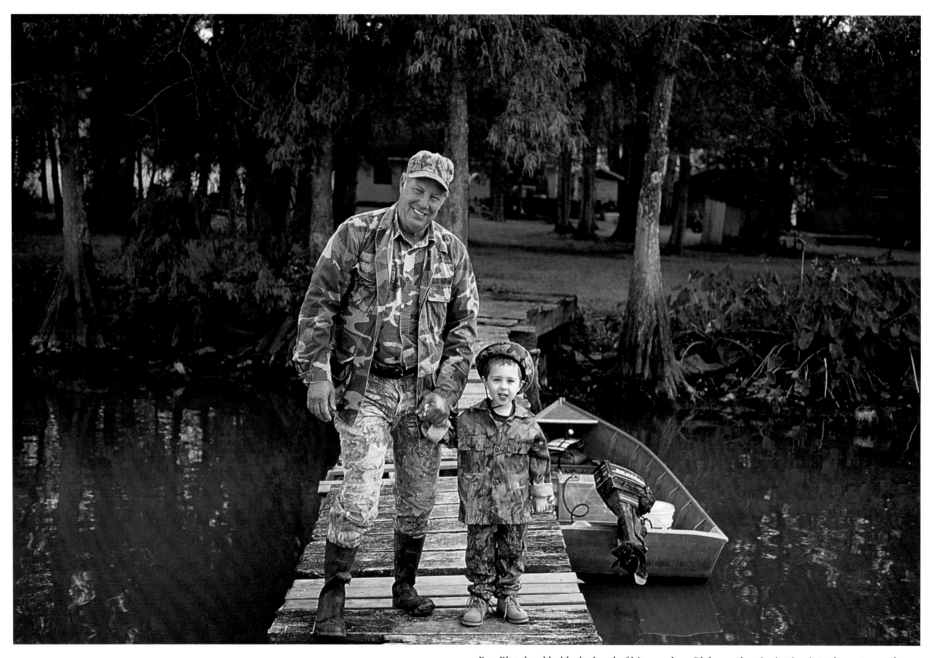

Roy Blanchard holds the hand of his grandson Blake on the pier jutting into the waterway behind Blanchard's house. Like many families in South Louisiana, the Blanchards consider a boat as important a possession as a car or truck.

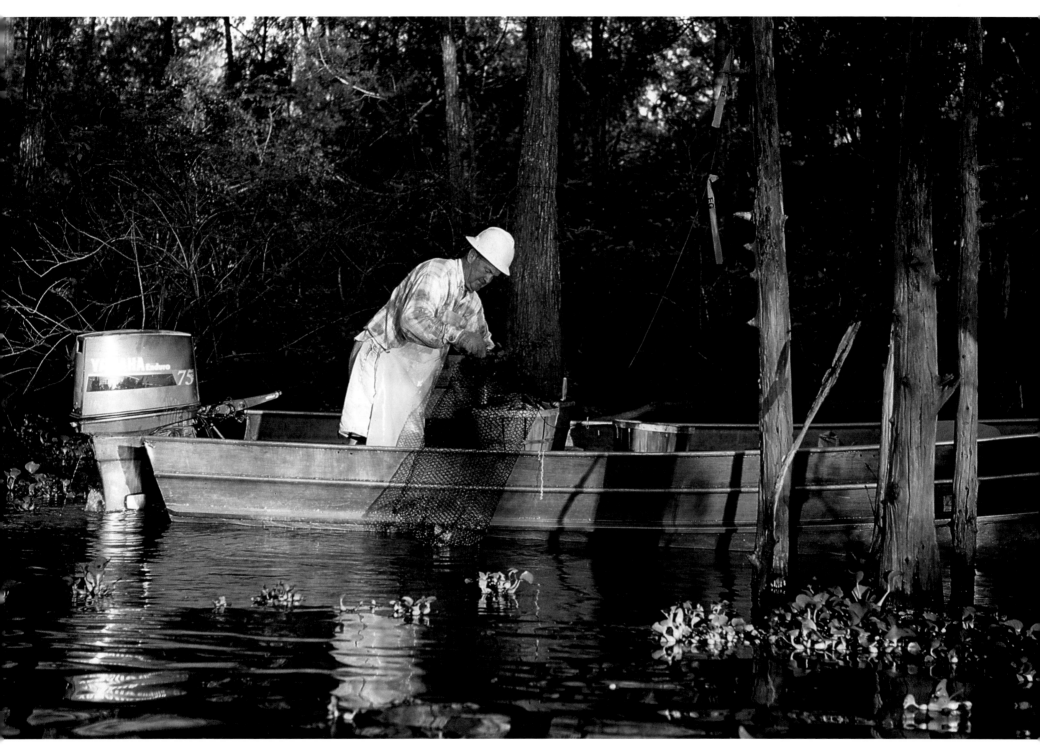

Bernard Blanchard, Roy Blanchard's cousin, empties a crawfish trap in the waters of the Atcha-falaya Basin. Crawfish grow several inches long in the freshwater swamps of South Louisiana and are considered a delicacy.

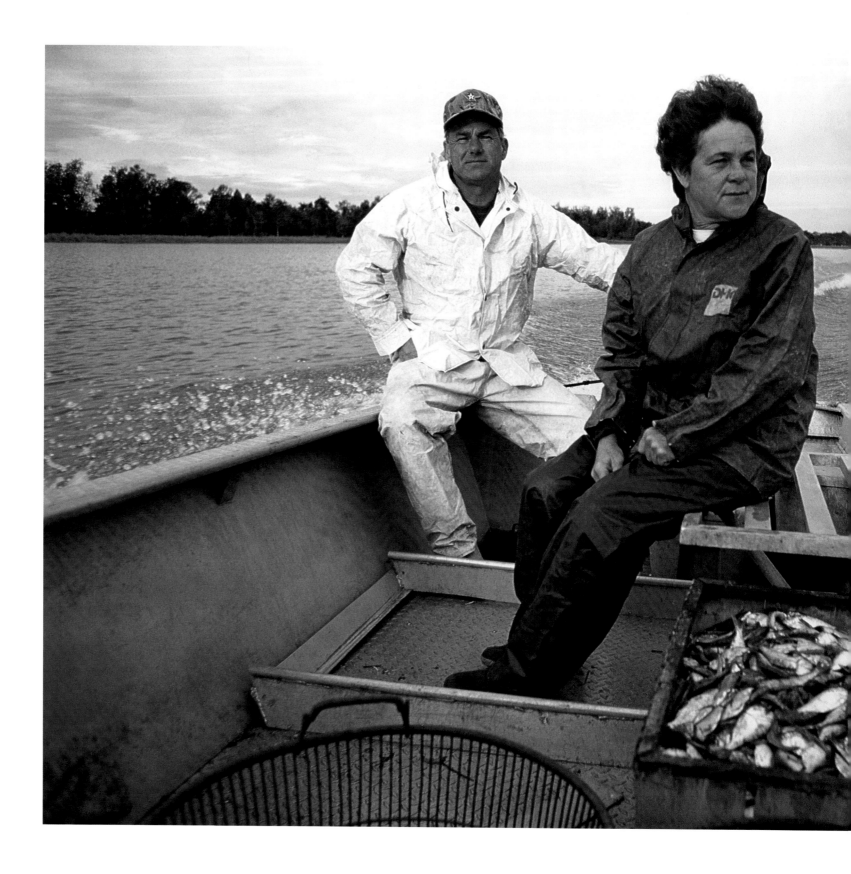

Sherbin and Louella Collette have fished the Atchafalaya Basin for decades; Sherbin started when he was twelve years old. Today, he is also mayor of the town of Henderson. "You can't make a living as a fisherman anymore—that's why I became mayor," he said, adding that he told voters he would continue to fish.

Collette says oil and gas exploration, pipeline canals, and navigation channels have caused the normal north–south flow of fresh water in the basin to spread east and west. Some areas are silting in because when the water moves east and west, it slows down and drops the silt instead of pushing it on out into the Gulf of Mexico.

"We take the basin for granted," he said of his and others' attitudes. "We were going into the basin to make a living. Now we see the beauty."

Collette also trawls for shrimp in Vermilion Bay in Southwest Louisiana. But there he sees the marshes that act as nursery grounds for shrimp disappearing.

The Winch family has been raising cattle in the marshes and grasslands of Pecan Island in Southwest Louisiana for more than forty years. Ronald Winch keeps a herd of about 100 cattle on 350 acres but also runs an airboat business. His father was a cattleman and oilfield worker, and his grandfather had cattle but also trapped and fished.

"It's hard to get enough land to just live off of cattle," Ronald Winch said. "The marsh used to go dry in the summers and the cows would graze," he added, but the use of water-control structures in an effort to stop the loss of fresh water often keeps the marshes too wet and further limits the space to graze cattle.

The Winches still drive cattle using horses, as the ground is often too soggy for trucks or tractors.

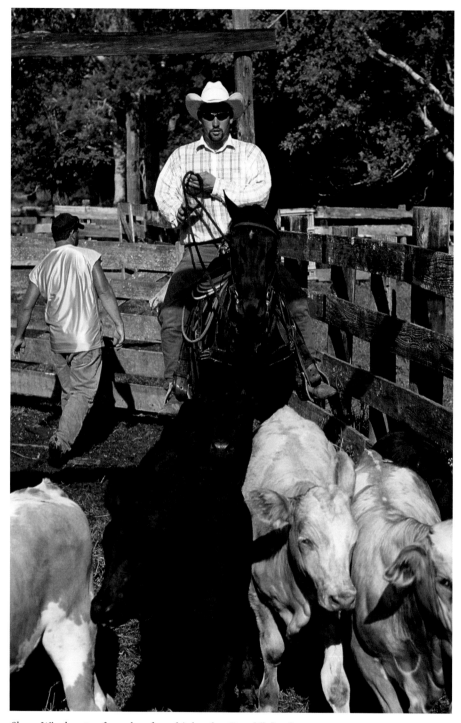

Shane Winch cuts a few calves from his brother Ronald's herd.

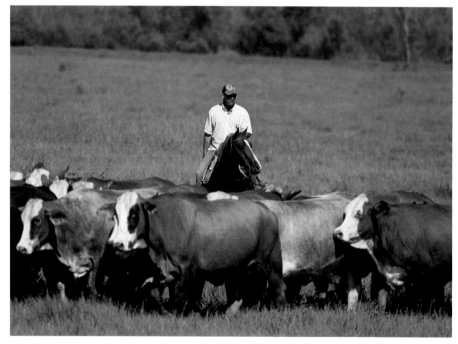

Ronald Winch drives cows from one pasture to another on the family ranch near Pecan Island in Cameron Parish. Many places in South Louisiana are not traditional islands but high spots that appear to be islands when storms flood the low-lying marshes. Often such "islands" sit atop underground salt domes, which pushed the land higher than the surrounding marsh.

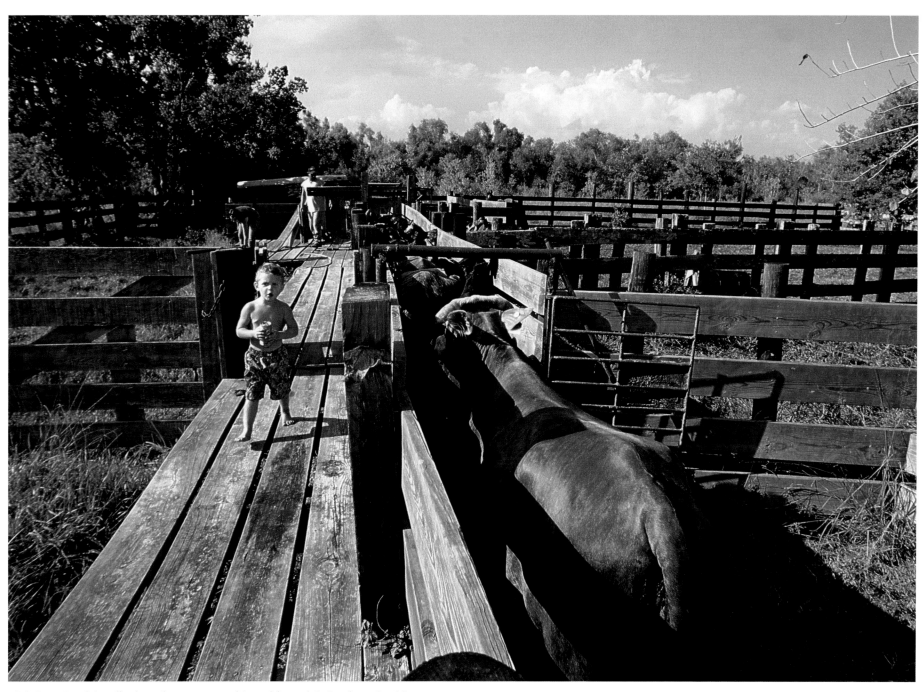

Little Bryce Latolais walks through a cow pen on his uncle's ranch in Southwest Louisiana.

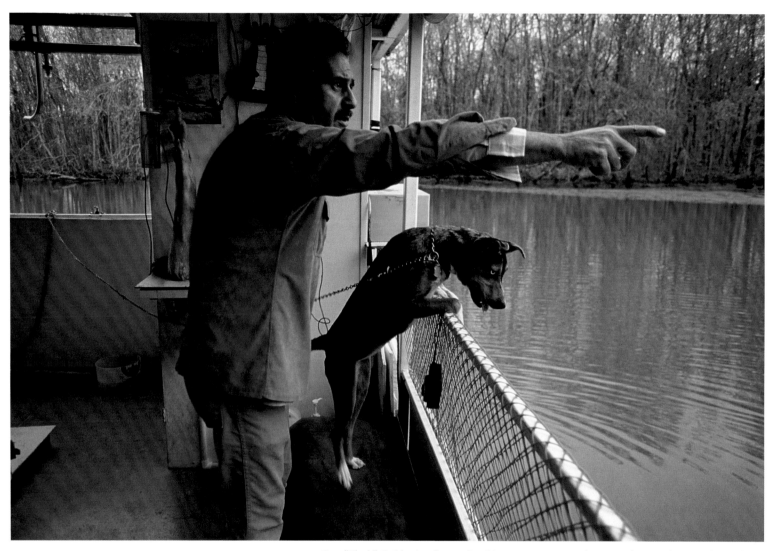

Ron "Black" Guidry is a former Louisiana state trooper who now takes tourists into the Atchafalaya Basin near his home in Houma. On his tour, he not only points out plants and animals but also talks about the Cajun culture and sings a few songs. "Everybody wants to see the alligators. He is the star of the show," he says.

Guidry is becoming concerned that he sees seagulls in his parking lot and saltwater fish are caught just a few miles from the freshwater swamp he loves. He fears a hurricane will push that encroaching salt water into the freshwater marsh and destroy it.

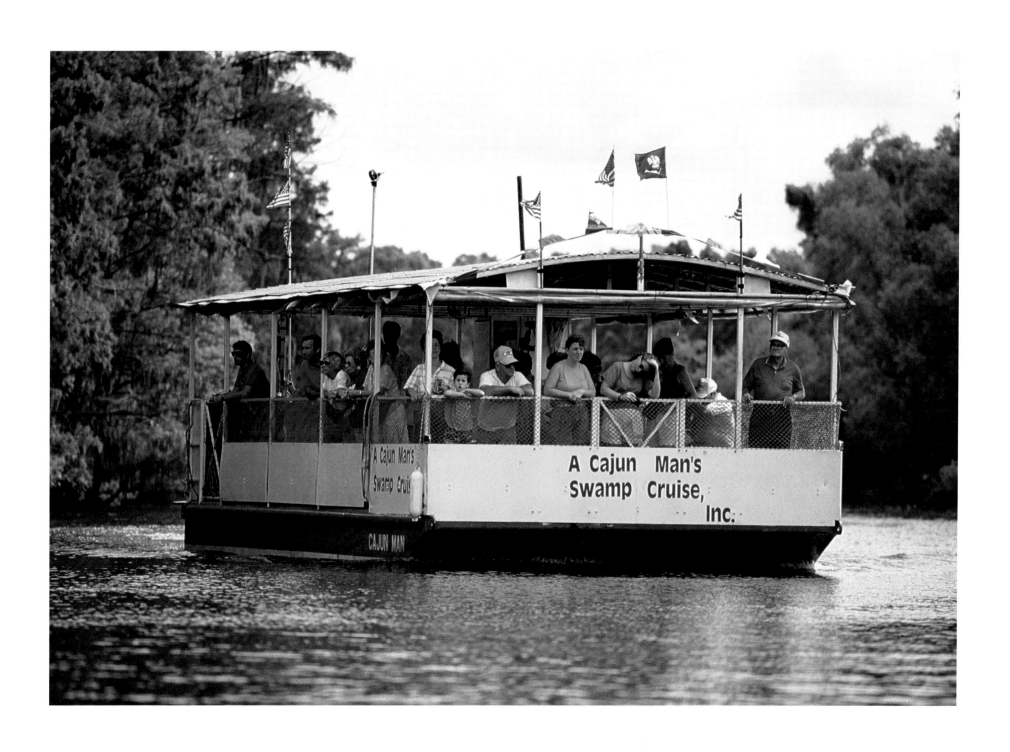

Cajun music is an important part of the culture in many of South Louisiana's coastal communities. Today's Cajuns are the descendants of the Acadians from France, who were driven out of modern-day Nova Scotia by the British and settled in the wetlands of Louisiana, where they adapted to fishing and hunting and farming in the bountiful marshes. In some families, French is still the language spoken at home.

Songs are written and sung in French, although many have been translated into English or even use both languages. The accordion and fiddle are featured instruments in Cajun music. Here, a group of musicians gathered for accordion player Tommy Michot's birthday at a camp on the banks of the Vermilion River spend a Sunday afternoon playing music and eating good food.

Michot is a wetland biologist who specializes in studying land loss. As a musician, he wrote "The Lost Marsh Waltz" to depict the link between the disappearance of the wetlands and the loss of the Acadian French culture in coastal Louisiana:

> Oh, my dear boy, you know it hurts me,
> When I look at the marsh and I see that it is lost.
> When I was young it was miles and miles of grasses.
> Now all the marsh is like a sea of salt water.

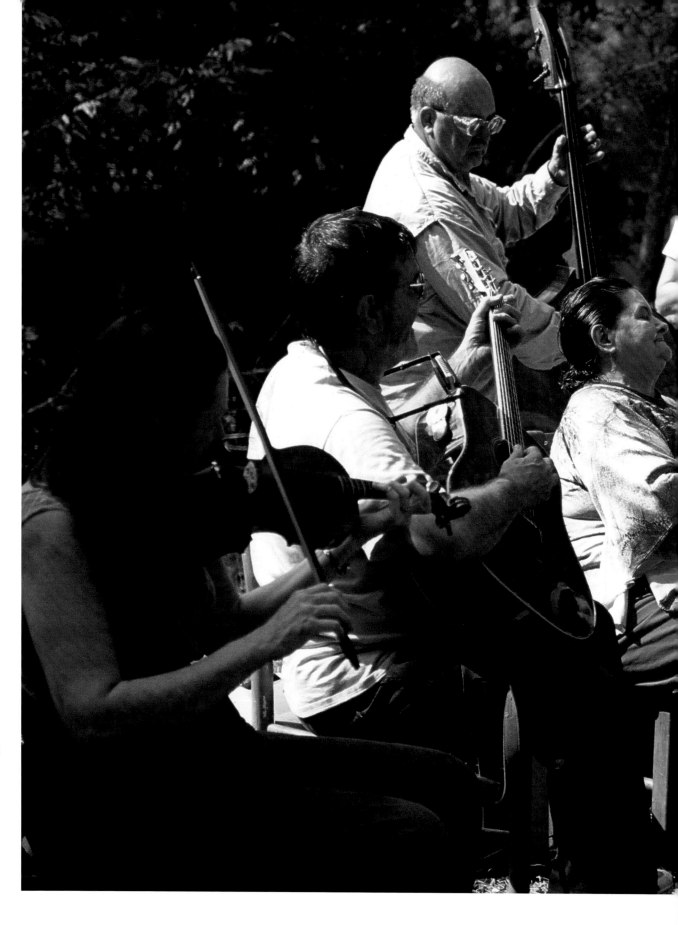

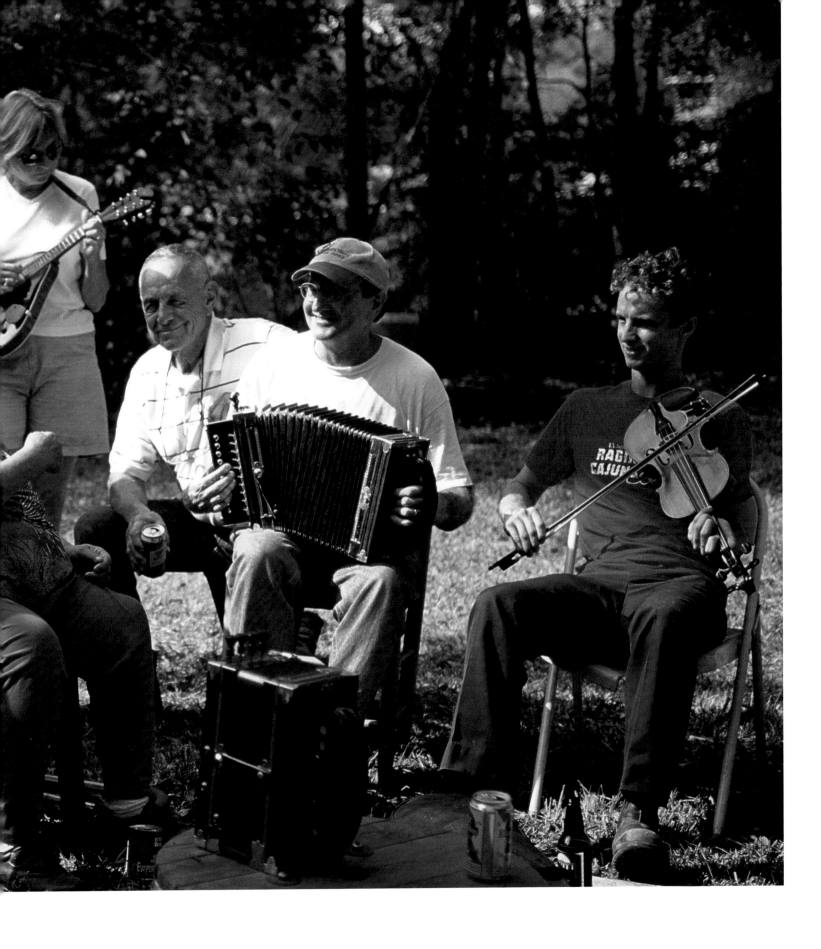

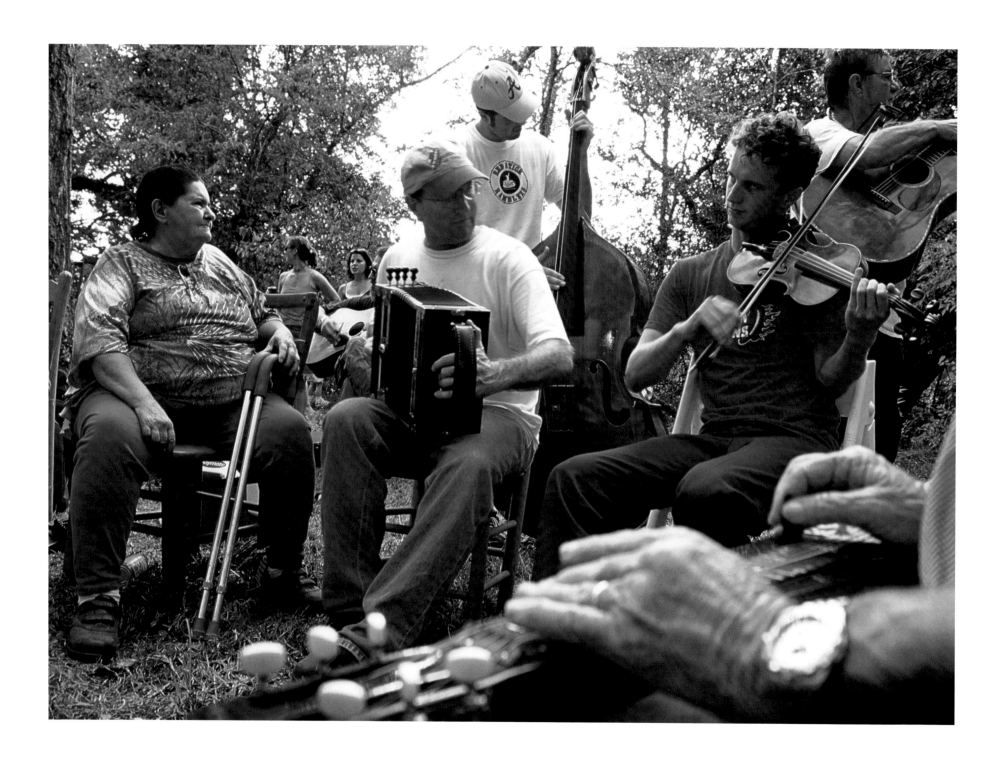

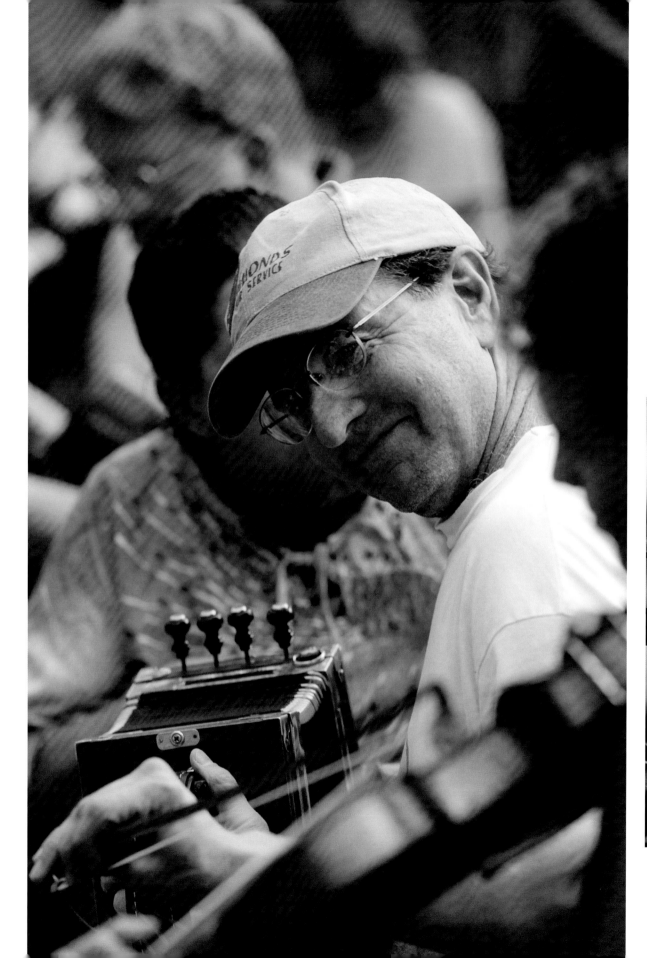

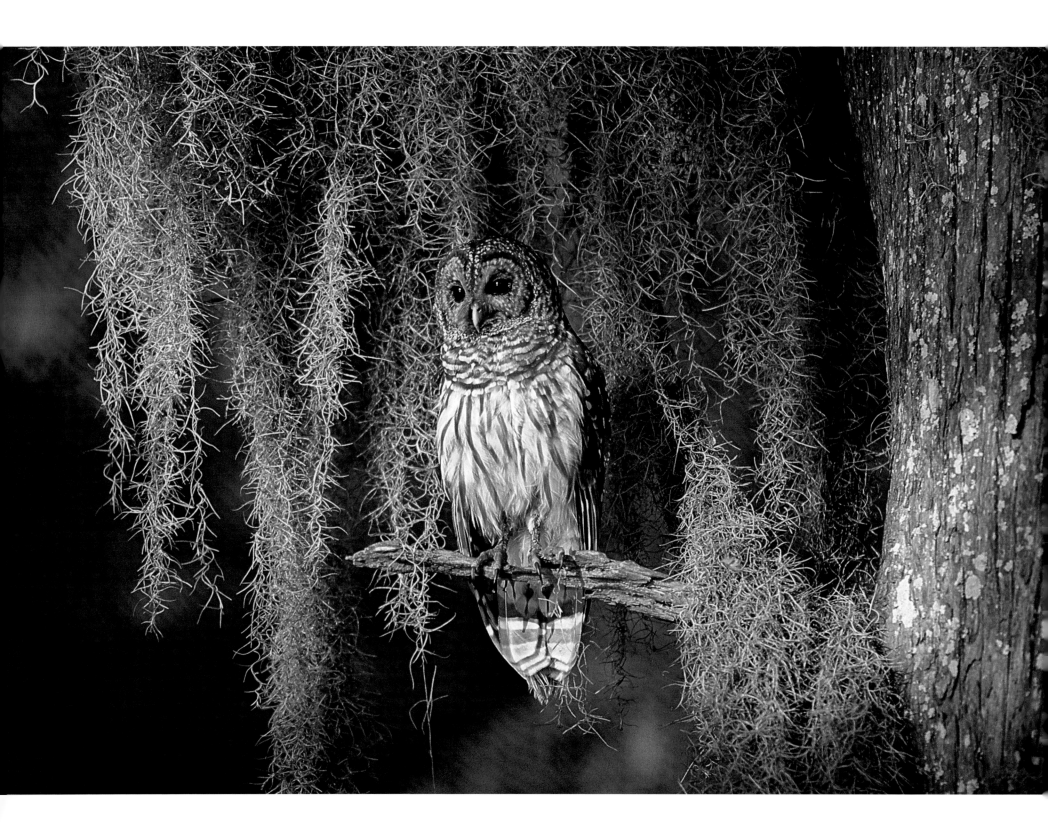

2

THE DISAPPEARING BOUNTY

Louisiana's marshes and wetlands are important to the nation's wildlife and ecology. Seventy percent of all birds that migrate through the Mississippi Flyway stop in Louisiana's wetlands to fuel up for further migration or to rest after crossing the Gulf of Mexico on their way back north.

The coastal marsh is also a nursery for fish and other sea life. The life cycles of 75 percent of the financially important fishery species, such as shrimp, rely on the combination of the Gulf of Mexico's salt water and the Mississippi River's fresh water. Bays where fresh and salt waters mix are called estuaries, and they are some of the most biologically productive areas in the ocean. Ninety-five percent of the commercial fish landed from the Gulf of Mexico, the bulk of which is landed in Louisiana, depend on coastal wetlands, according to the Louisiana State University Agricultural Center. Louisiana fisheries account for about 25 percent of all seafood consumed

Left: An owl sits amid the moss on a cypress tree in the Atchafalaya Basin, waiting for sundown, when its night vision gives it the advantage.

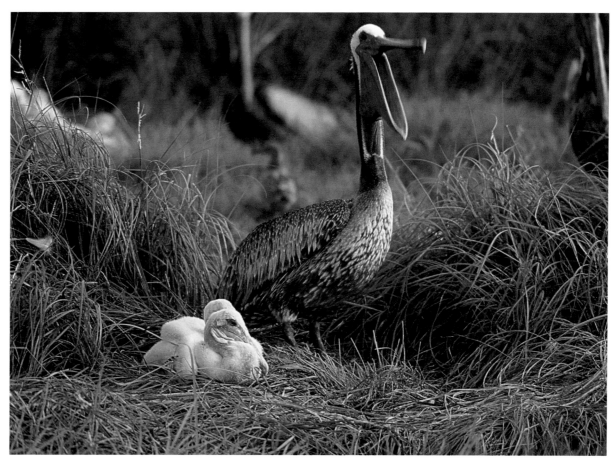

A mother pelican squawks as she defends her two babies on Breton Island in the Breton National Wildlife Refuge. Baby brown pelicans are born white but change colors as they age.

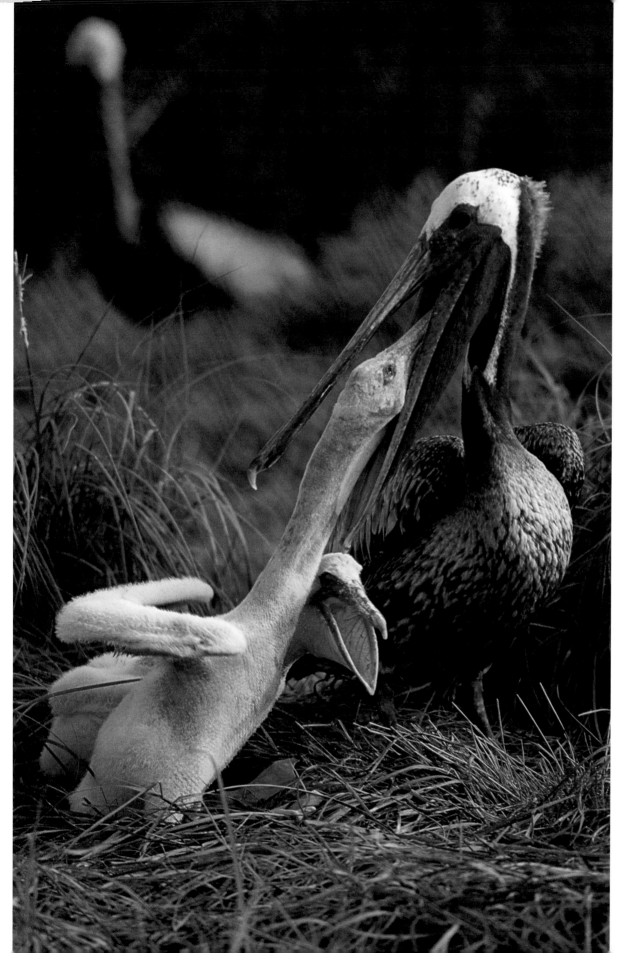

in the United States. The commercial and recreational value of those fisheries is $3 billion annually. The fishery value isn't just in scrumptious shrimp or blackened redfish. Menhaden, an oily fish that man won't eat, is an important ingredient in chicken feed and helps keep broiler chickens more affordable for everyone.

The top attraction on many tourists' lists, alligators, and the state bird, the brown pelican, are perhaps the best-known denizens of the Louisiana wetlands. Both have been brought back from near extinction—showing ecological restoration does work. For the pelican, now-banned pesticides flowing down the rivers that empty into the Gulf of Mexico kept eggshells from hardening and babies from hatching. By 1963, the symbol of Louisiana was no longer found in state waters. In 1968, brown pelicans from Florida were reintroduced, and they are found now in the same numbers and ranges as they were found in 1950.

The other wetland animal star is the alligator, also hunted to near extinction by the 1950s and 1960s. Populations have rebounded following a hunting ban for several years and then regulations on harvesting. There are farmers who collect eggs from the wild and grow hatchlings for marketable hides and meat.

The stories of the gators and pelicans prove that properly planned and managed restoration efforts can be a success. Now, the new worry for both pelicans and alligators is the loss of their habitat as the wetlands slowly disappear.

A baby pelican stretches to get food from its mother's bill pouch.

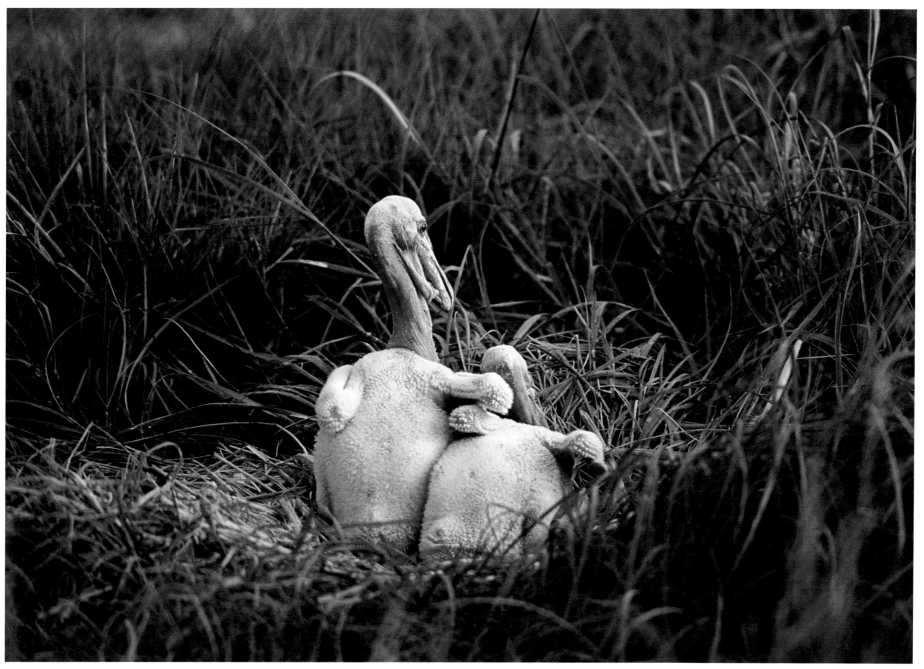

As if a bigger brother is putting a protective wing around his little brother, two baby pelicans await Mom's return on Breton Island.

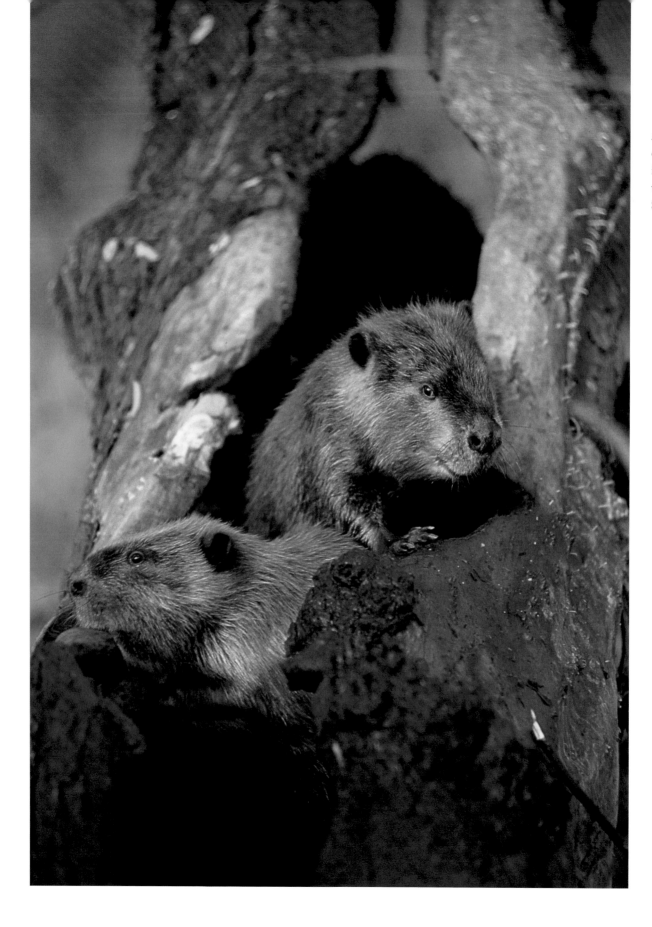

A pair of baby beavers peer out of their hiding place inside a hollow log in the waters of the Atchafalaya Swamp.

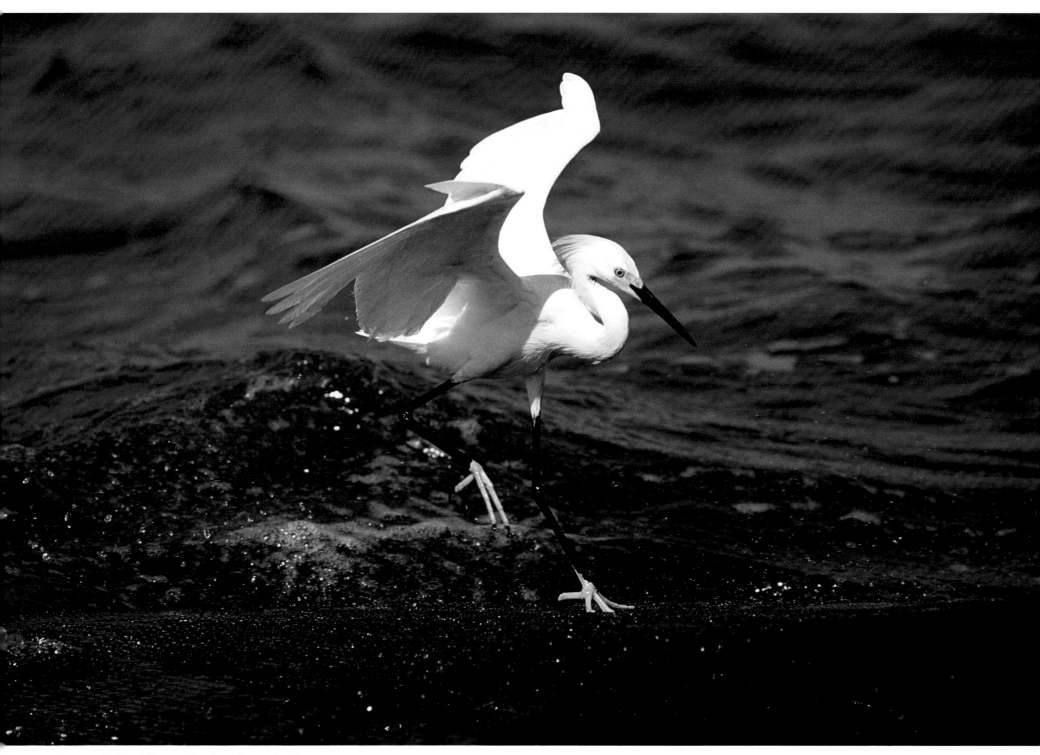

An egret looks as if he were dancing as he touches down to
look for something to eat.

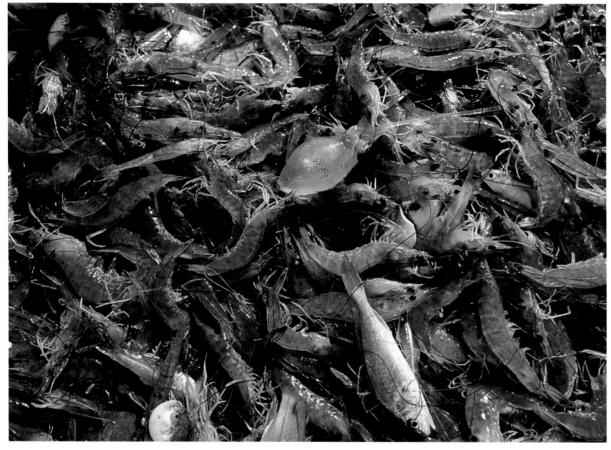

Shrimp is the most lucrative seafood product caught in the Gulf of Mexico. Also caught in the nets are a few squid and minnows. Shrimp spend part of their life cycles in the inland marshes, which are disappearing at an alarming rate, as well as the open waters of the Gulf of Mexico.

The morning sun paints the waters of Breton Sound pink as a shrimp boat trawls.

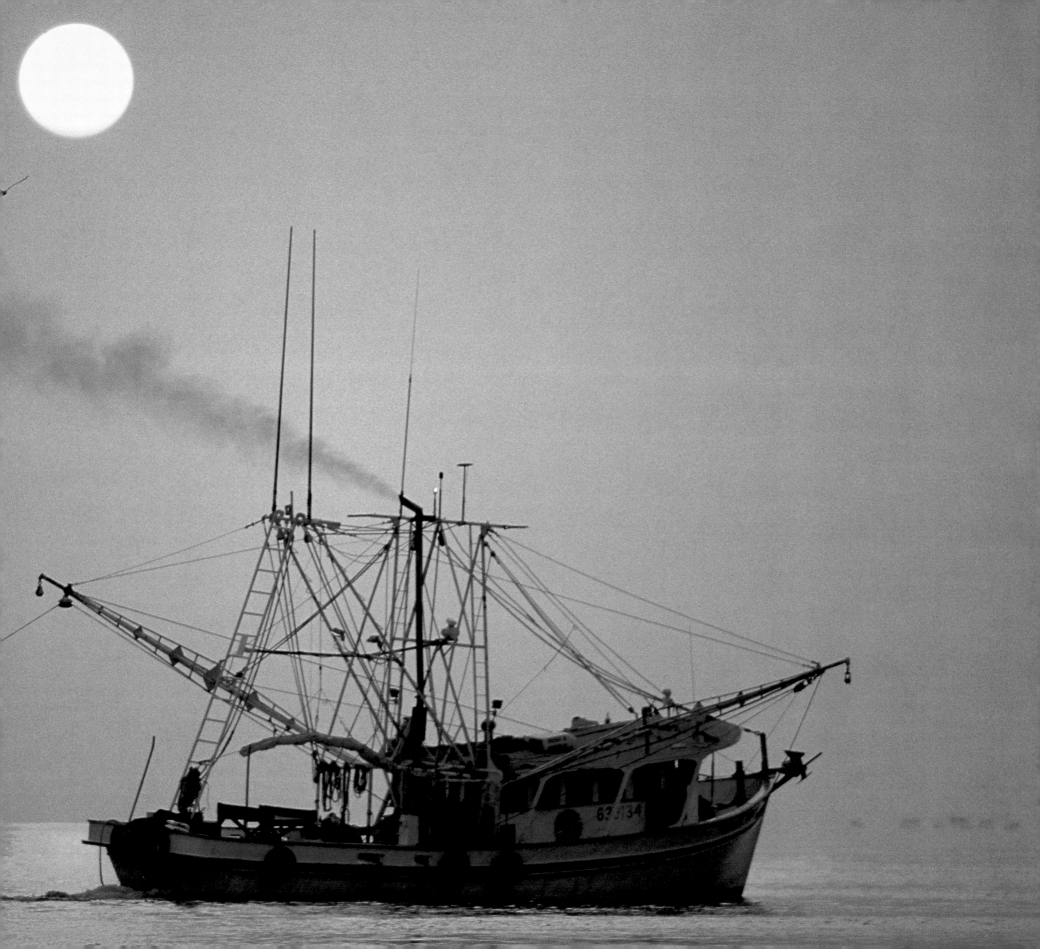

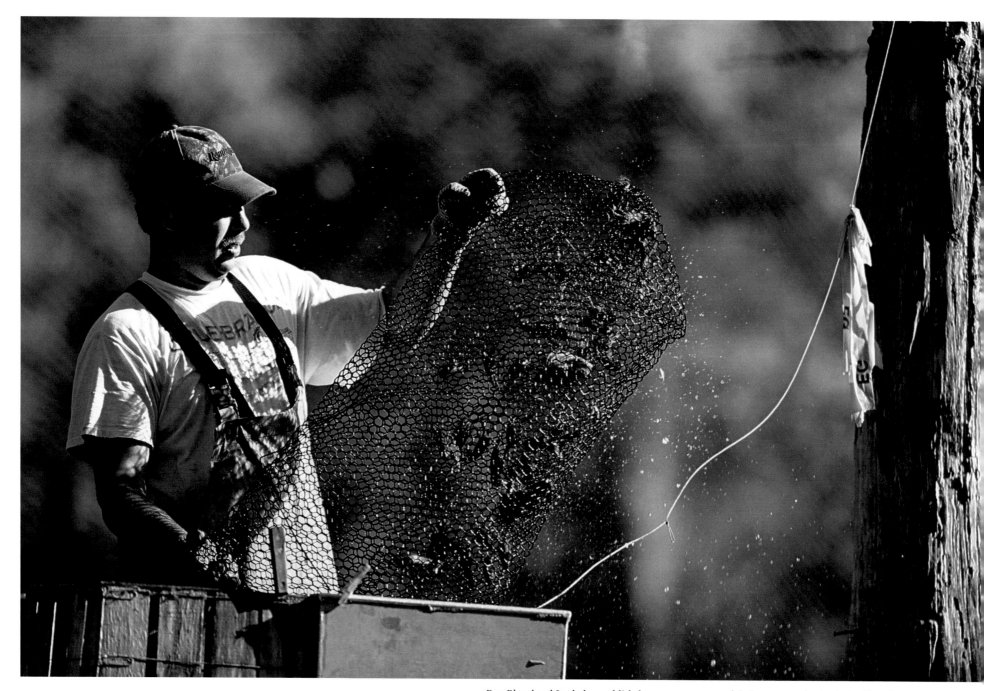

Roy Blanchard Jr. shakes reddish-brown swamp crawfish from a trap in the Atchafalaya Swamp. Crawfish, which look like little lobsters, are a delicacy in South Louisiana and provide some fishermen with a seasonal crop.

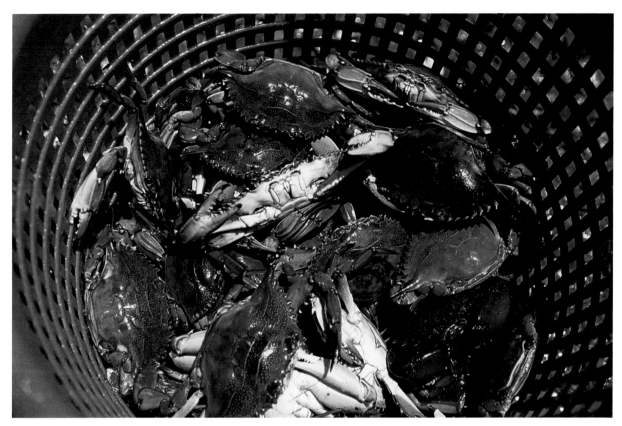

A basket of freshly caught blue crabs will soon be boiling—part of the bounty of the sea.

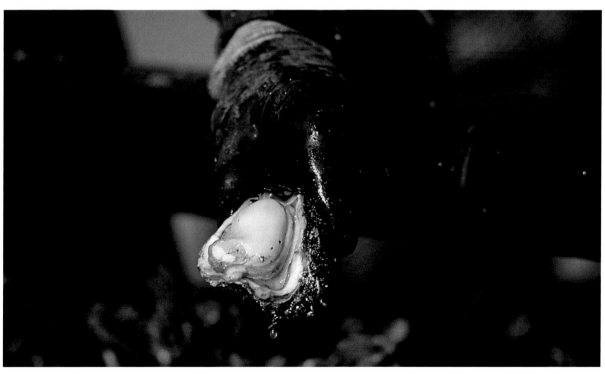

An oysterman shows off his catch. Succulent Louisiana oysters are a delicacy around the country. Oysters live in the zones where fresh and salt waters mix. Too much salt—or too little—can kill them. Coastal restoration programs have begun buying oyster leases from farmers, many of whom have created and farmed the same reefs for generations.

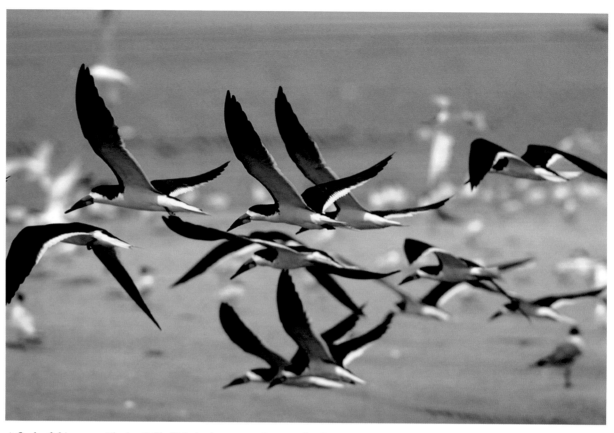

A flock of skimmers ride the Gulf of Mexico breezes on Breton Island.

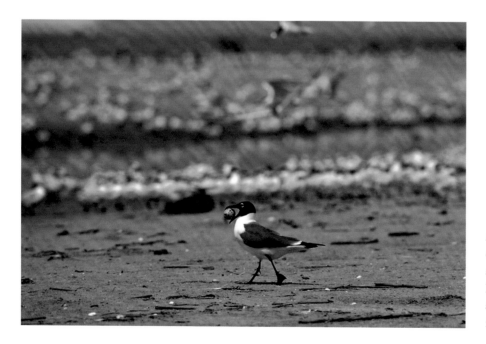

A seagull carries a skimmer egg after stealing it from a skimmer nest on Breton Island. Gulls harass the black-and-white skimmers looking for such opportunities.

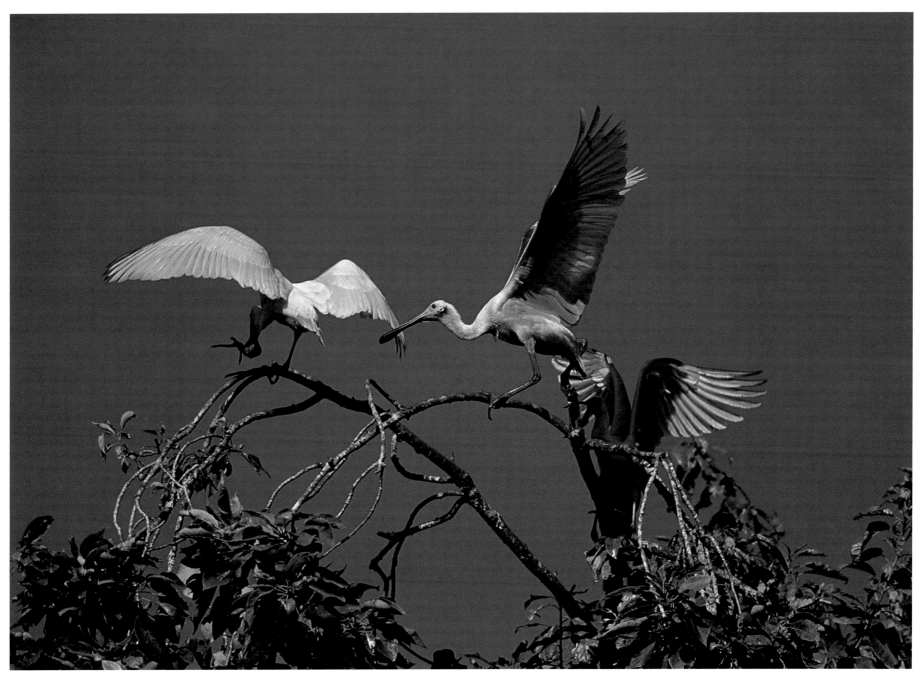

Roseate spoonbills, one of the more exotic waterbirds to live along Louisiana's coastal wetlands, jockey for position in a tree at Lake Martin, a rookery where visitors can see waterbirds nesting each spring right along a roadside.

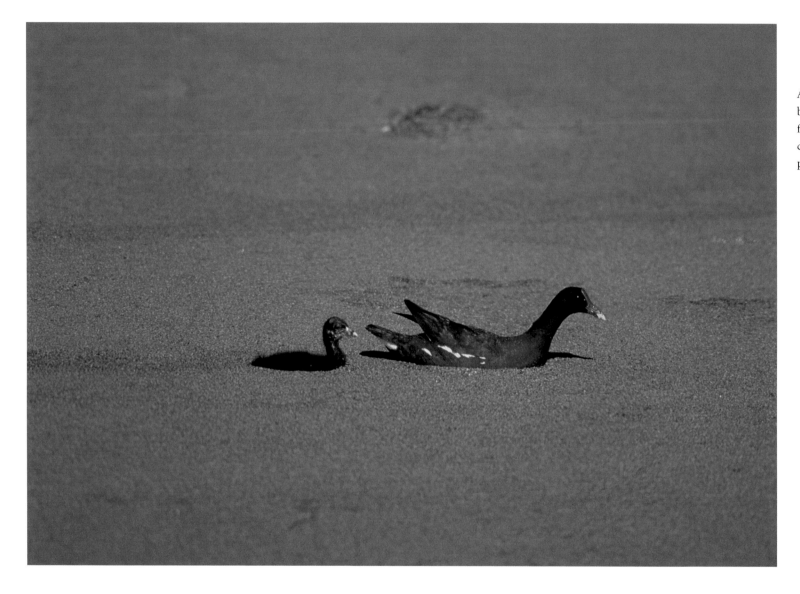

A mother moorhen, with baby in tow, swims through floating duckweed, which covers some freshwater ponds and lakes.

Each summer, farmers locate alligator nests and harvest eggs, which are incubated and hatched. Farmers then feed the little alligators until they reach about four feet in length. Fourteen percent of the hatchlings are returned to the wild—about the same ratio that survives in nature. The rest can be kept for skins and meat.

The farm-raised hides have an estimated value of about $15.8 million per year. Another 33,000 alligators are harvested from the wild, bringing in another $8.2 million.

The Louisiana Department of Wildlife and Fisheries says that in the 1930s, about 65,000 alligators were harvested from the wetlands in the state each year. Populations dropped to about 100,000 during the early 1960s. In 1967, alligators were placed on the federal endangered species list.

Restoration efforts brought alligator populations back up to about 1 to 2 million in the coastal marshes. Each year, the state sets a limit on the number of alligators that can be harvested through hunting.

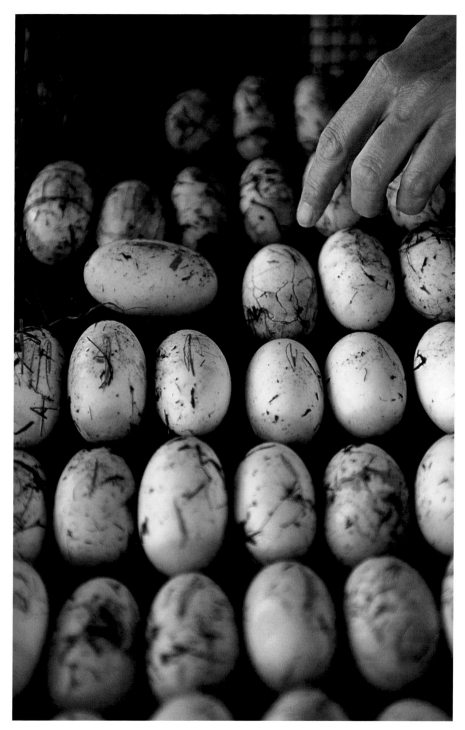

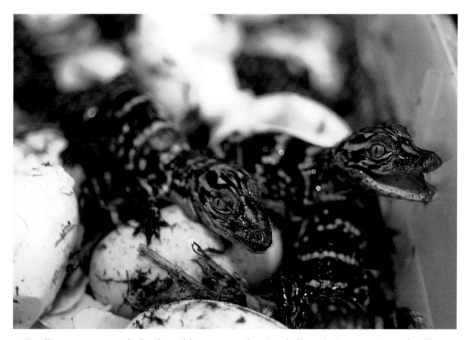

Baby alligators seem ready for the wild as soon as they hatch from their eggs at Savoie's Alligator Farm.

Alligator eggs are harvested and hatched at Rockefeller Wildlife Refuge and in gator farms across South Louisiana. Alligator population has rebounded thanks to conservation and research like that done at the Rockefeller refuge.

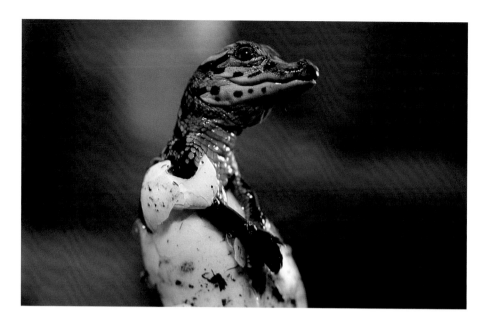

A baby alligator looks as if it has decided to pose for this picture before finally climbing out of his shell.

Alligator farmers return some of their hatchlings to the wild under the regulations that govern their business.

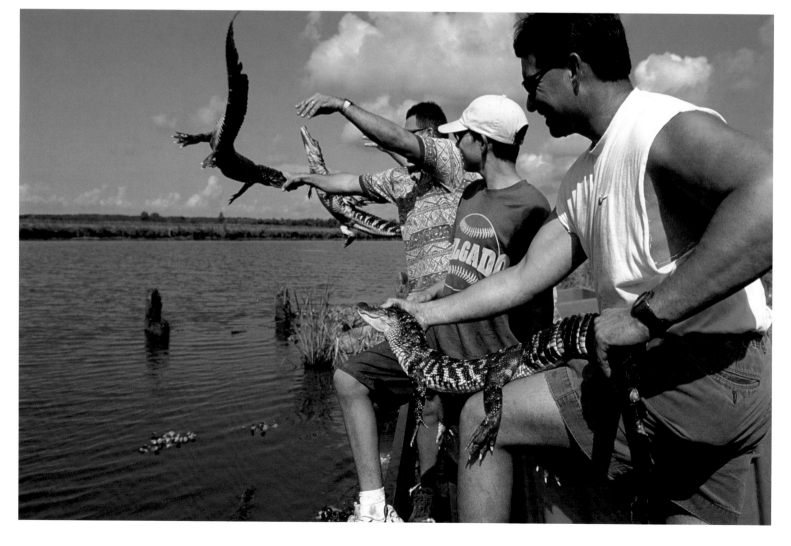

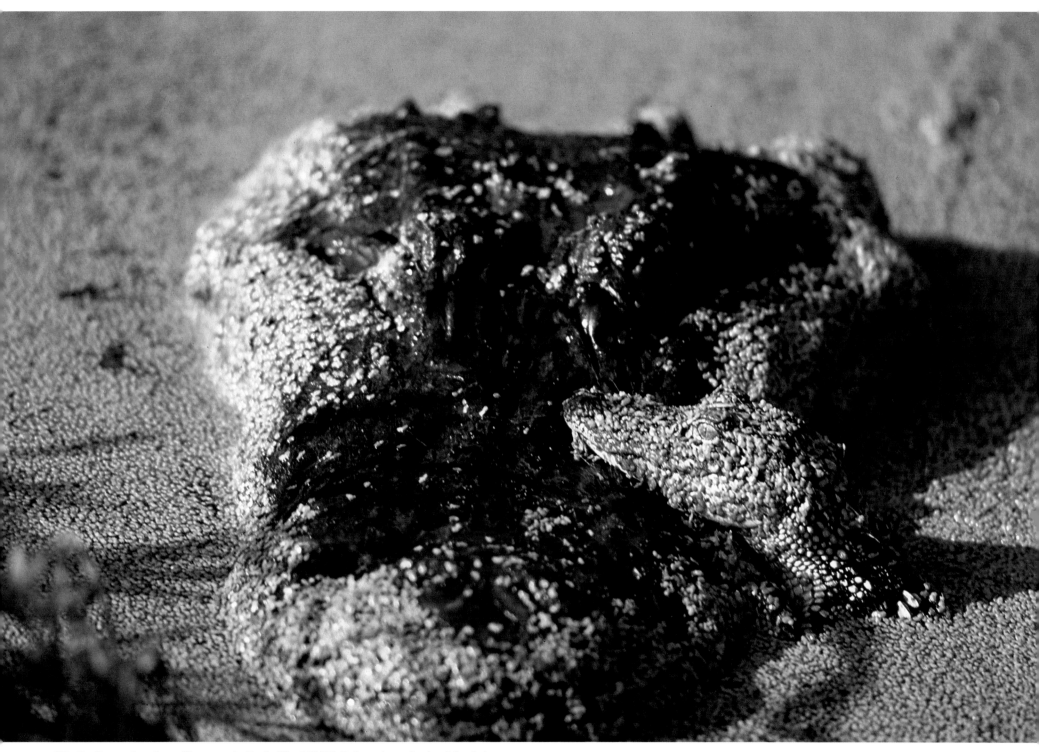

"Big Boy," a 12.5-foot-long alligator at the Rockefeller Wildlife Refuge, sits patiently while a baby climbs up on his head. The baby is lucky, as alligators can be cannibalistic.

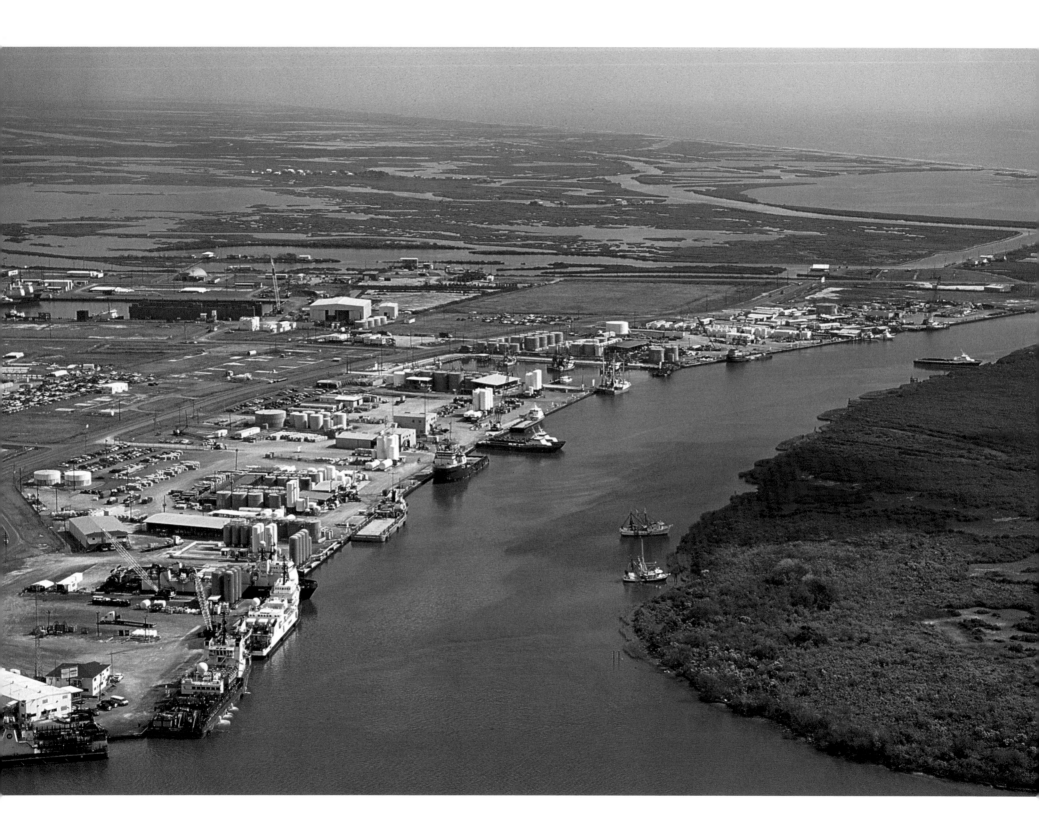

3

A NATION'S SECURITY THREATENED

Louisiana's wetlands are not just mud and marsh grass. We know today that these wetlands, long considered wastelands, are invaluable in many ways. They provide protection for more than 30,000 miles of pipelines that carry much of the nation's oil and gas. They are home to the U.S. Strategic Petroleum Reserve, and 34 percent of the nation's natural gas supply and almost 30 percent of its crude oil supply are either produced off Louisiana's shore or move through the state's coastal wetlands.

Hurricanes marching across the Gulf of Mexico can shut down oil and gas production long enough to cause rises in the world's oil prices. Natural gas pipelines converge in a place called the "Henry Hub," the point where financial markets determine the value of natural gas.

A lot of oil infrastructure built in once-healthy

Left: Port Fourchon in Lafourche Parish services most of the central Gulf of Mexico oil and gas exploration. Goods and supplies are trucked in on Louisiana Highway 1, which often goes under water from storm tides days before a hurricane or tropical storm makes landfall. As the wetlands around the port erode, it becomes more vulnerable.

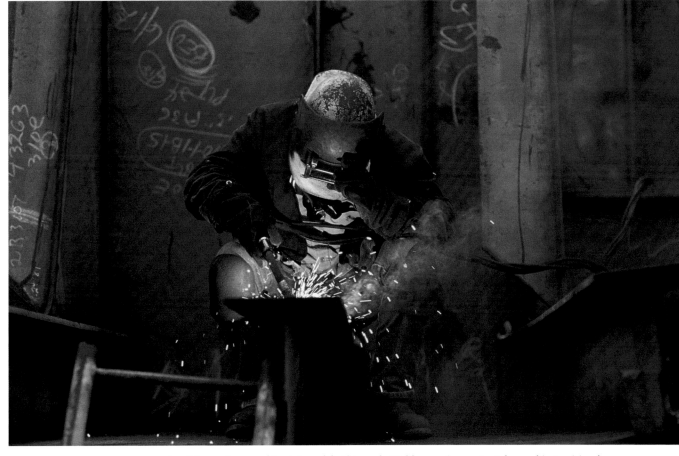

A welder works on a ship at Avondale Shipyards. Welders are in constant demand in Louisiana's coastal area for work ranging from building ships to laying pipelines.

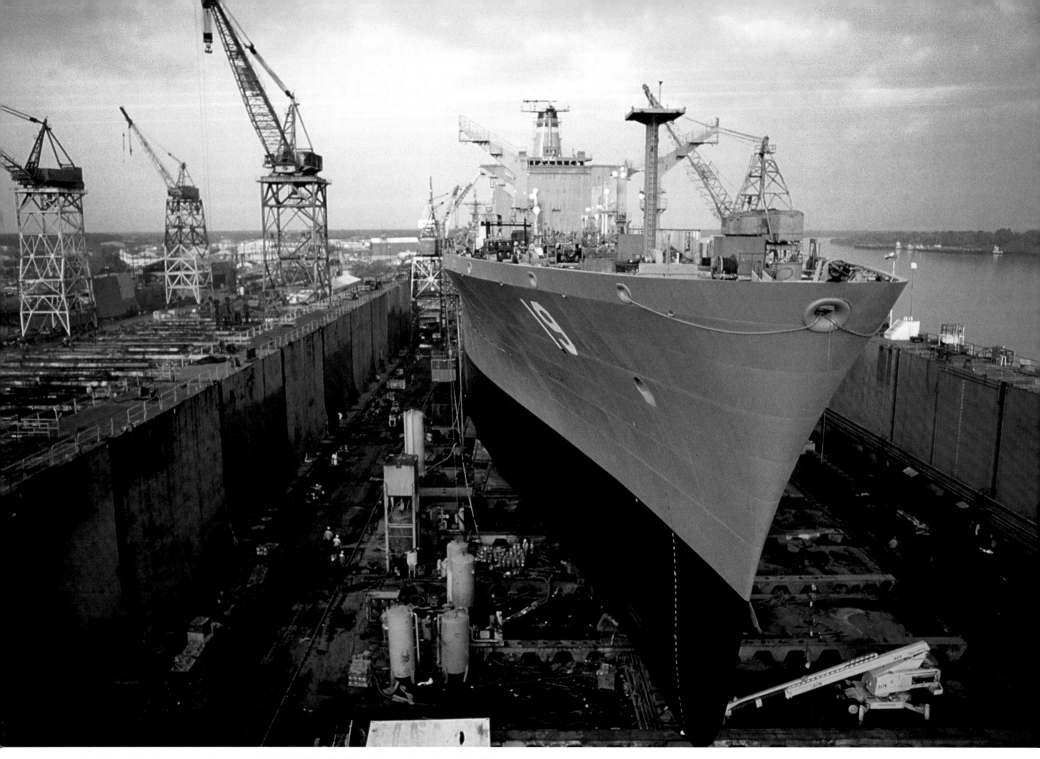

South Louisiana's waterways host several shipbuilding facilities, like the giant Avondale Ship-yard on the Mississippi River just above New Orleans.

marsh is now in open water and subject to the battering of waves. In coming years, if nothing is done, much of it will have to be replaced or abandoned.

The Mississippi River, Gulf Intracoastal Waterway, and other navigational channels account for nearly 500 million tons of waterborne commerce annually.

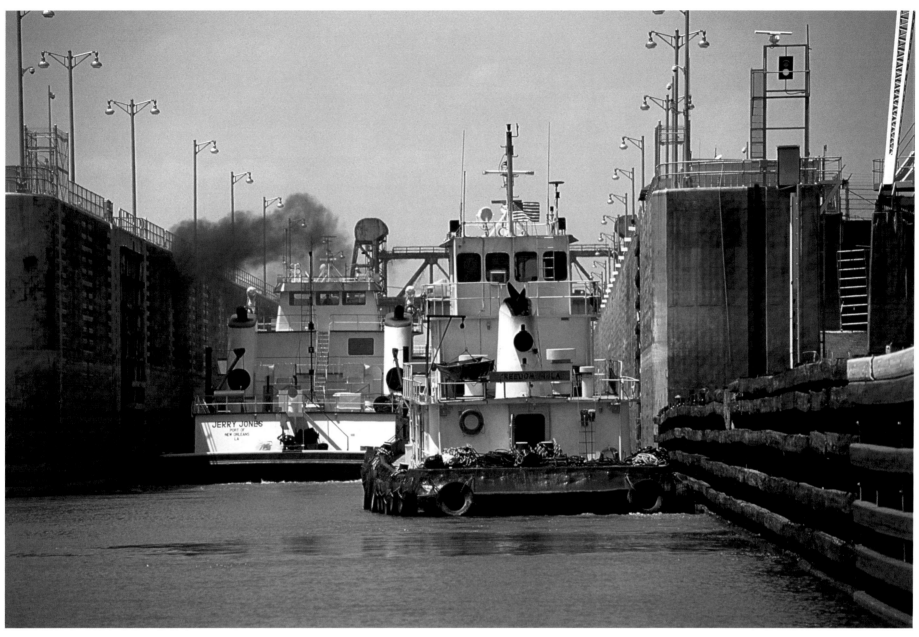

Millions of tons of cargo travel through shipping channels that slice through America's Wetland, providing safe inland routes for barge traffic. Here, a tow goes through the lock system that connects the Mississippi River to the Gulf Intracoastal Waterway in Port Allen, near Baton Rouge.

That's 21 percent of all waterborne commerce in the United States. Four of the ten largest ports in the United States are located in Louisiana. The state also has several shipyards, such as the giant Avondale Shipyards on the Mississippi River in New Orleans.

Nearly one-quarter of the nation's basic chemicals are produced along the Mississippi River and other Louisiana waterways. About 150 miles of inland water-ways are threatened; many miles of waterway are protected by only a thin strip of marsh preventing waves from reaching barge and ship traffic.

While drilling, pipelines, and canals have all played a part in wetlands loss in

the past, there's a greater environmental sensitivity today. Drilling in the coastal marshes is more tightly controlled, with fewer canals being dug and more wells being drilled from a single platform using new technology.

One measure industry has taken to help preserve the wetland has been to install a pipeline to service an outer continental-shelf field only in the water, taking a longer route rather than cutting across marshes. Other companies have put pipelines under barrier islands rather than cutting across them as well.

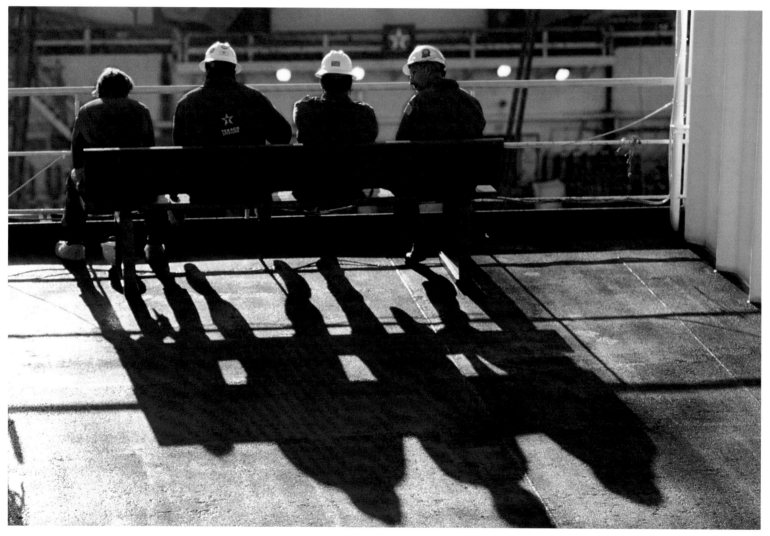

Offshore oil platform drillers on break and at work. Workers usually work two weeks on a platform doing double shifts and then take two weeks off. More than 80 percent of the nation's offshore oil and gas is produced off Louisiana's coast, and almost 30 percent of the entire nation's foreign and domestic oil comes across the state's shore by tanker, barge, or pipeline.

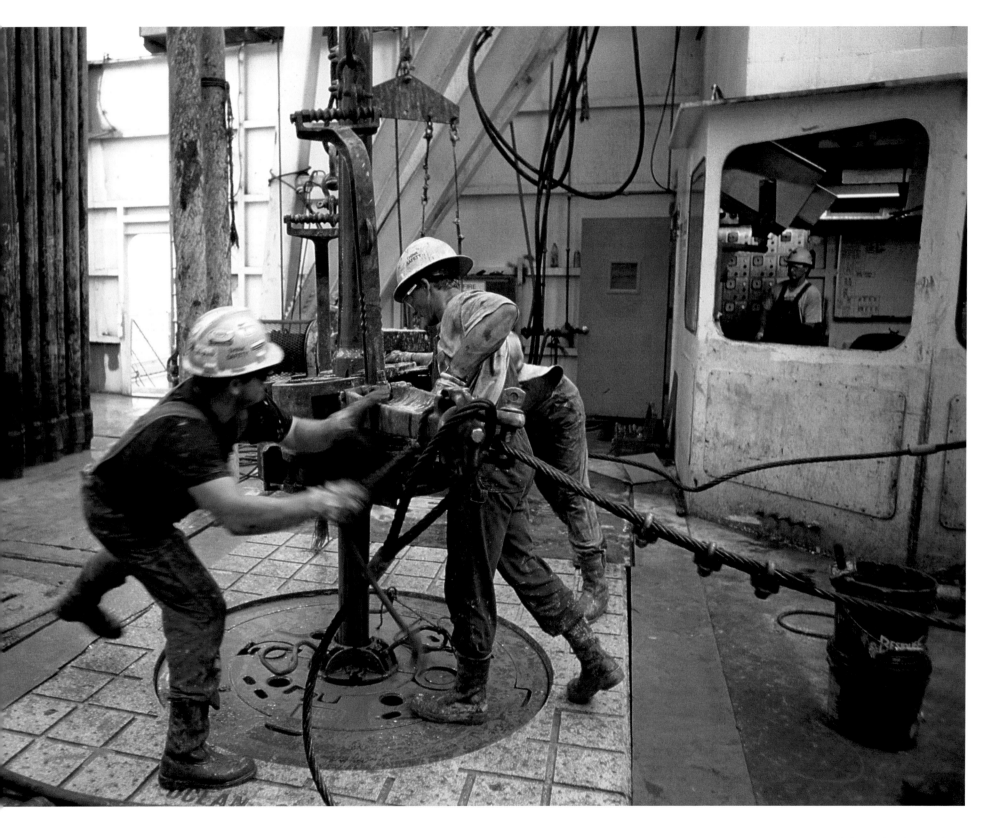

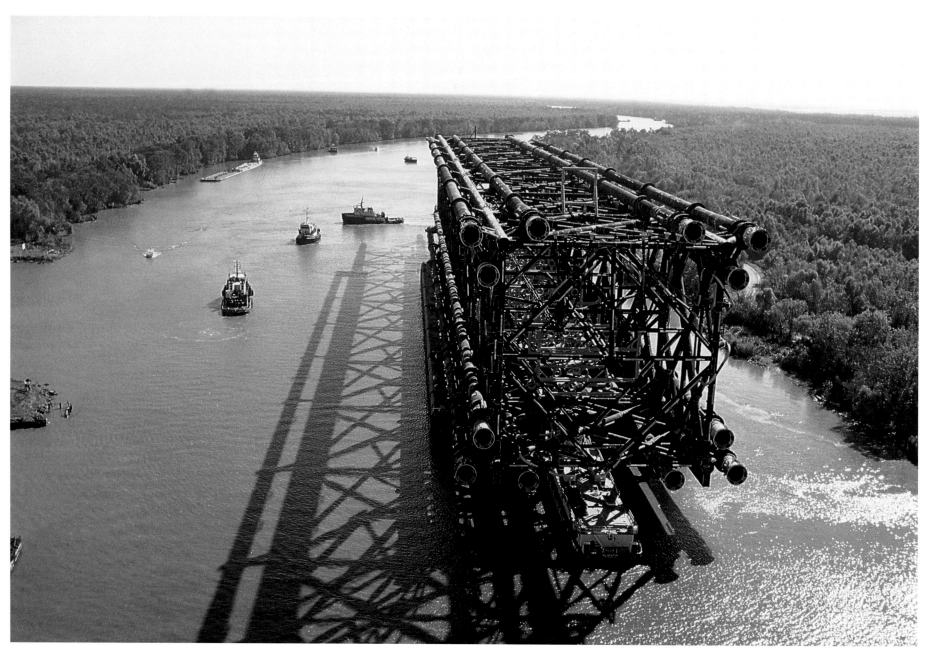

The oil and gas drilling platforms and the legs that will hold them up above the water's surface are fabricated inland and then floated out to deepwater sites and placed into position.

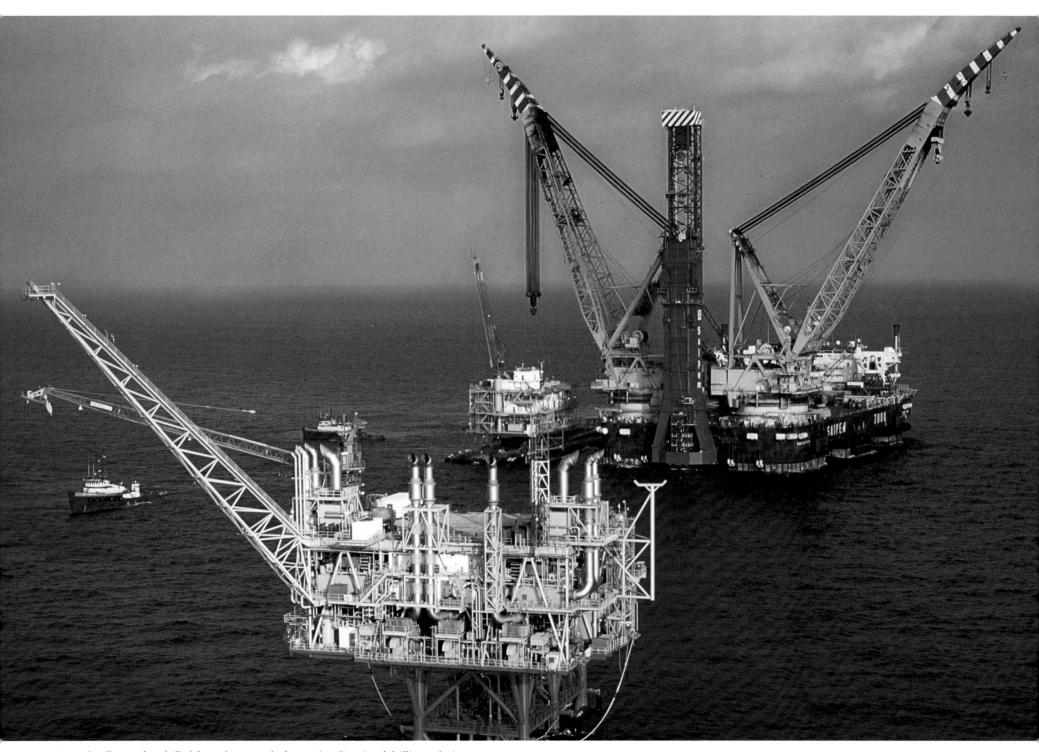

Several wells are often drilled from the same platform using directional drilling techniques.

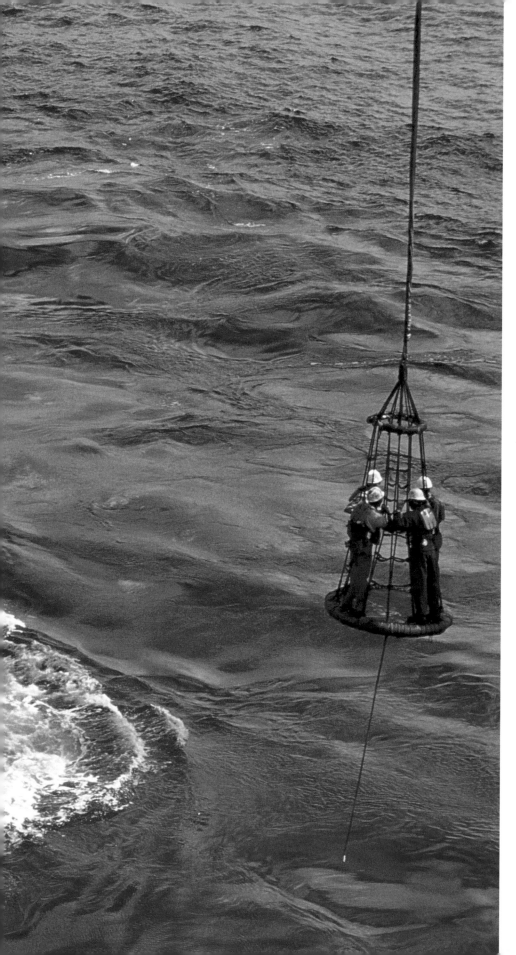

A crane hauls up some workers from the crew boat that brought them out to an offshore oil platform.

Miles of cable are needed for drilling platforms to do their job.

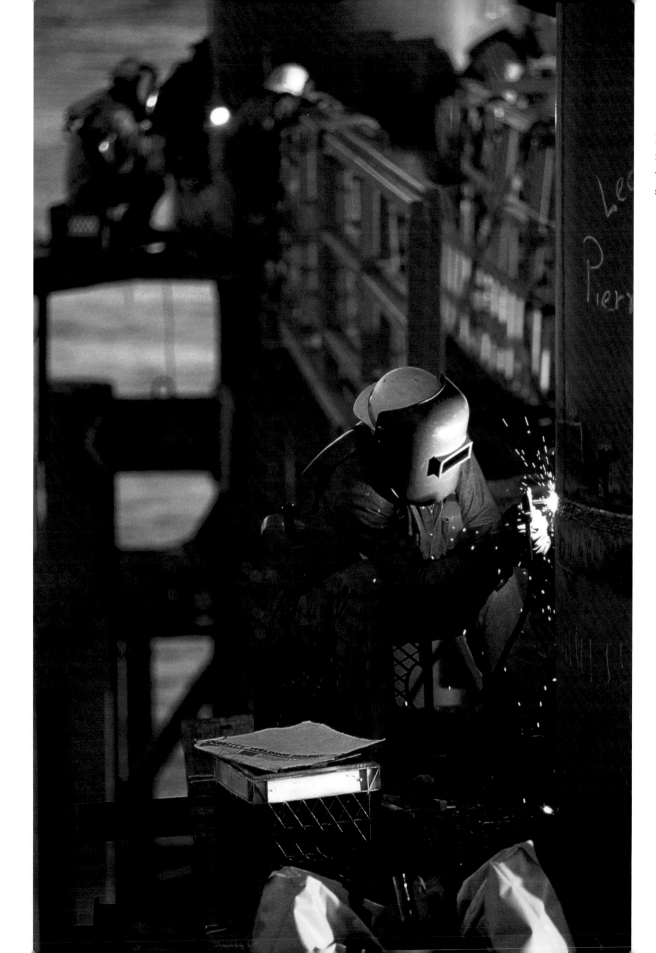

Drilling for oil involves many skilled jobs, and welders are often highly sought after.

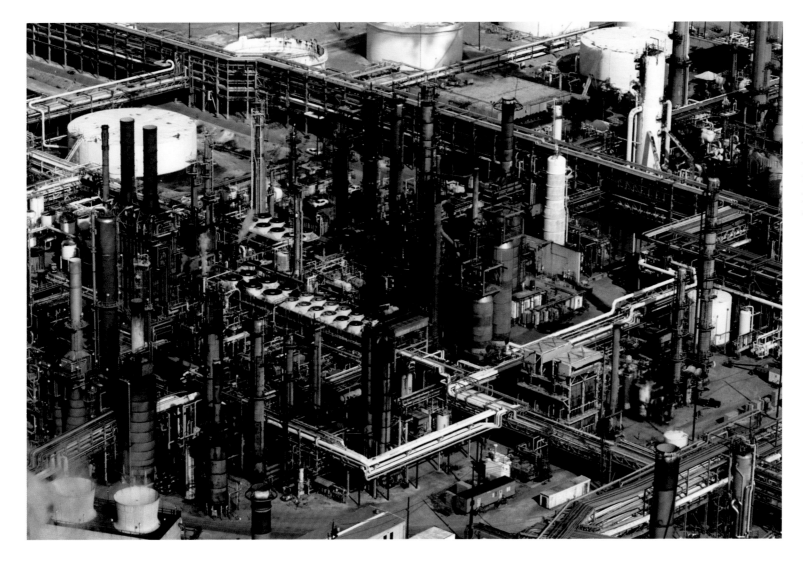

Chemical plants and refineries dot the landscape in coastal Louisiana, taking advantage of waterways for shipping, rivers and bayous for cooling water, and the proximity to natural gas and oil for raw materials.

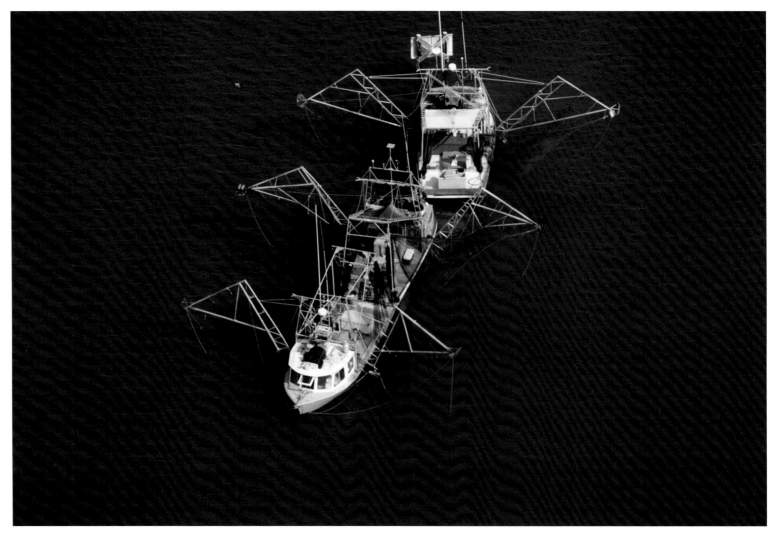

The skimmer arms that hold out the nets shrimp boats use to catch their quarry look a little like an insect's legs from the air as these boats sit tied together. Shrimpers usually wait for tides to move before trawling and often link up to socialize or sleep until the water begins to move.

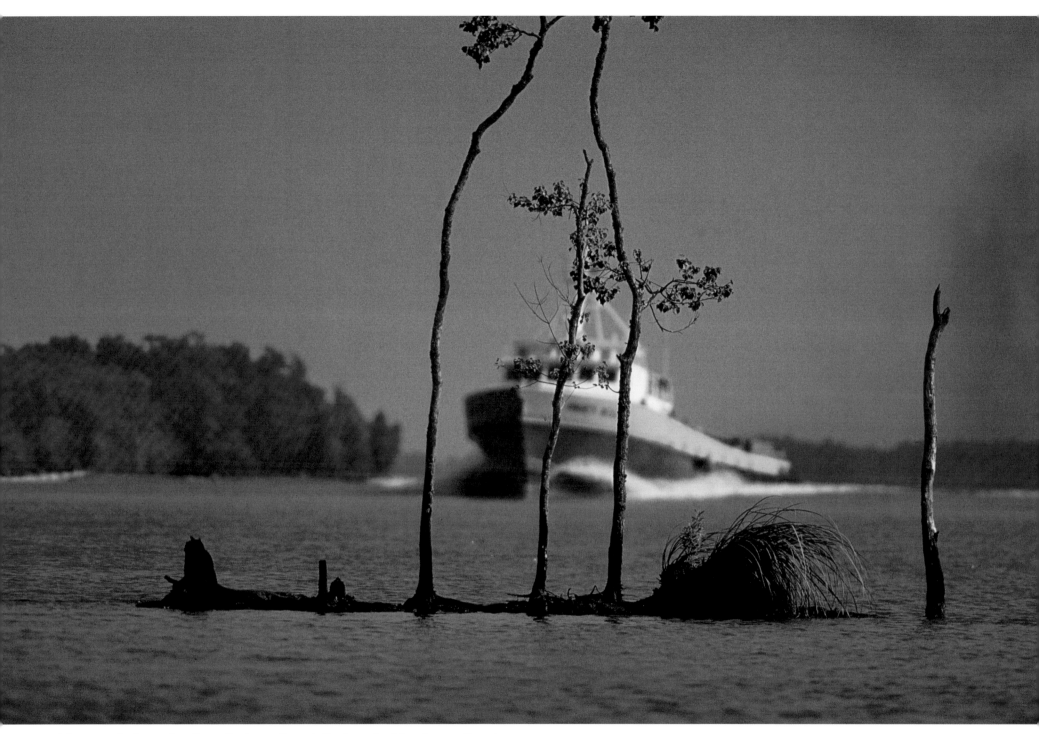

A fragment of a former shoreline on Freshwater Bayou in Southwest Louisiana faces another set of waves from a gigantic crew boat speeding by. Some boat captains have been known to bet on whether their boat's wake can topple rocks that have been placed along the shoreline to slow erosion.

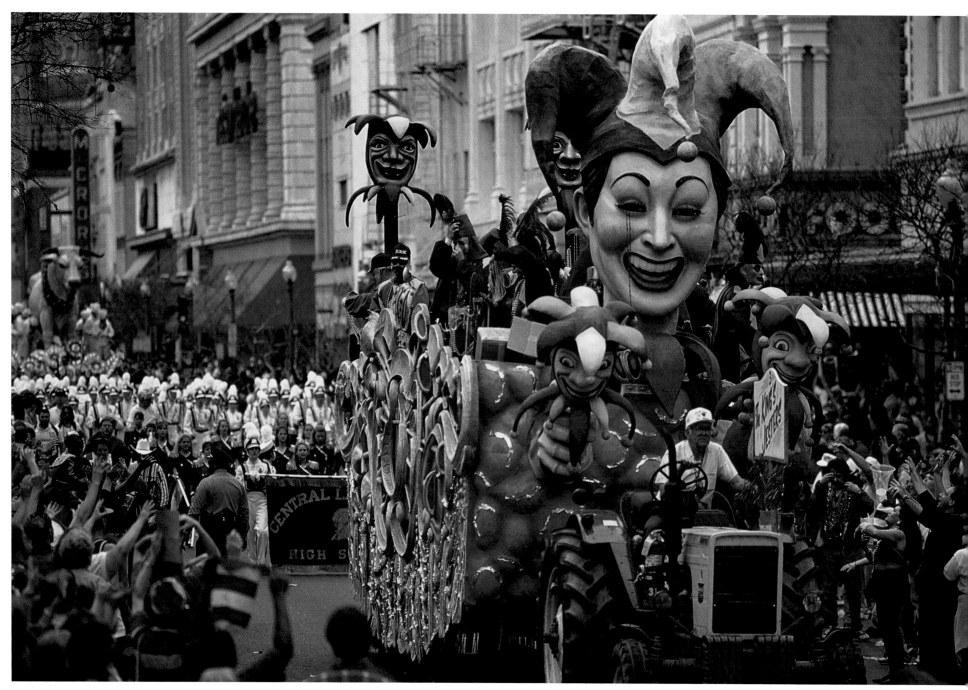

New Orleans is known as the "City that Care Forgot," in part for its annual Mardi Gras celebration to mark the beginning of the Lenten season. Riders on floats throw beads and trinkets to the crowd, and bands provide the music.

4

AMERICA'S ATLANTIS

New Orleans, the "Big Easy," could easily become "America's Atlantis." A historically significant city with a unique culture, New Orleans is also below sea level, protected on all sides by a levee system between Lake Pontchartrain and the Mississippi River.

The coastal wetlands that protect that levee system are slowly eroding, and every 2.7 miles of wetlands reduces storm surge—the bulge of water pushed inland by a storm—by one foot.

Even a slow-moving Category 3 hurricane, with sustained winds of 111–130 miles per hour, could flood New Orleans, says Dr. Ivor van Heerden, deputy director of the LSU Hurricane Center. He is studying what could happen and devising possible responses. "If you flood it completely, you are going to have thirteen to seventeen feet of water in the city. That forces people to get up on their roofs," van Heerden says. "There would be upwards of 400,000 people trapped because a large number will not evacuate. A large number don't own motor vehicles; some are disabled or street people."

One idea about how to rescue those people is what van Heerden and his associates call "Operation Dunkirk," evoking the famous retreat of the British and their allies in Europe early in World War II. Private boats from the area would be used to reach the trapped people. Van Heerden says authorities would obviously use helicopters, too, but notes that an inundated New Orleans "would stress every resource we've got." The health of people stranded on their roofs would also be a concern.

Pumping all the water out of New Orleans could take up to nine weeks.

"Maybe we will have 700,000 people homeless," he estimates. "This would be a catastrophe, a national catastrophe, and the economic impact would probably exceed $50 billion."

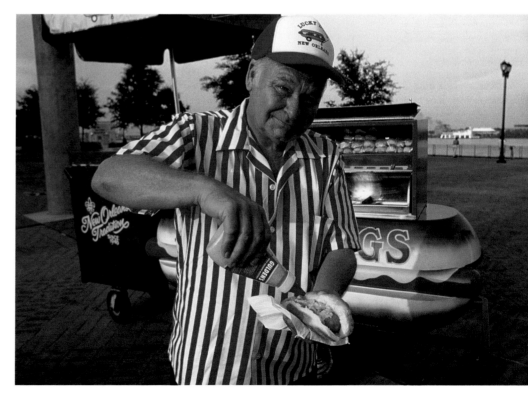

Hot dog vendor Chet Anderson sells famous "Lucky Dogs" on the riverfront in New Orleans.

New Orleans has already had close calls, prompting massive traffic jams on interstates when motorists try to flee the city on a limited roadway system that can quickly flood with a storm even twenty-four hours from landfall. Under water, with tens of thousands of causalities, New Orleans could become the site of America's greatest natural disaster.

Right: One of New Orleans's unique streetcars travels down St. Charles Avenue. Though the Crescent City doesn't normally appear to be below sea level, it is, and rainwater must be pumped out to prevent flooding.

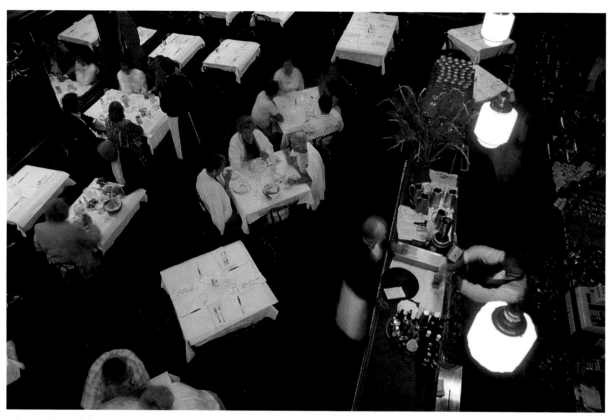

Diners enjoy a delicious meal at one of the many restaurants in New Orleans. The city is known for fine dining, with a culinary style that grew from the ingredients of the wetlands and the people who came to populate them. Creole cooking is a melting pot of Caribbean, African, French, and Spanish influences.

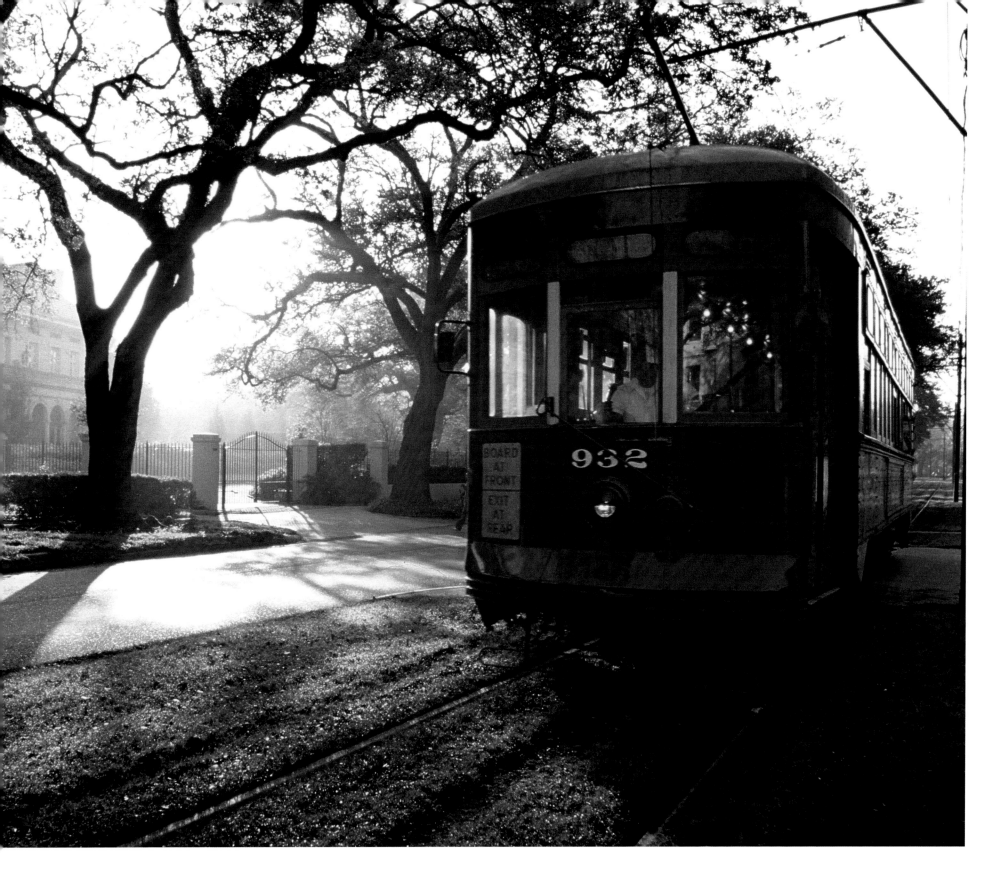

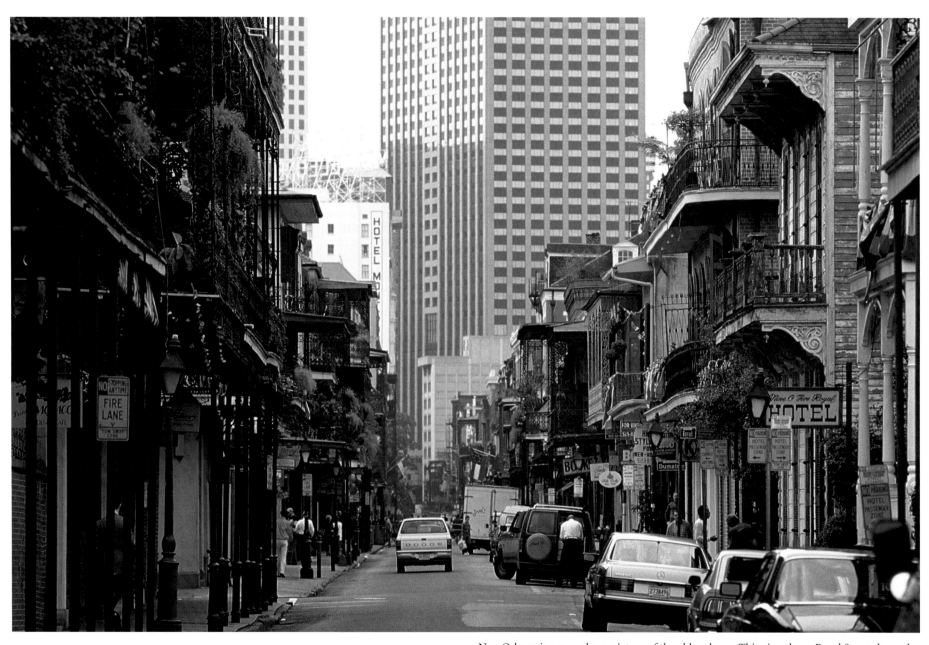

New Orleans is a marvelous mixture of the old and new. This view down Royal Street shows the influences of Spanish and French colonial days in what is now a modern business center.

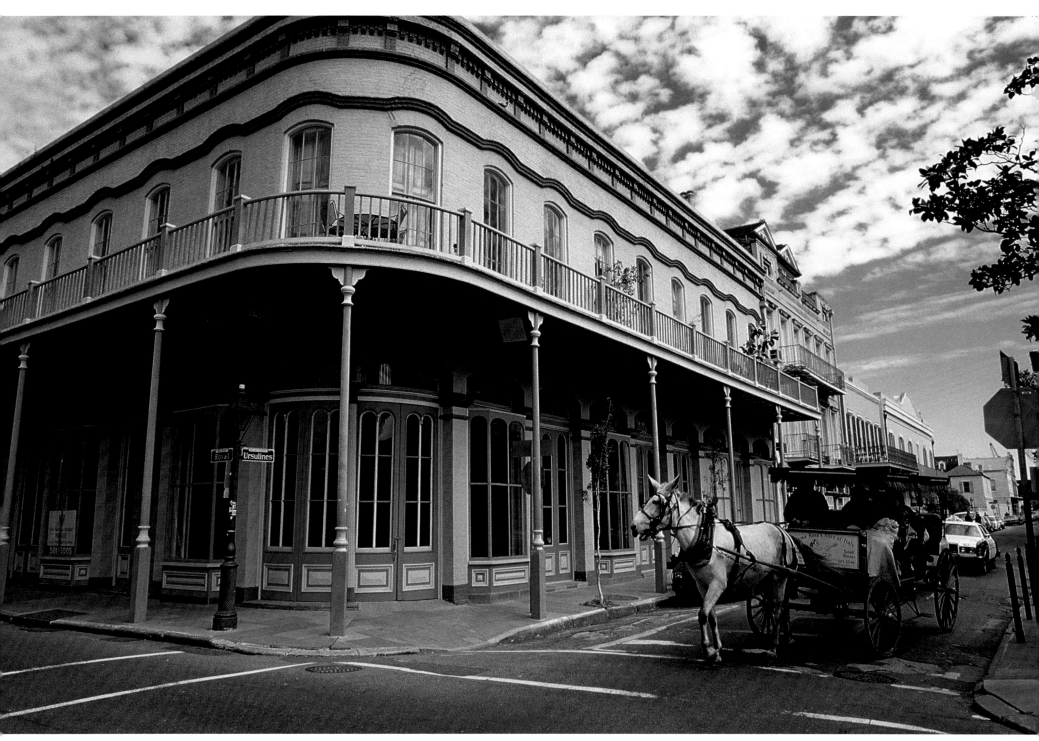

Tourists enjoy a horse-drawn carriage tour of the Vieux Carré, or French Quarter, of New Orleans. The city has the most registered historic sites in the United States. A strong hurricane storm surge topping the city's protective levees could leave water almost as high as the balcony.

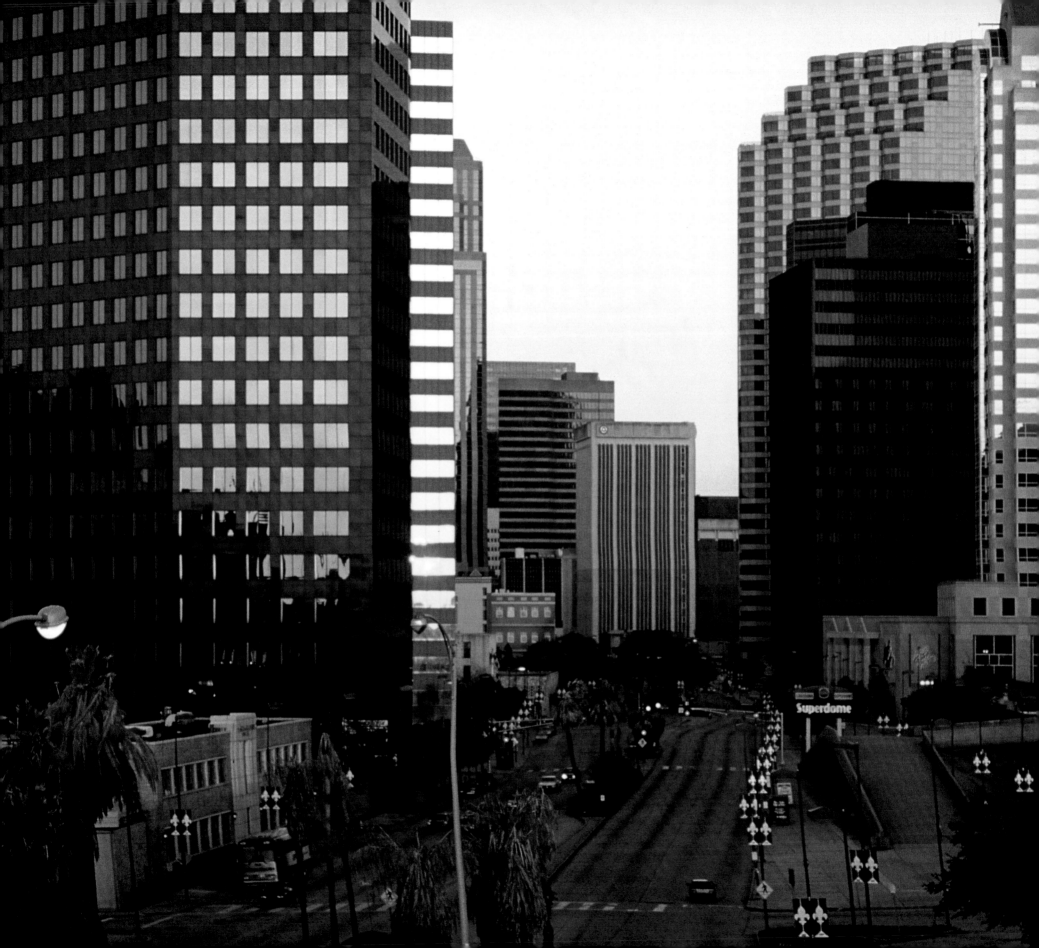

Left: The setting sun playfully sparkles on some windows and hides others in shadow as the last of the day's workers begin their drives home down Poydras Street. The Louisiana Superdome is to the right. Because many residents of the city will not be able to evacuate for a hurricane, going up in buildings may be an alternative means of escaping the floodwaters that could inundate the city with a strong hurricane.

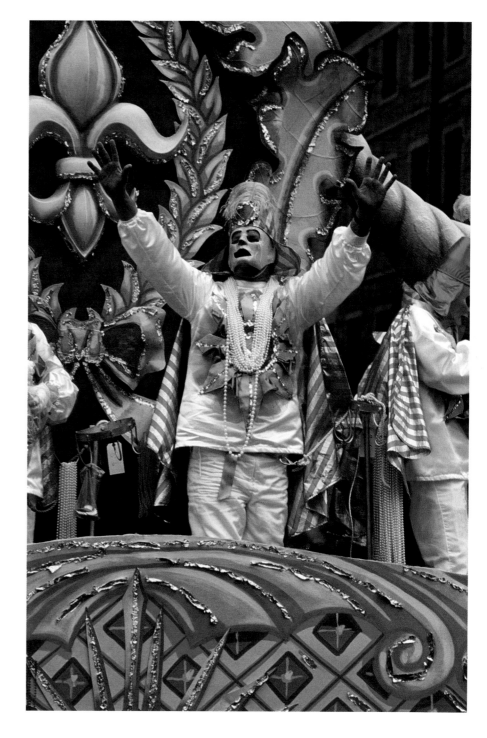

Right: A rider on one of the Krewe of Rex floats waves to the crowd before he throws treats to them.

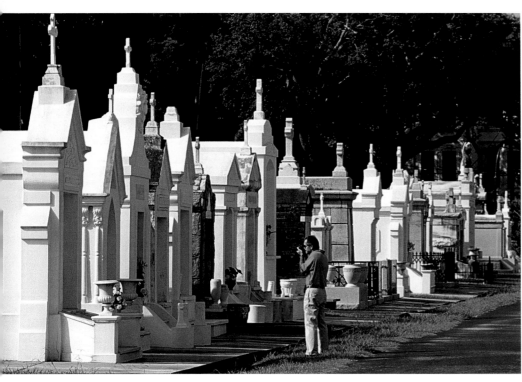

Because New Orleans lies below sea level, people are often buried above ground in vaults like these. The unique cemeteries are popular with photographers and tourists.

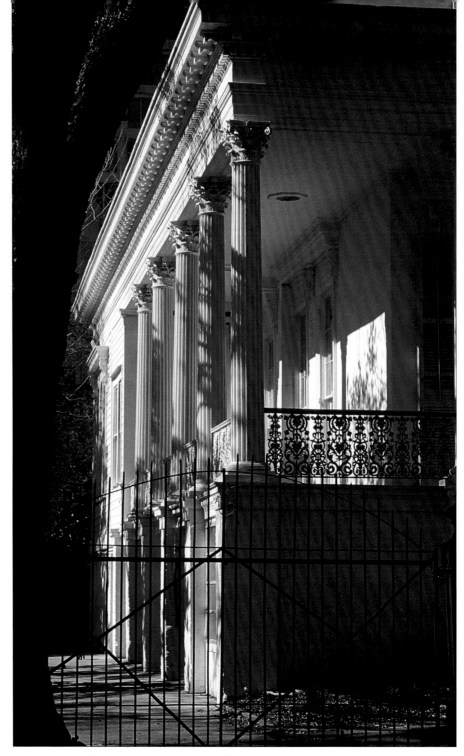

New Orleans is filled with historic old homes that could be flooded should a strong hurricane top protection levees.

Right: St. Louis Cathedral anchors one side of Jackson Square, a prominent landmark of the old French Quarter.

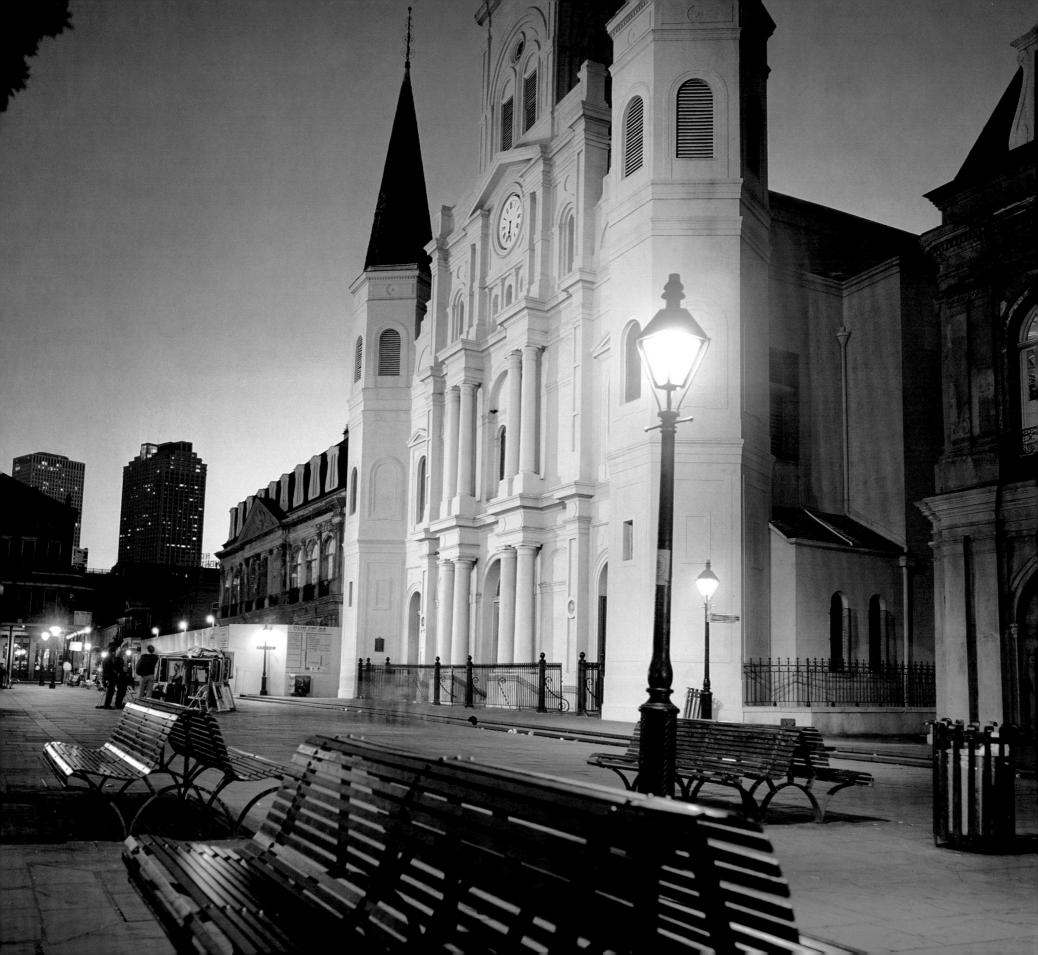

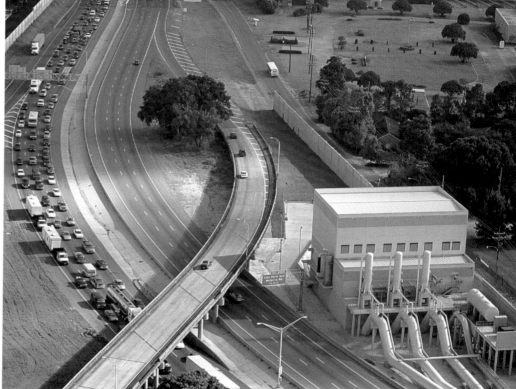

A massive new pumping station has been built on Interstate 10 to keep a railroad underpass from flooding in torrential rains. New Orleans relies on such stations to pump out the rain that falls into the city. The traffic seen here is leaving New Orleans, fleeing Hurricane Ivan.

New Orleans was founded on the Mississippi River in 1718 and today is one of the world's busiest ports. The threat of flooding from a hurricane doesn't come from the Mississippi River but from Lake Pontchartrain, which is north of the city, and from swamps that border it on the east and west.

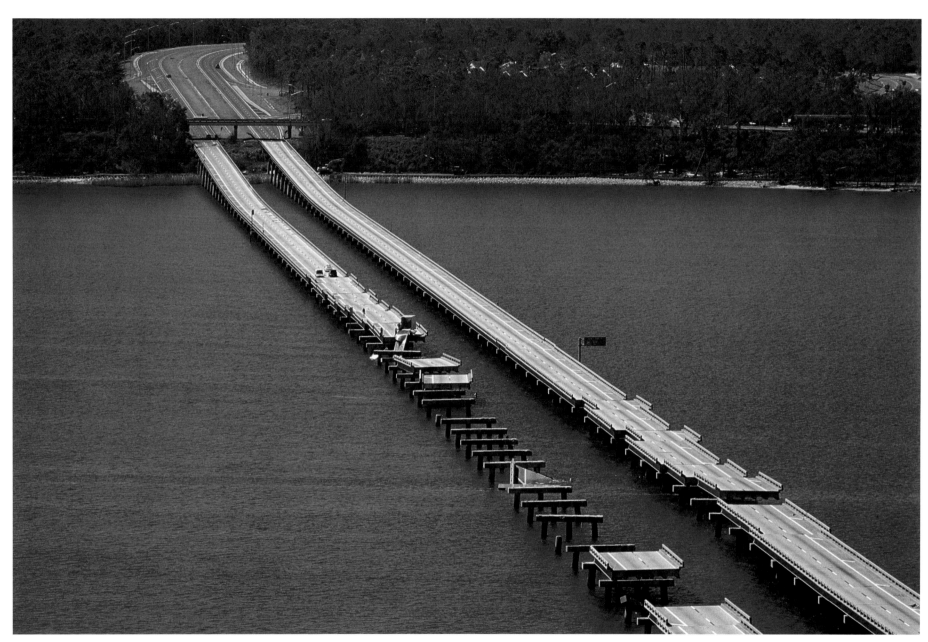

Hurricane Ivan showed the damage a strong Category 3 storm can wreak, even far inland, such as knocking out several spans of the Interstate 10 bridge over Escambia Bay. The bridge is more than ten miles north of the Gulf of Mexico. Such storm surges could move far inland on Louisiana's low-lying coast.

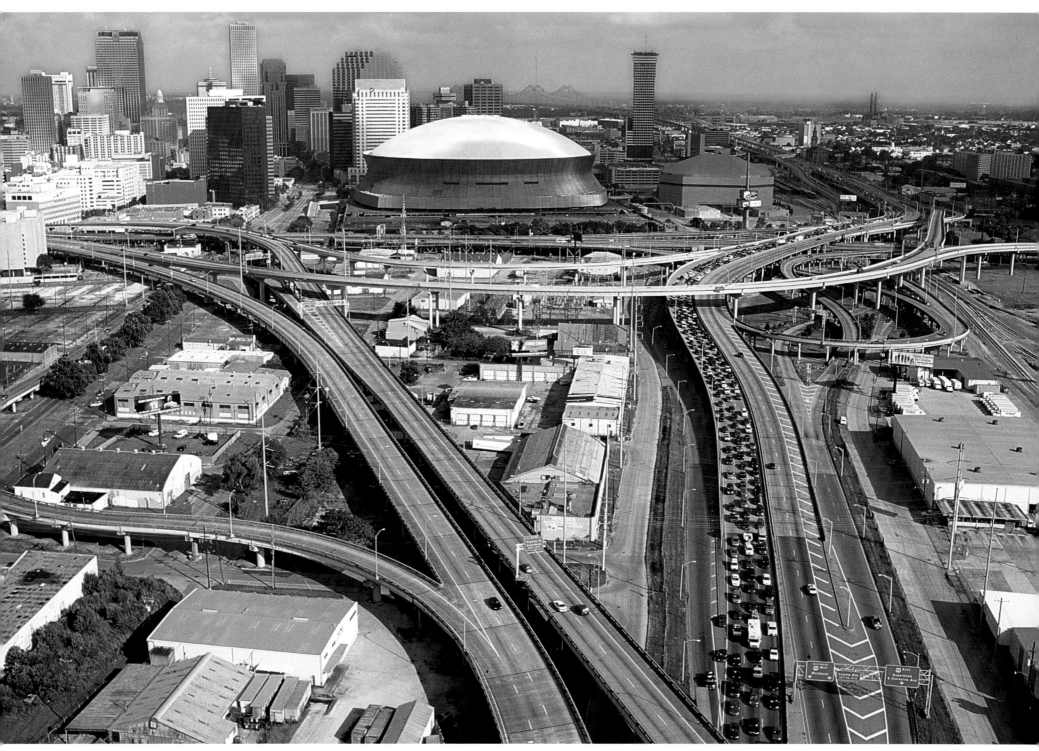

Traffic clogs the Interstate 10 lanes leading out of New Orleans as the city evacuates with the approach of Hurricane Ivan. An estimated 600,000 of the city's 1 million people evacuated. Ivan changed course and severely damaged the Alabama and Florida Gulf Coast. But the LSU Hurricane Center's Ivor van Heerden says that if the storm had been fifty to sixty miles to the west, it could have pushed enough water over hurricane protection levees to flood New Orleans. A strong Category 3 hurricane, with winds in excess of 111 miles per hour, traveling west of New Orleans, could put the downtown area under 13 to 17 feet of water, he says.

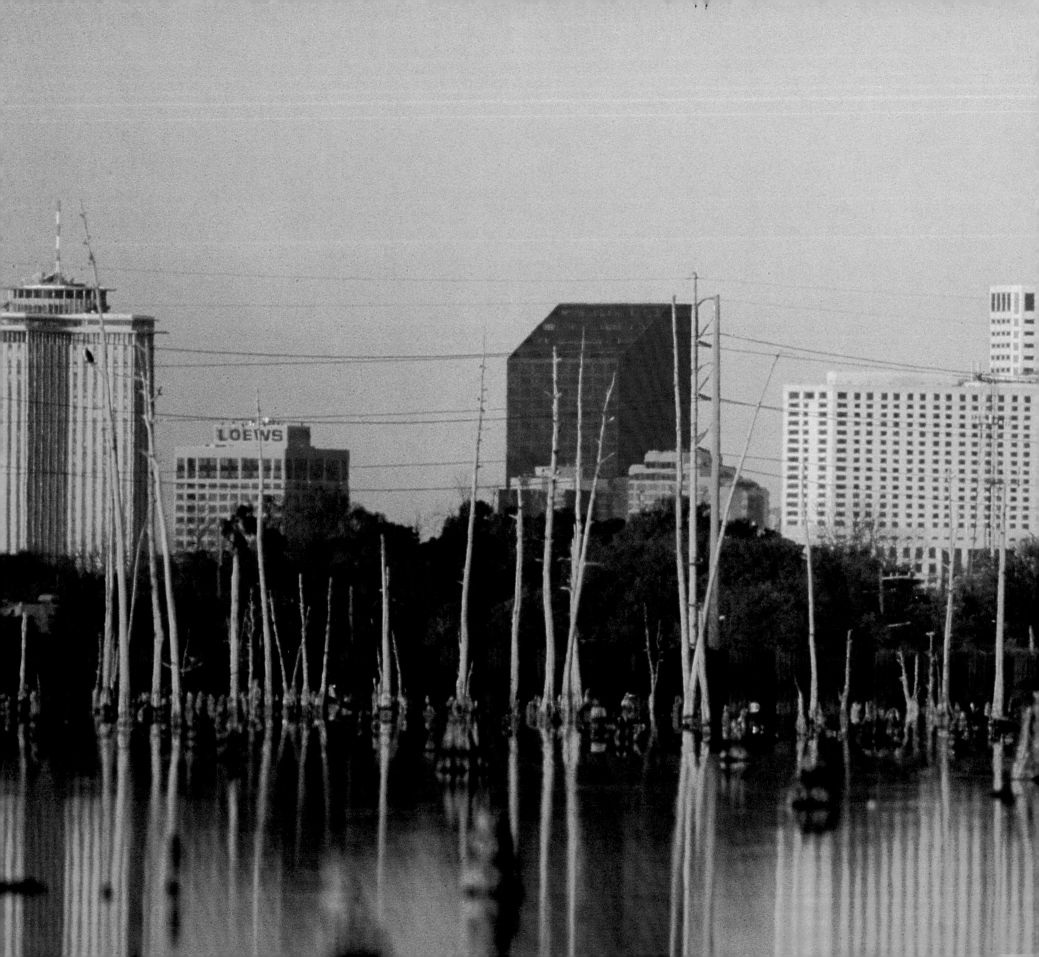

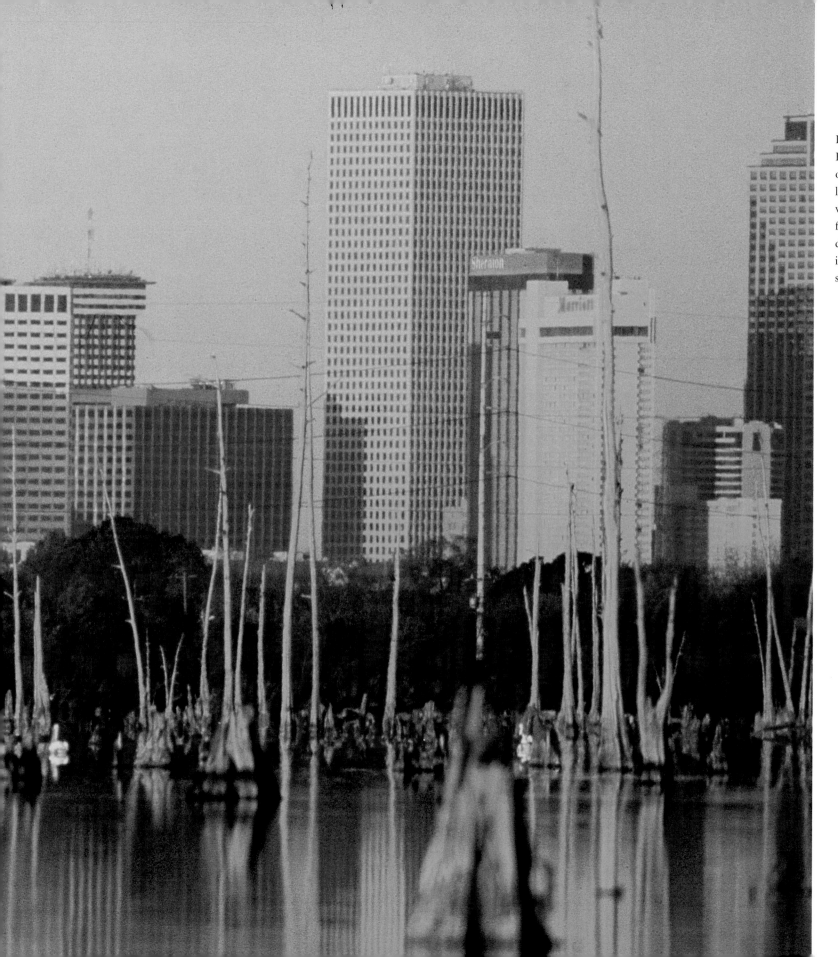

Dead cypress trees in the Bayou Bienvenue swamp east of New Orleans show how land loss makes the city more vulnerable to storms. The freshwater swamp trees have died as salt water has crept into areas where the land has subsided and eroded.

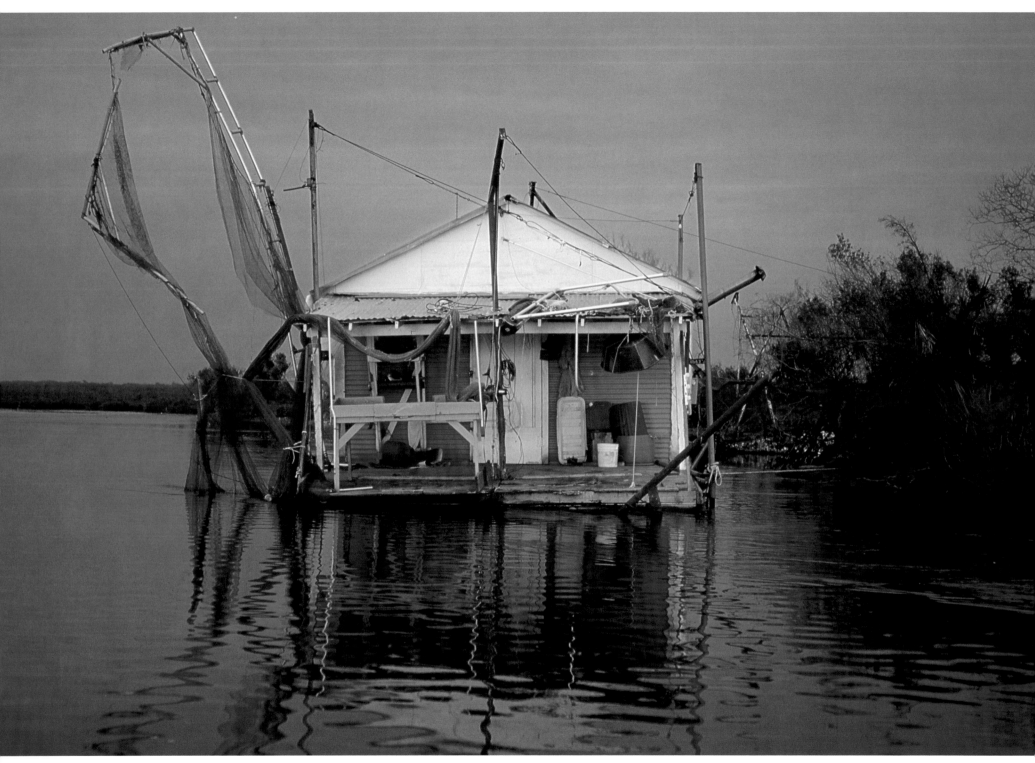

A houseboat floats on Bayou Pointe aux Chenes in Terrebonne Parish. For most residents of southern Terrebonne Parish, life is connected to the waterways.

5

LEFT OUTSIDE THE LEVEE

When the U.S. Army Corps of Engineers announced the limits of its seventy-two-mile Morganza-to-the-Gulf hurricane protection levee plans in 2003, it was a death sentence for a community founded nearly two centuries ago by Native Americans and European trappers, most of them French.

The proposed alignment leaves out communities like Isle de Jean Charles, population about 240. Other Terrebonne Parish communities south of Houma are also left out of the levee system, which will be designed to withstand the storm surge of a fast-moving Category 3 hurricane with winds up to 130 miles per hour. The proposed system of nine- to fifteen-foot-high levees could contain such a once-in-a-century storm.

Being surrounded by water was a way of life for islanders. But the water used to be farther away and rarely chased them from their homes. Wenceslas Billiot—named for the saint on whose feast day he was born—remembers two hundred yards of pastureland being behind his house, which fronts Bayou Isle de Jean Charles. Now the water is just beyond his back fence, with soft marsh just two dozen steps from his back door.

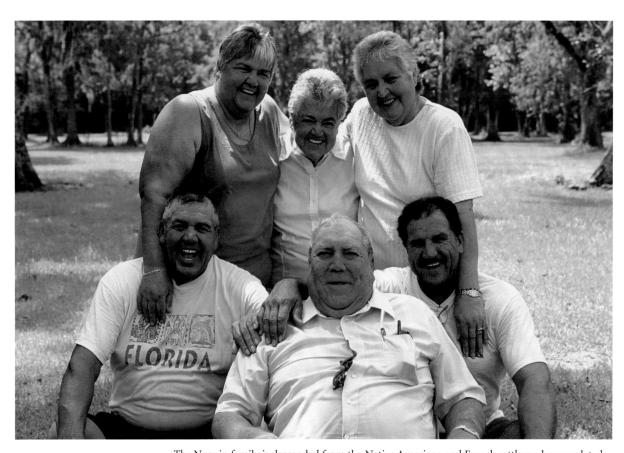

The Naquin family is descended from the Native American and French settlers who populated Isle de Jean Charles more than 150 years ago. The chief of the Isle de Jean Charles Band is Albert Naquin, bottom right. Next to him is his older brother, a former chief Deme Naquin. Also on the first row is another brother, Pierre. Behind them are sisters (left to right) Anzelie Dardar, Denicia Billiot, and Nolia Dupre.

"We had to paddle to school in our pirogue—four and a half miles, rain or shine," said Billiot. "When I was a kid, we didn't have a road out here. After they built the road, life started changing."

Father Roch Naquin, a priest who grew up on the island and returned after his retirement, remembers trees with Spanish moss where he and others would chop wood for stoves in the winter. There are few trees left around the edges of the

Right: Father Roch Naquin, a retired Catholic priest, often says a special mass for Isle de Jean Charles residents in his driveway in the small community of fishermen and oilfield and shipyard workers.

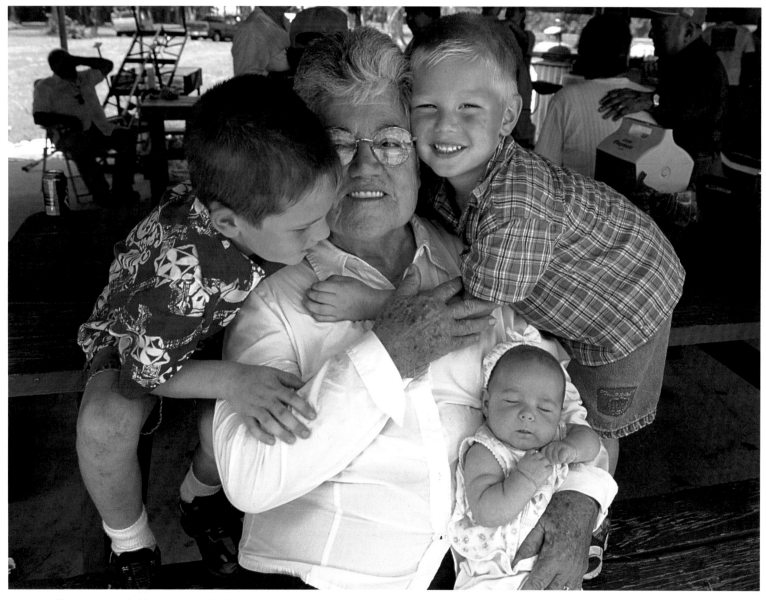

Denicia Billiot is surrounded by great-grandchildren during a Naquin family reunion: Tristien (six), left; Shaye (three), right; and two-month-old Kyley in her lap.

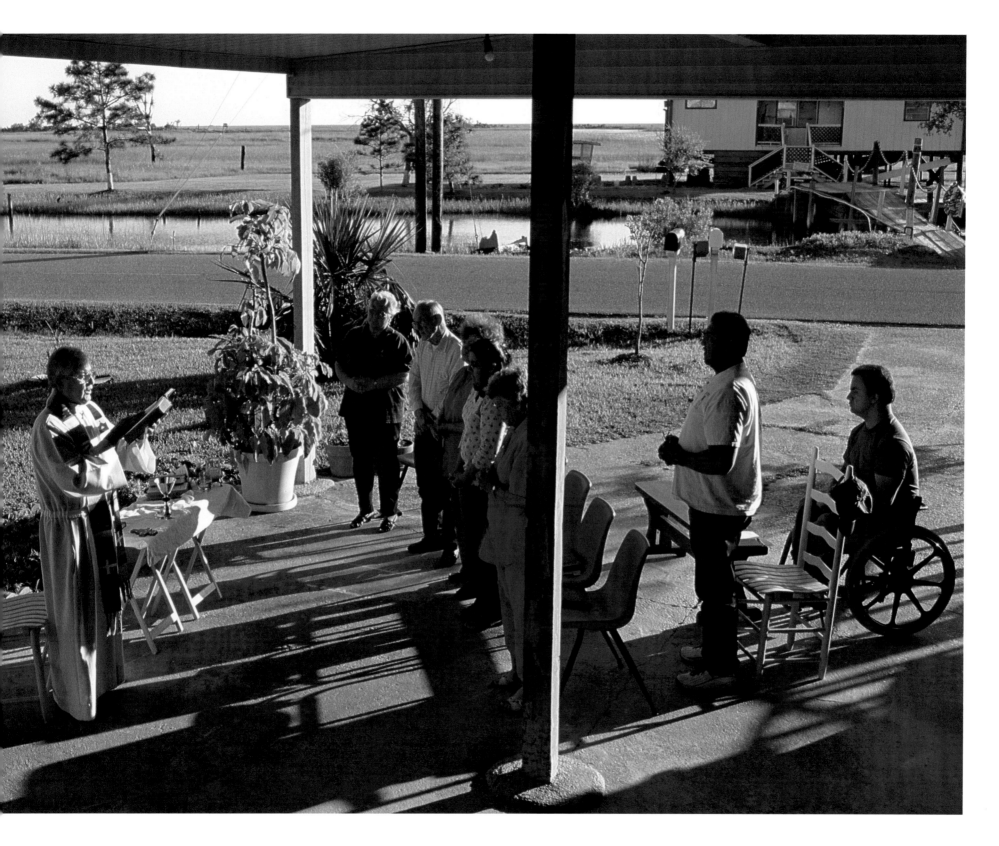

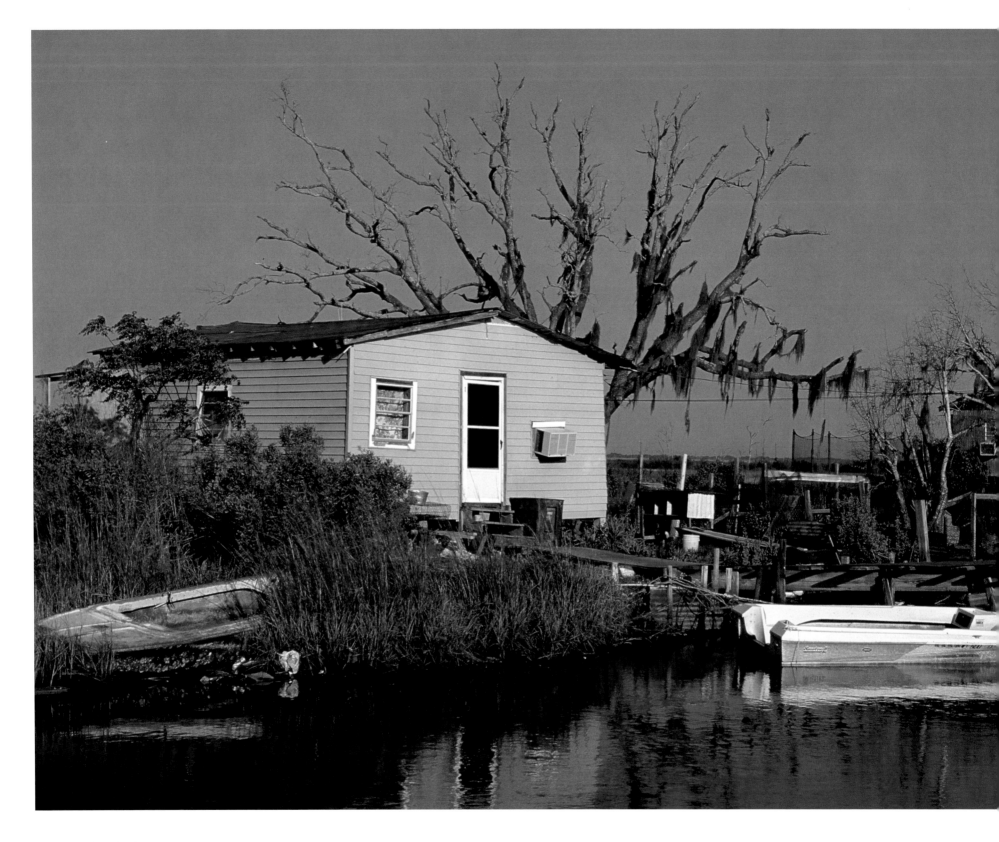

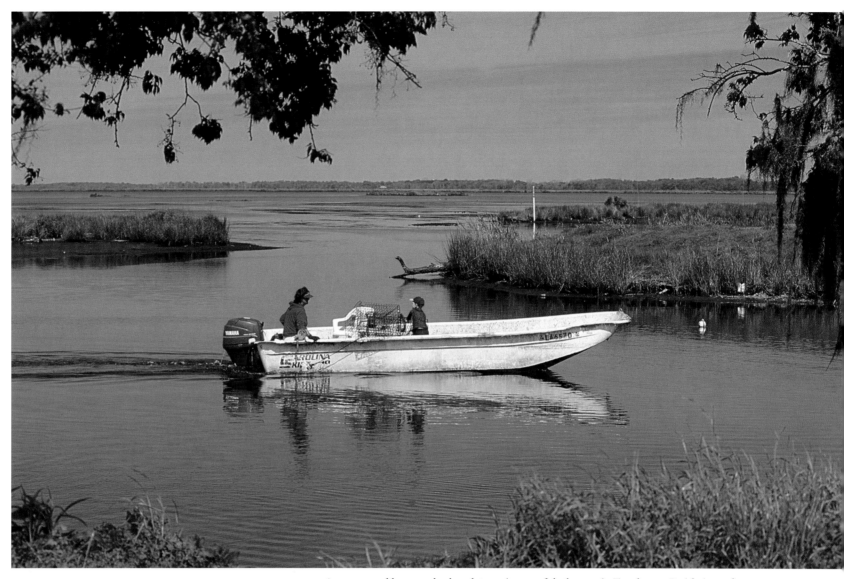

A woman and her son check crab traps in one of the bayous in Terrebonne Parish, just a few miles from the Gulf of Mexico.

An oak tree that once shaded this home in Isle de Jean Charles is now a skeleton, a victim of saltwater intrusion and sinking land. The community will be left out of a hurricane protection area and will probably disappear in a few decades. Farm fields that once stood behind these houses are now soggy ground that floods often.

community, not because they were all chopped down but because the land is too soggy for trees to grow.

Like Billiot, Father Roch remembers having a large garden: "We used to plant potatoes, beans, corn. Two rows two hundred feet long! Now, you can see, it is just about all marsh on the back side. Where we used to drop trees, people are fishing."

A dirt road, built fifty years ago, allowed the first cars and trucks to get to the community. Eventually, it would be covered with clam shells and then overlaid

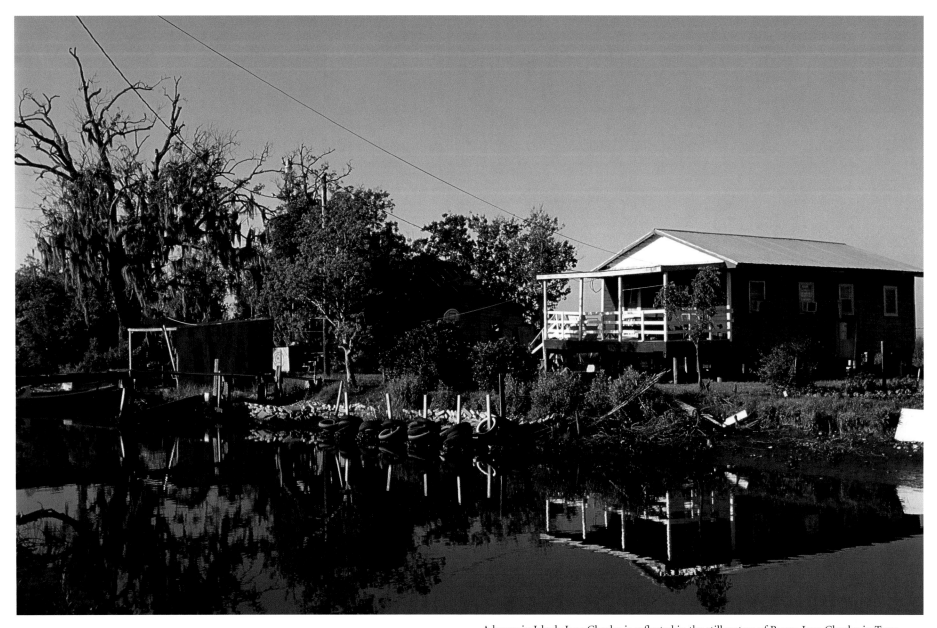

A house in Isle de Jean Charles is reflected in the still waters of Bayou Jean Charles in Terre-bonne Parish.

Right: Kaylynn Portier feeds a puppy a shrimp as Kurissa Portier, Keyondre Authemont, and mother Casey Brunet look on. Also standing are Shellie Portier and cousin Tre Pellegrin. The Brunet family lives in a small house in Isle de Jean Charles. Casey's father, Willie Brunet, said he used to be able to walk two to three hundred feet behind his home. But in recent years, he has lost more than a hundred feet of land. The family's home was destroyed by Hurricane Andrew in 1992, and they built a small elevated house so they could remain in the community where they have always lived. Willie Brunet works as a welder at a local shipyard.

with blacktop. But like the land around the island, it kept sinking. Children often missed school because the road was too flooded for a school bus to pass safely.

Albert Naquin, now chief of the Indian tribe that has called Isle de Jean Charles home for nearly two centuries, fought to get the road elevated by four feet in the 1990s. "If I won the Powerball [lottery], I'd build a levee all around the island," Naquin tells visitors as he proudly shows off the community he loves. He still has brothers and sisters and cousins who live on the island. "Every time we

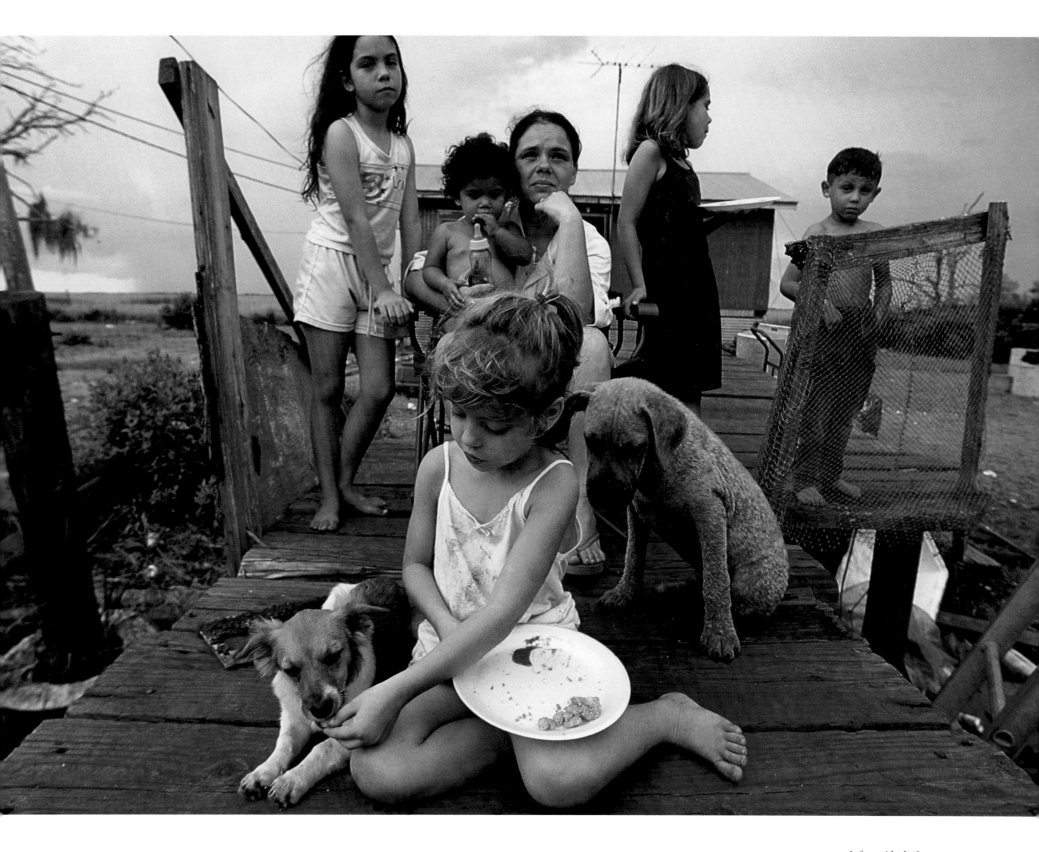

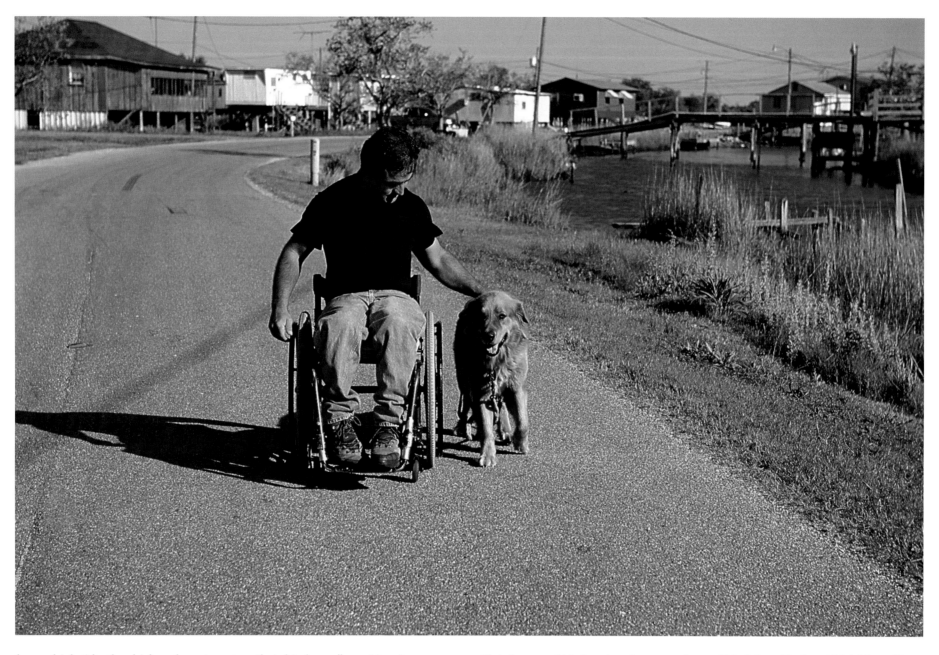

have a high tide, the chickens have to put on their hip boots," says Naquin, now a constable for Terrebonne Parish.

It may be easy for others to write off Isle de Jean Charles. "But it is not easy when it is your home," Naquin says. "My grandpa, when he was alive, saw it growing. My father and uncle saw it when it was about at its peak. Now that I am chief, I am watching it wash away."

Chris Brunet and his dog take a short tour of part of Isle de Jean Charles, which is bisected by a bayou. Only one side of the bayou has a road. The first road into the community wasn't built until the 1950s. Before that, children took boats to an Indian school in nearby Pointe aux Chenes.

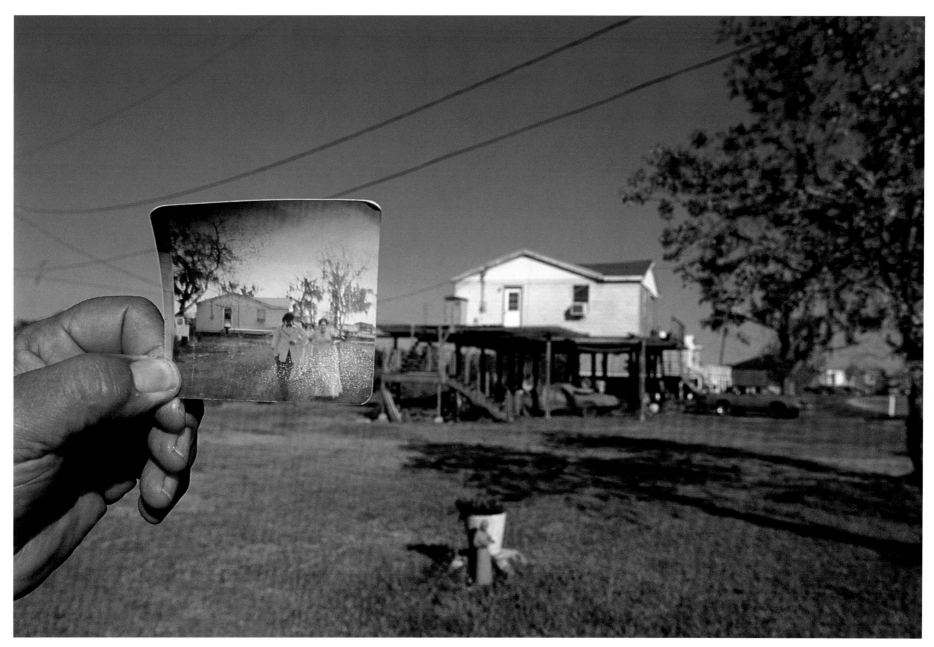

The faded old photograph in the foreground shows how residents have raised their houses to reduce flooding problems from hurricanes and storm tides as the buffer of marsh continues to disappear. They are using a special program available through the Federal Emergency Management Agency.

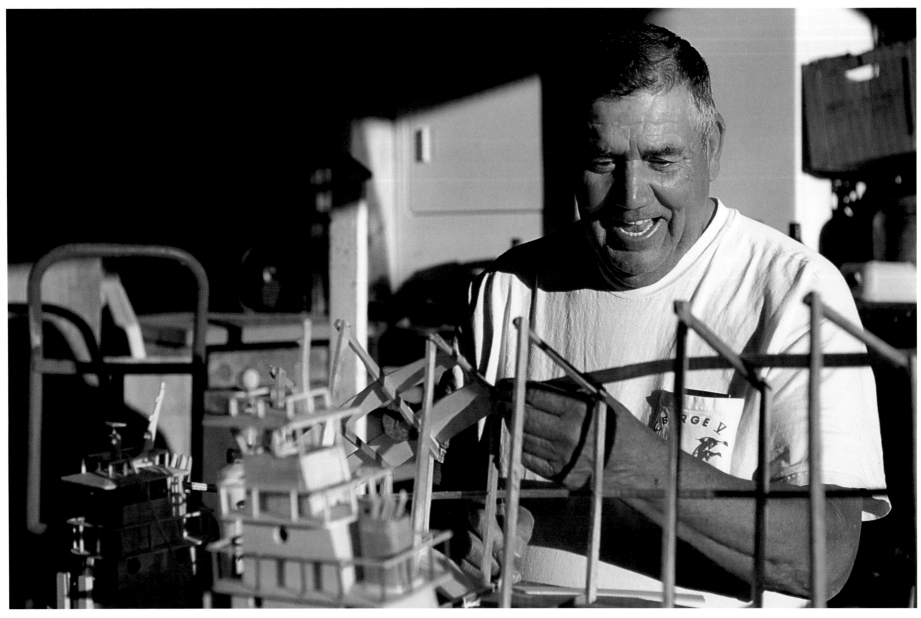

Pierre Naquin laughs at a joke as he builds a model boat. Like many of the Indians who lived in Isle de Jean Charles, Naquin makes the boats to sell at crafts fairs as a way to supplement his retirement income and pass the time.

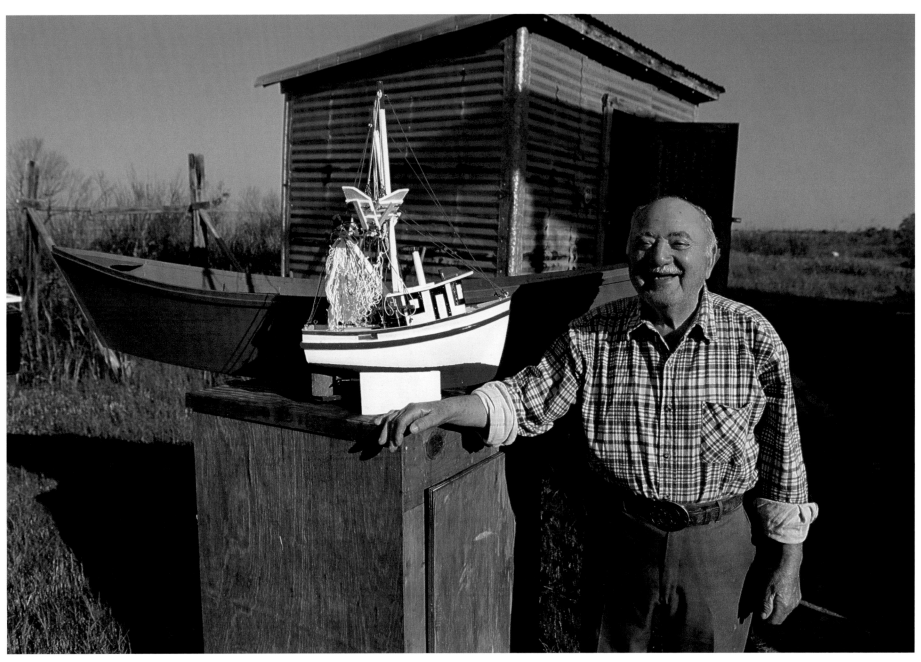

Wenceslas Billiot poses in his backyard with one of the model boats he builds. A pirogue he carved from a plan in his head, handed down to him from his father, is in a museum at nearby Nicholls State University.

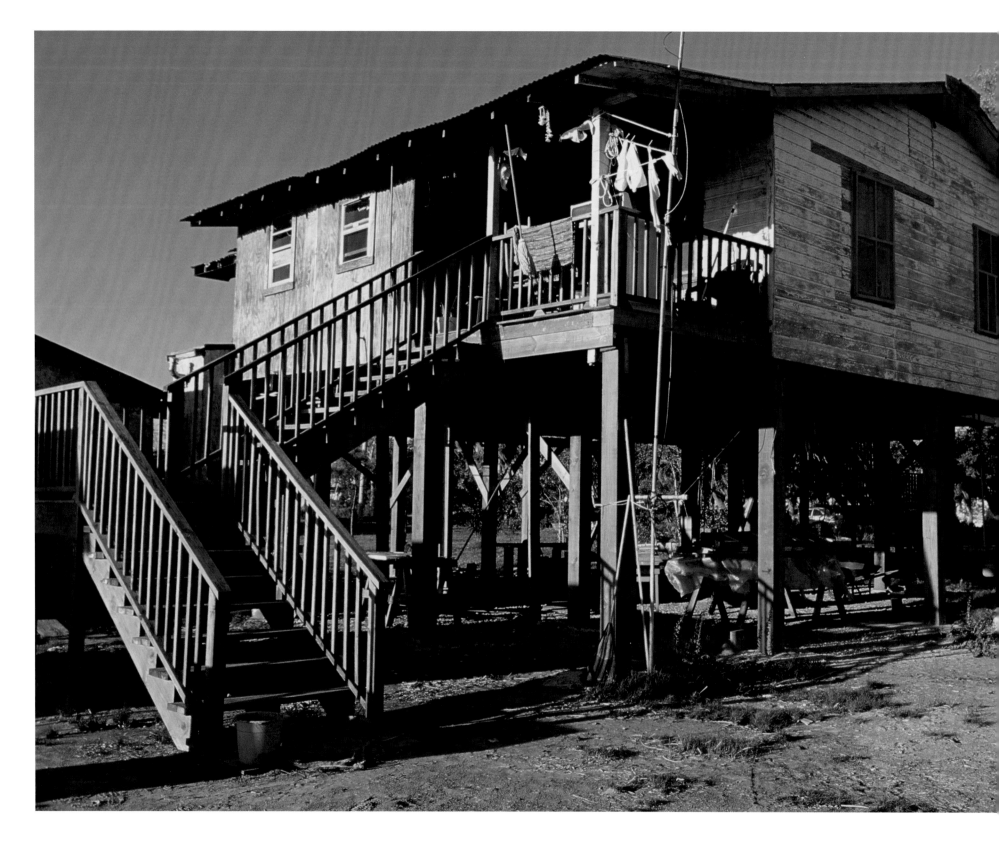

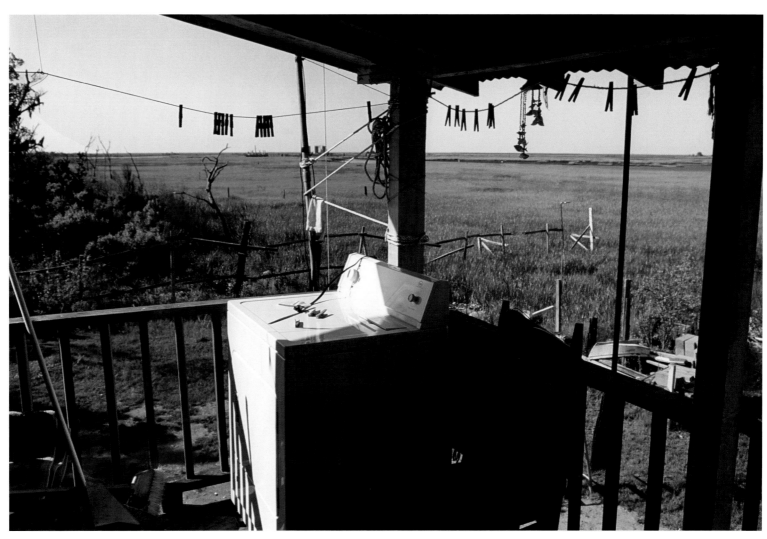

Residents of Isle de Jean Charles once had farms and pastures behind their homes. But in recent decades, the area has subsided, and erosion has brought the water closer to their homes. The fields can no longer be used for farming or even pastureland in most cases.

The Billiots have raised their home a few feet higher as storms and hurricanes more frequently flood Isle de Jean Charles.

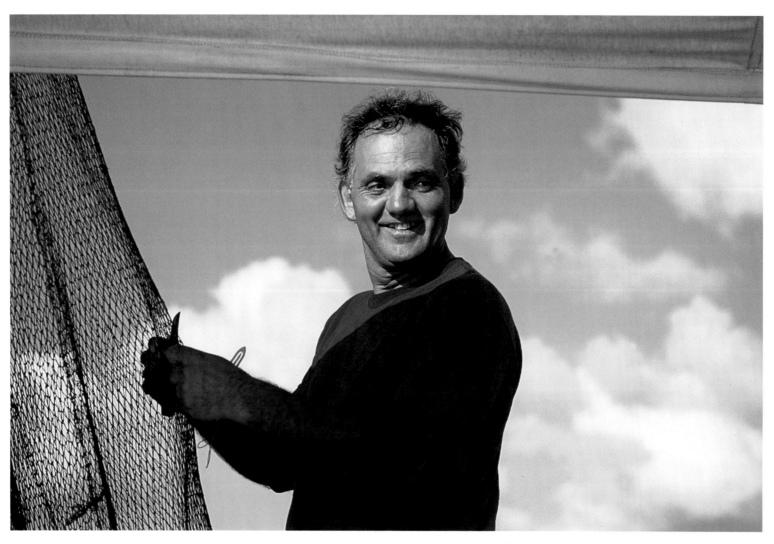

Donald Dardar and his wife, Theresa, fish the inlands waters of Terrebonne Bay for shrimp during seasons set by state wildlife officials and for crabs in between shrimping seasons.

A good catch will be a thousand pounds of shrimp. Donald has been fishing for more than thirty years and has seen islands that once dotted the bays around an area known as Lake Felicity disappear completely. "Some of them were pretty big islands, too," Dardar says. Such islands give juvenile fish and shrimp a place to hide from predators.

Dardar hopes the marshes and inland bays will sustain fisherman like himself for a few more years, but he is unsure about the future.

The Dardars live in an area known as Pointe aux Chenes, and Donald says the bayou he travels to get to the bays where he fishes has lost land on both sides. When hurricanes or winter storms come up, there is nothing to stop the water from rising quickly, often cutting off roads needed to escape the rising waters, Dardar says.

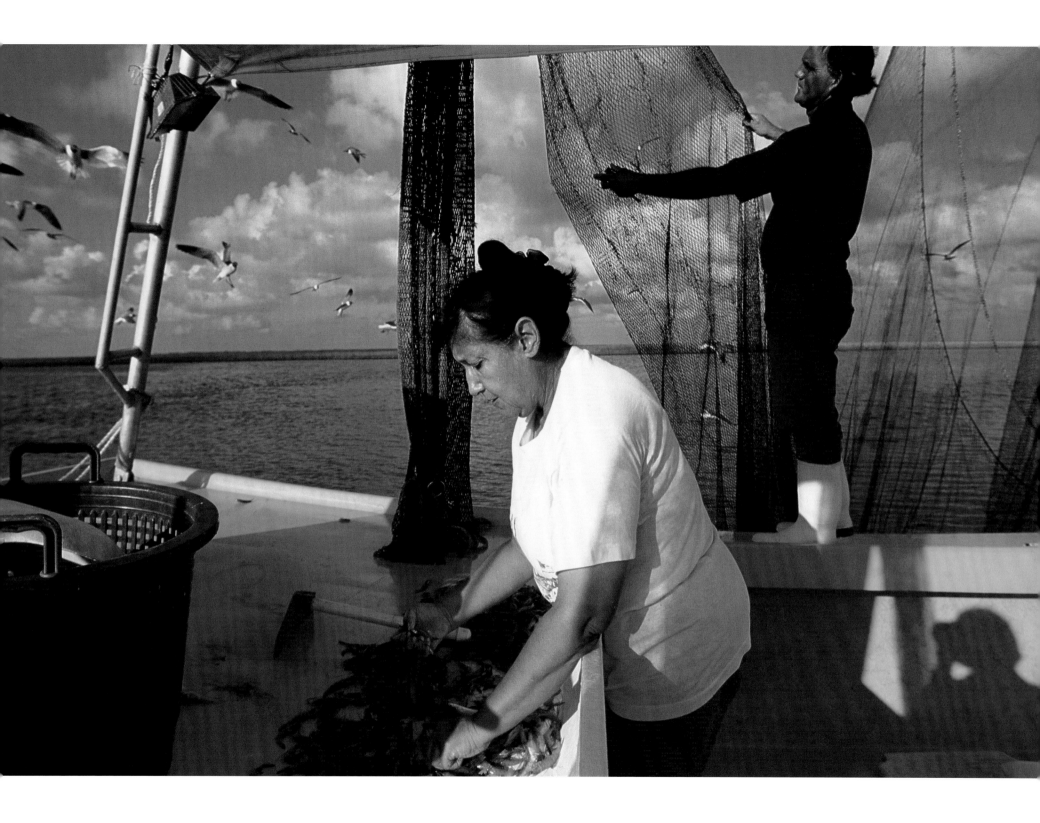

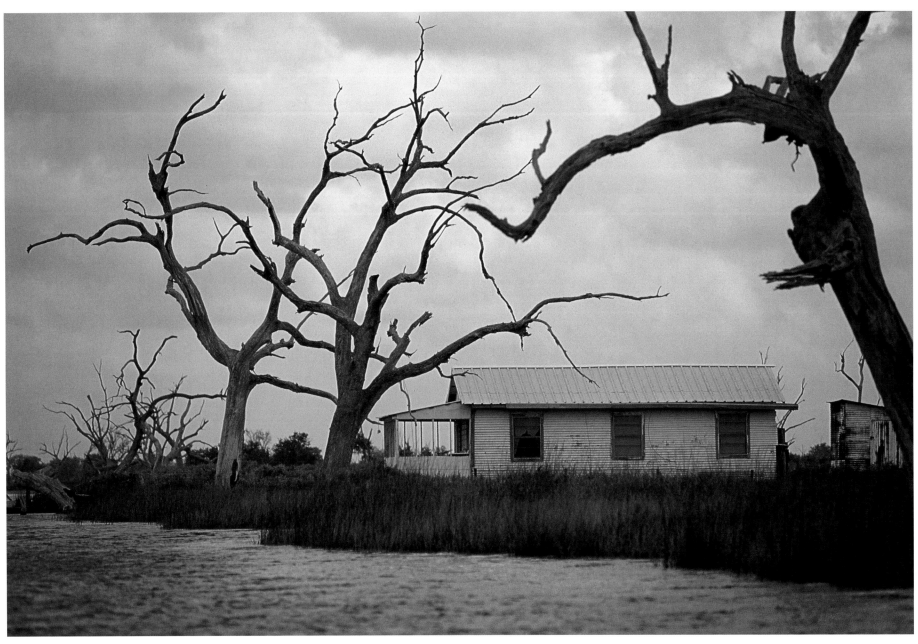

Dead trees mark sinking land and saltwater intrusion around this camp in Pointe aux Chenes, or Point of the Oaks. Oak trees mark the high land, since they cannot survive in soggy ground or tolerate salt water.

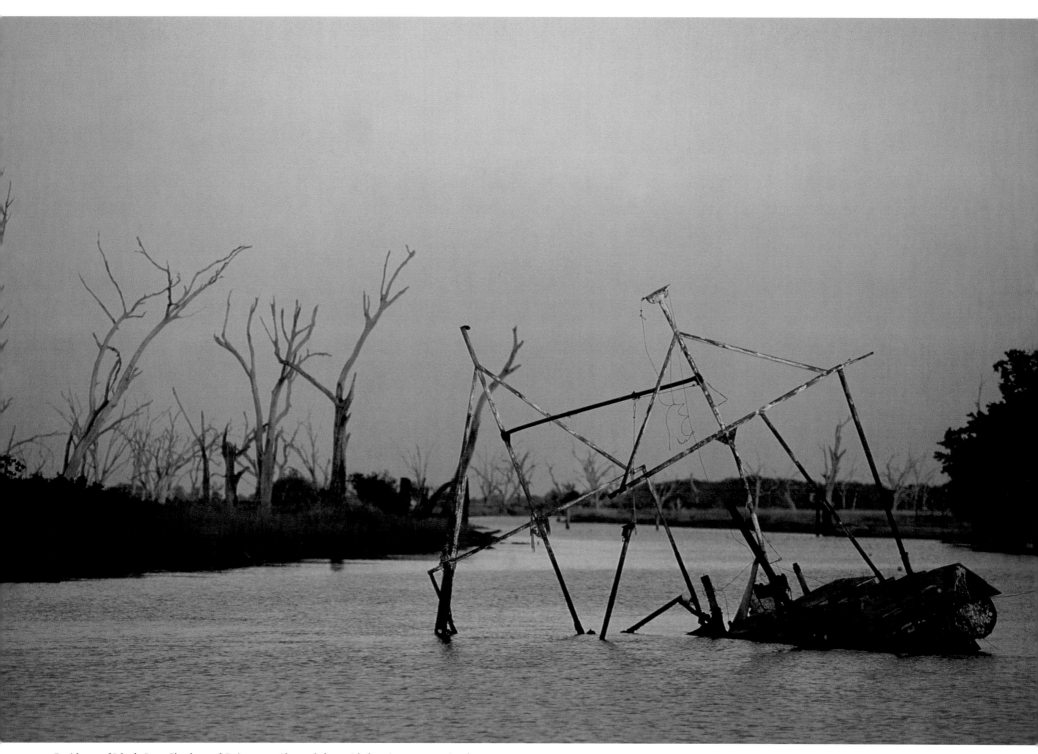

Residents of Isle de Jean Charles and Pointe aux Chenes left outside hurricane protection levees fear their future will look like this: a sunken shrimp boat under the skeletons of oaks that have died from soggy soil and saltwater intrusion.

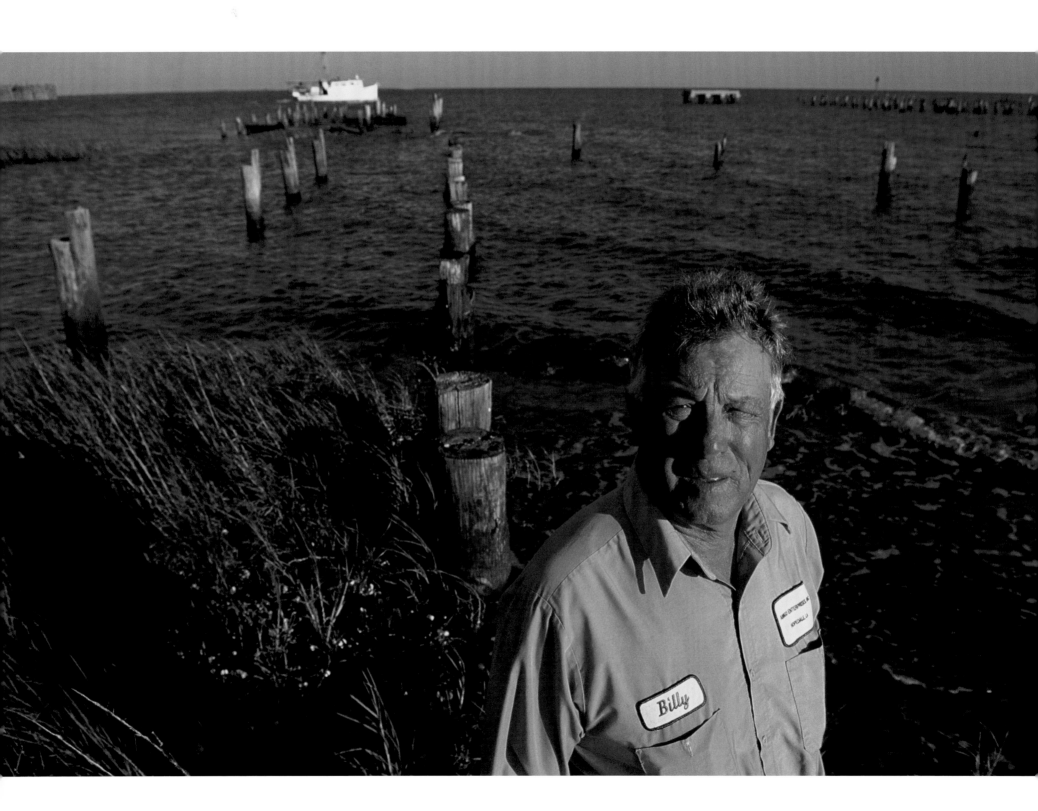

6

LOST IN A LIFETIME

SHELL BEACH—Frank "Blackie" Campo, eighty-six, sits on his porch, eight feet above the street level, and watches some of his grandchildren swim in Bayou Yscloskey, just as he and his sons did as children. The water in the bayou this August day is two feet higher than normal, flooding portions of his marina dock. Despite the high water, Campo's son Kenny and other grandsons stay busy using a lift to launch and retrieve the steady stream of boats of recreational fishermen who flow in and out of Shell Beach every weekend.

"We didn't used to have that," Campo says of the high water. Decades ago, the government dug the five-hundred-foot-wide Mississippi River Gulf Outlet, called "Mr. Go" by locals. This ship channel runs

through the St. Bernard Parish marsh and provides a shortcut to New Orleans's Inner Harbor. Before the channel was built, the wind would have to blow for three or four days from the north to drive an extra two feet of water into the bayous and wetlands of eastern St. Bernard Parish. Now it just takes a day.

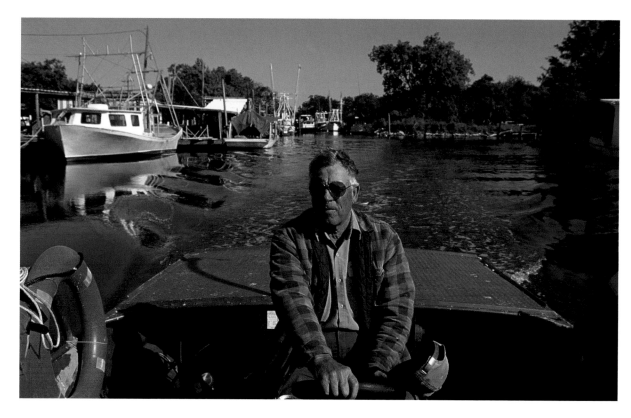

Left: Billy Stander of Hopedale stands on the shoreline of what is left of old Shell Beach, the community he and Frank "Blackie" Campo grew up and lived in before the Mississippi River Gulf Outlet cut the community off from the mainland. Shell Beach was relocated on the west side of the shipping channel. Erosion has washed away much of what was once the old Shell Beach. The pilings behind Stander were part of a foundation for a U.S. Navy base in World War II and were driven into what was then the ground. That ground has eroded and left the old pilings sticking up out of the water.

A small tropical storm that didn't hit the area directly pushed six feet of water under his raised home a few years ago. Campo and other St. Bernard residents feel the ship channel carries not only container ships but storm surge, flooding the community so fast it is difficult to evacuate.

Shell Beach and the marshes that make the area so rich in fishing are slowly disappearing. "It goes at maybe a spoonful for each wave" from the giant container ships that occasionally run down the twenty-six-mile channel, Campo said. "When they opened the ship channel, that's when things started to erode."

The original 500-foot-wide channel is now 1,500–2,000 feet wide in places. The narrow strip of land separating "Mr. Go" from Lake Borgne and Breton Sound is being gobbled on the channel side by the three-foot wakes of oceangoing ships and more slowly from the waves on the lake and sound shores.

Bayou Yscloskey, once shallow enough to walk across when the wind was blowing the tide out, has since widened and deepened.

The ship channel cut off the original Shell Beach from the mainland when it was dug in the late 1950s. So Campo and others who lived there had to move to the western side of the channel in order to have roads and other services. They have already lost their community once.

Today, Campo, who still makes sure he gets out fishing every Tuesday, can float in his fishing boat with several feet of water beneath him where his house stood forty years ago.

During World War II, navy ship gunners at a Shell Beach base once learned to fire everything from .50-caliber machine guns to a big five-inch gun that shook the whole village. Now nothing is left but pilings in the water that used to be in the mud, underlying the foundations of the base's buildings.

Meanwhile, as the U.S. Army Corps of Engineers studies the impact of closing the ship channel, it continues to dredge it. The few container ships that still

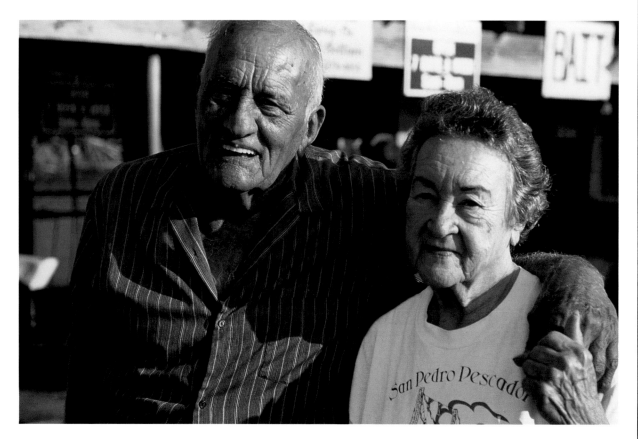

Frank "Blackie" Campo, eighty-six, and wife Mabel have lived most of their lives in Shell Beach in St. Bernard Parish. Blackie has been a fisherman, fishing guide, and marina owner for decades and has been active in trying to get more support for coastal restoration in his community and state.

The sun begins to rise at Blackie Campo's Marina on Bayou Yscloskey in Shell Beach. Recreational fishing is an important part of the economy of many small coastal communities.

ply the channel need deeper and deeper channels. Dredging the channel to keep it open costs taxpayers about $21,630 for each vessel.

Back on Blackie Campo's porch, he points to the Mississippi River Gulf Outlet. "If they closed it tomorrow, it would take 150 years to fill in," he says. In a little more than half of his lifetime, the channel has already done its damage. He doubts the government will ever shut it down. And he wonders how much longer the second Shell Beach will continue to exist.

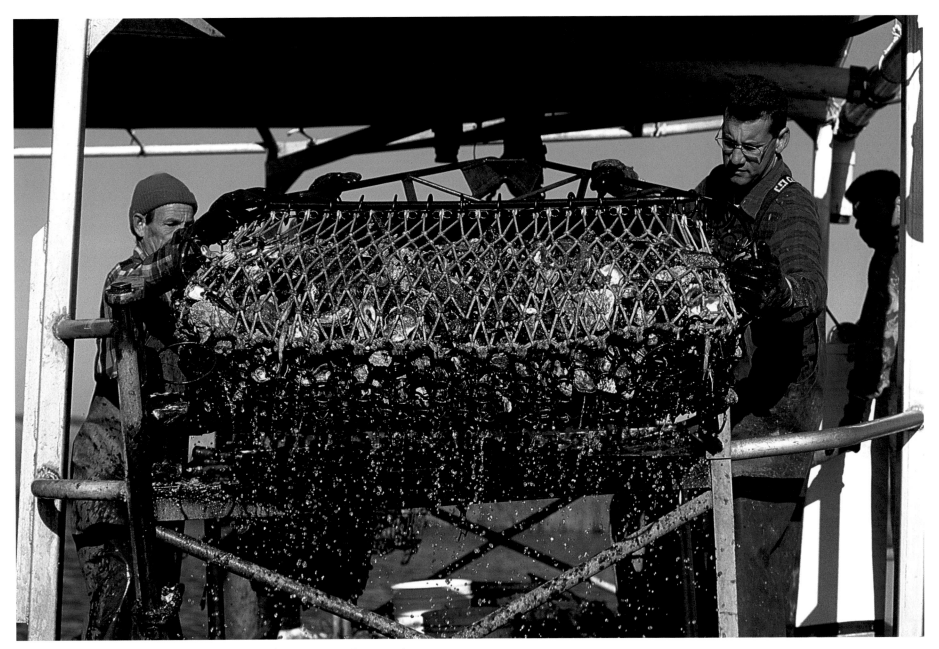

Michael Campo (right) also works oyster beds in the Lake Borgne area. Oystermen lease state water bottoms and lay down shells or crushed limestone to create their own reefs and then harvest their crops, in this case using a rake with a rope pouch on it.

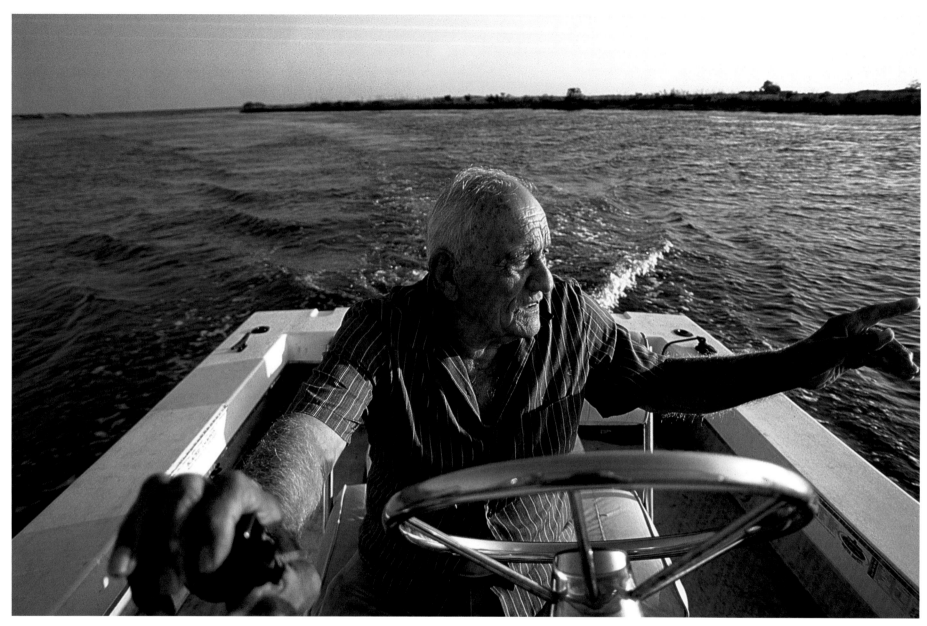

Blackie Campo points out how much land has been lost around his home in Shell Beach. Behind Campo is what is left of "old" Shell Beach. The land his home stood on in the 1950s is now under five feet of water. The Campo family and others living in old Shell Beach were moved farther inland when the Mississippi River Gulf Outlet was dug through the St. Bernard Parish marshes. The shipping channel has widened and allowed greater tidal flow into Bayou Yscloskey, gobbling the land that once stood under his old house.

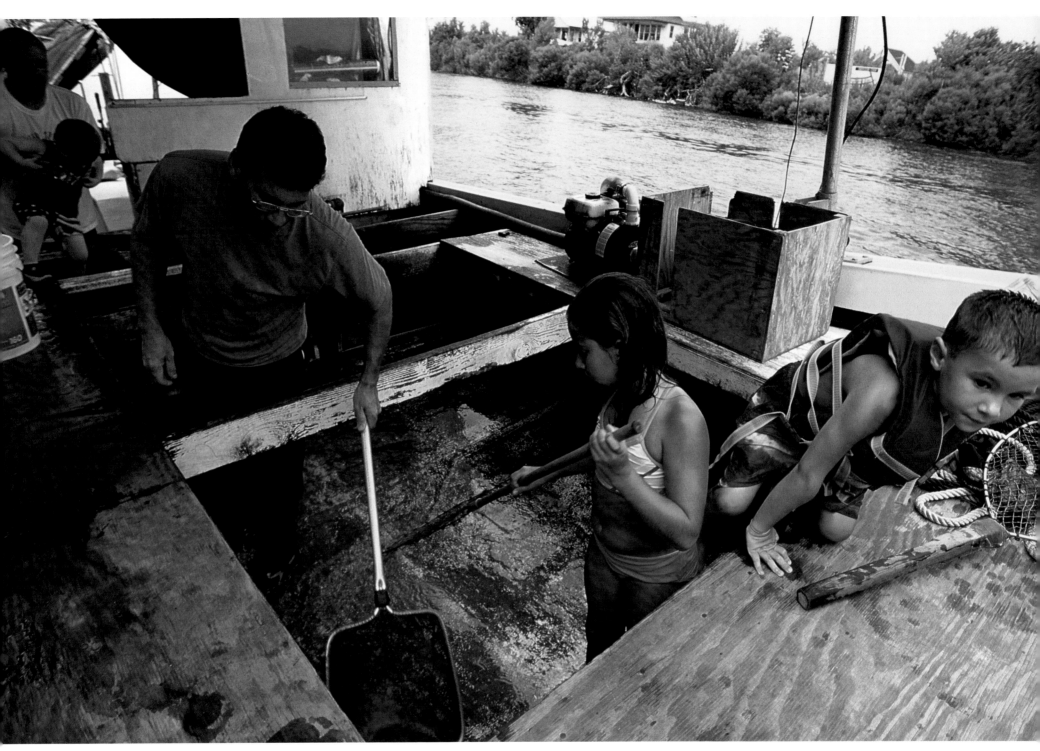

Michael Campo scoops bait shrimp from the bottom of his boat in Shell Beach as his two children, Colby Campo, in the life jacket, and Emily Wattigney play. Campo often trawls area waters for shrimp to sell as bait at Campo's Marina, a launching place for recreational fishermen.

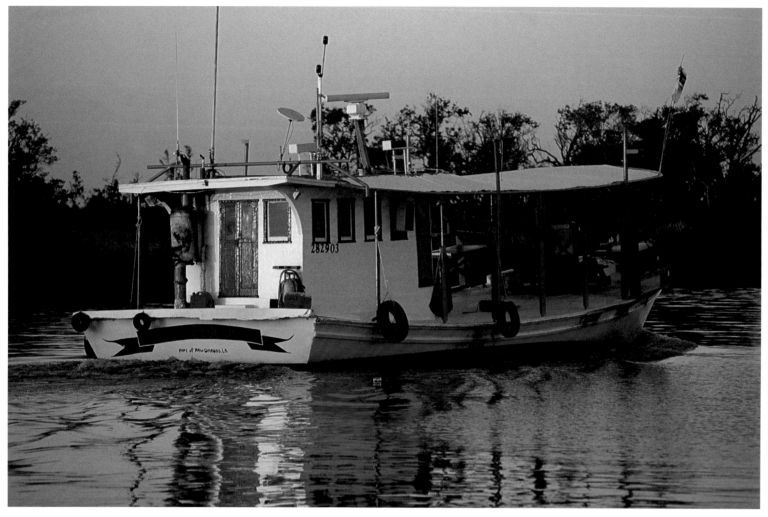

An oyster boat, or lugger, heads out in the morning sun to harvest the succulent shellfish from reefs created and cultivated by the owner.

Father Herbert Kiff of St. Pedro Catholic Church sprinkles holy water onto a passing boat on Bayou Yscloskey as he blesses the shrimp and oyster fleet at the end of the summer. Fishermen are proud of the fact that the Gospels say Jesus started his ministry by picking fishers. In return for a small donation, the boats receive a magnet with a picture of Jesus on it that can be stuck to the boat for the season.

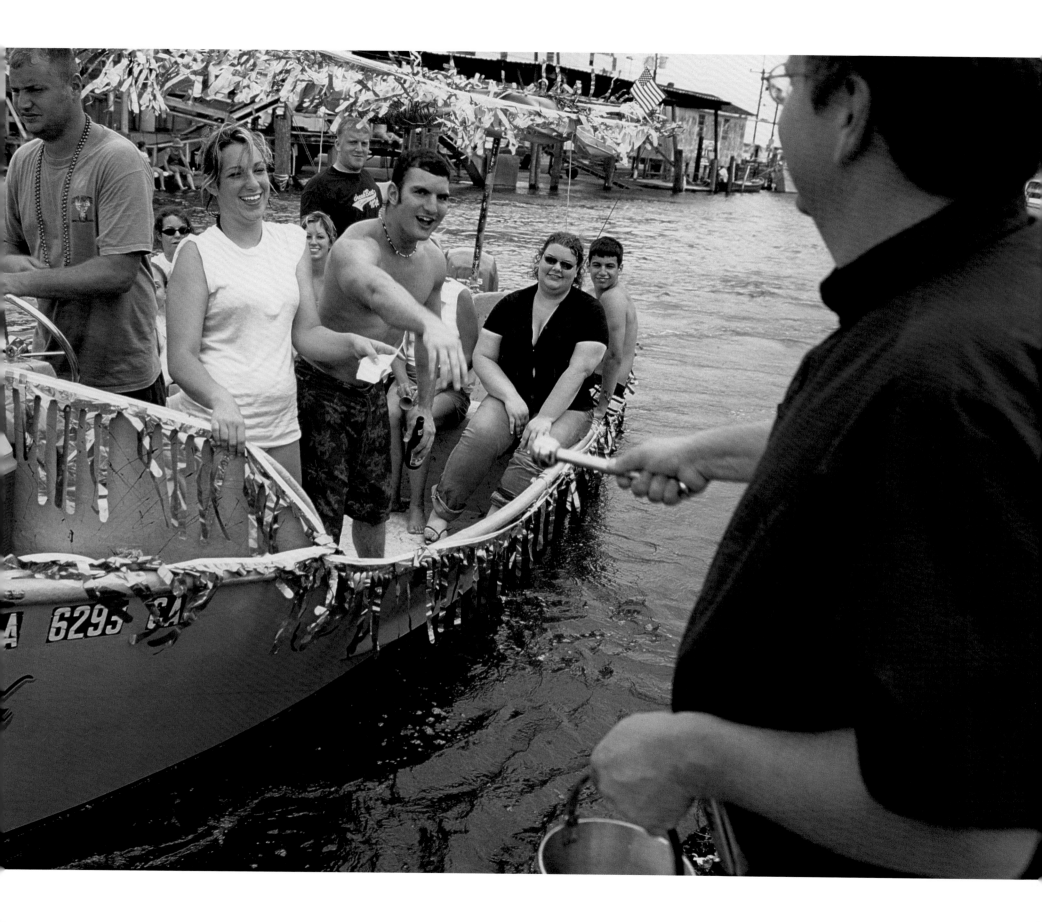

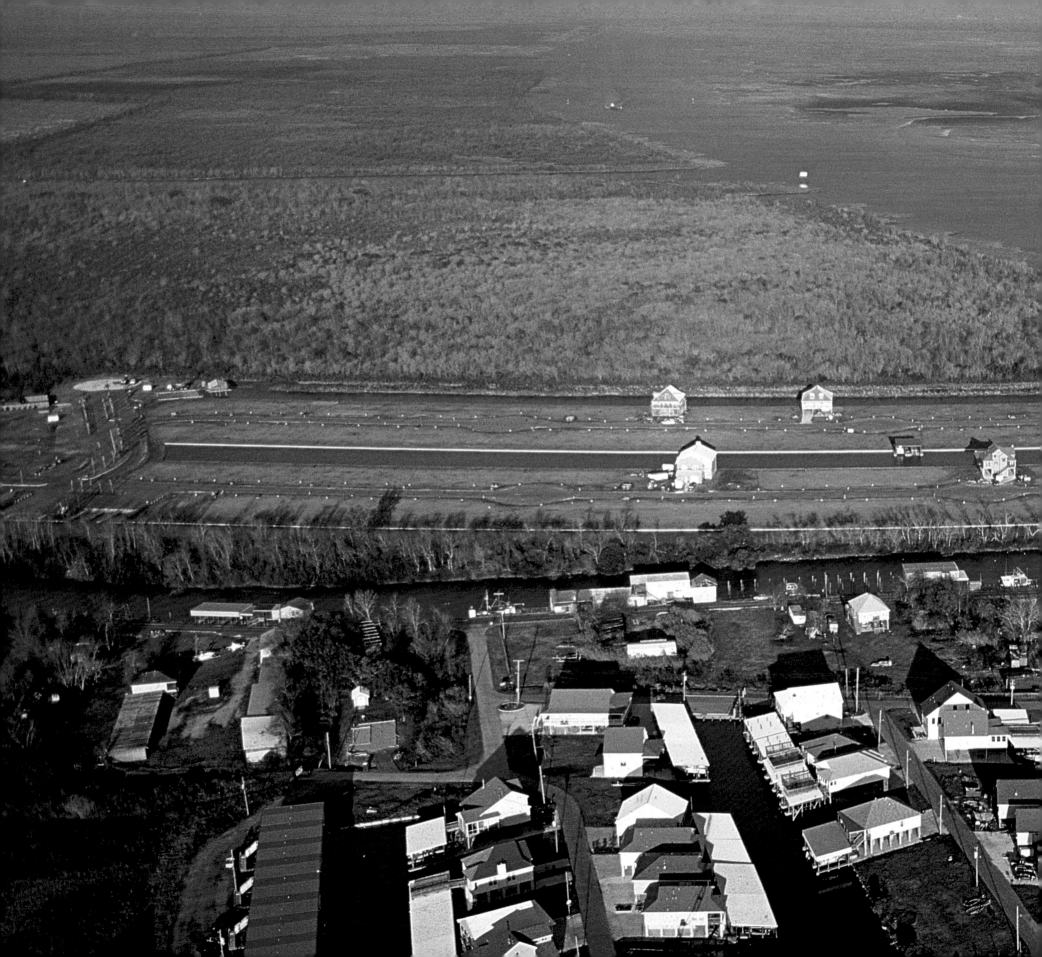

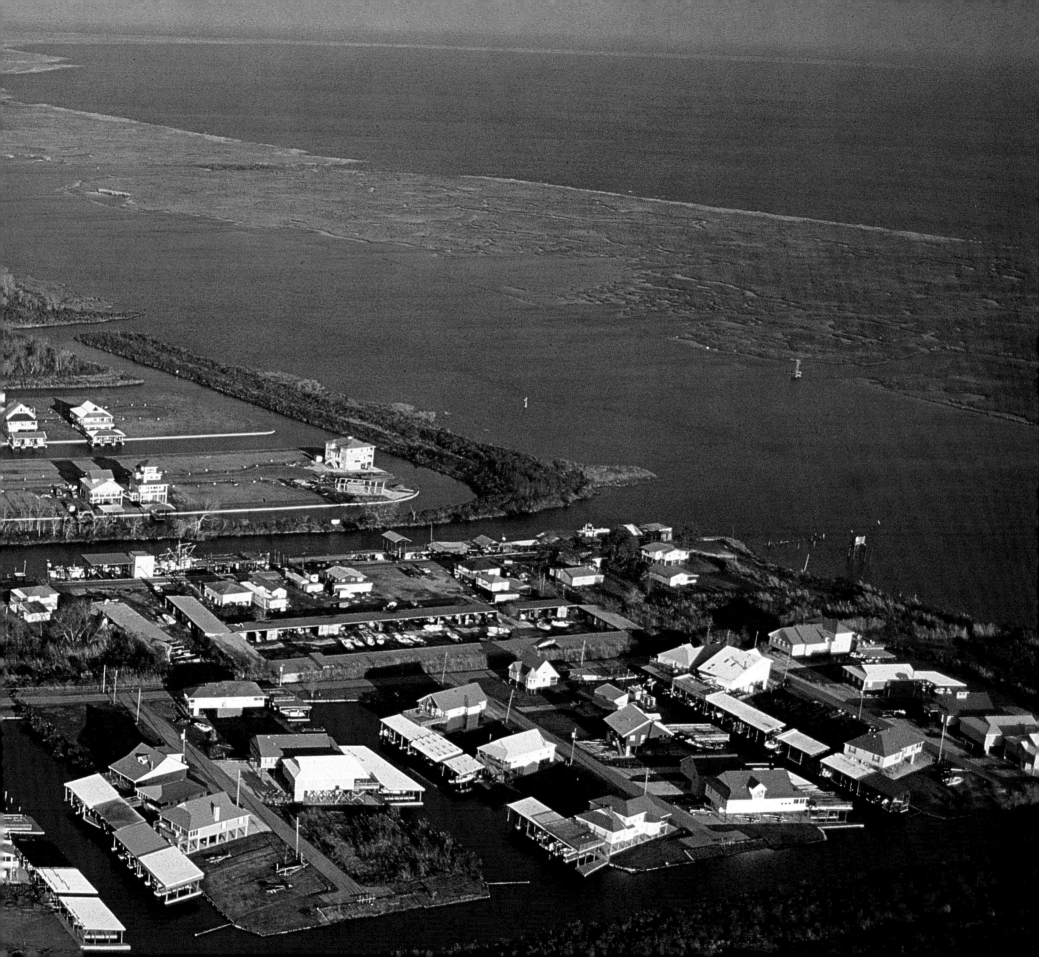

Overleaf: While the land continues to erode, it has not stopped development of expensive fishing camps and homes in the Shell Beach area. To the right is a small strip of disappearing marsh between the Mississippi River Gulf Outlet and Lake Borgne.

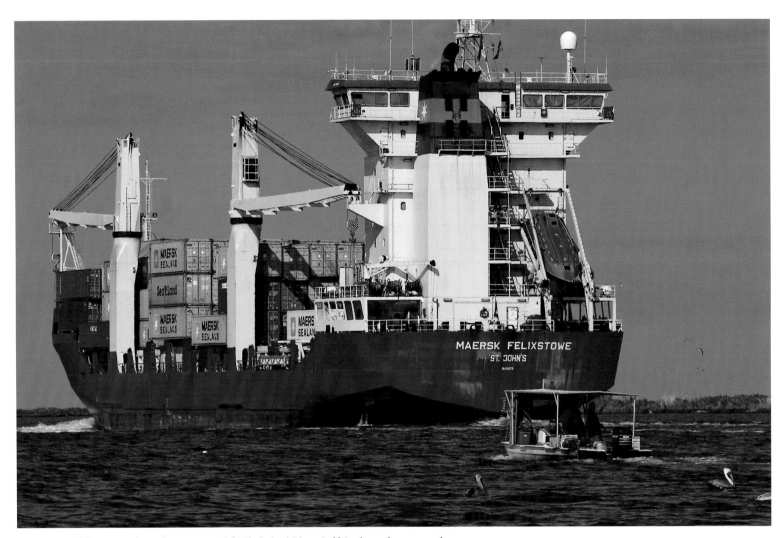

A container ship steams along the controversial Mississippi River Gulf Outlet, a shortcut to the Port of New Orleans. The channel is used by only about one or two ships per day but costs millions of dollars to keep open and allows salt water to move further inland, killing freshwater marshes.

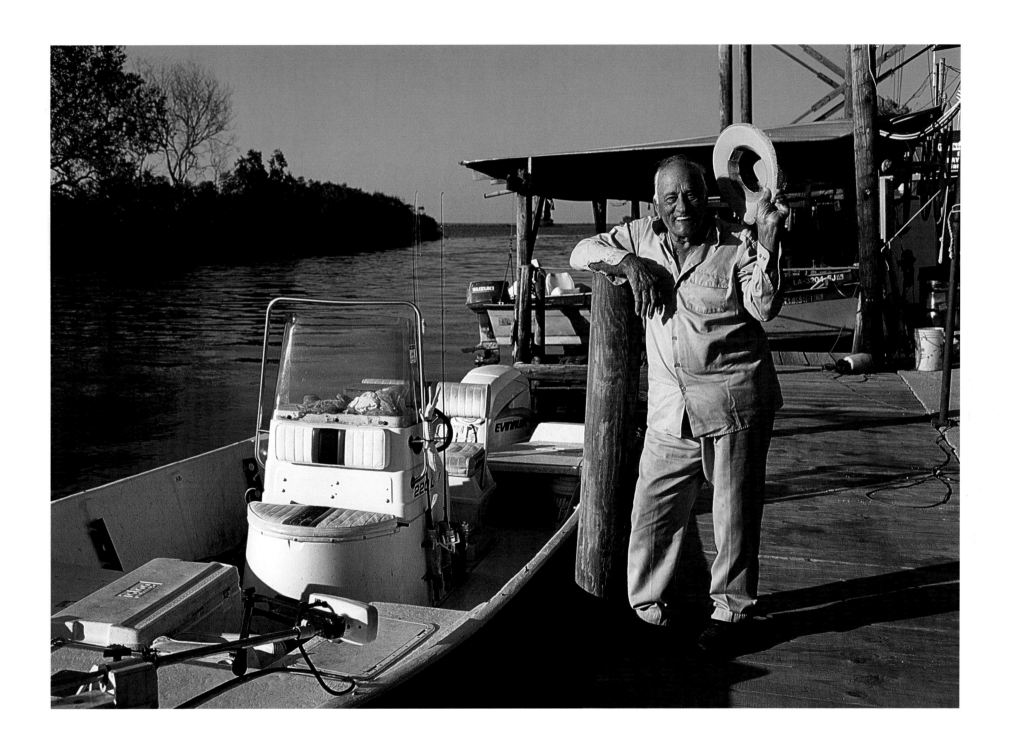

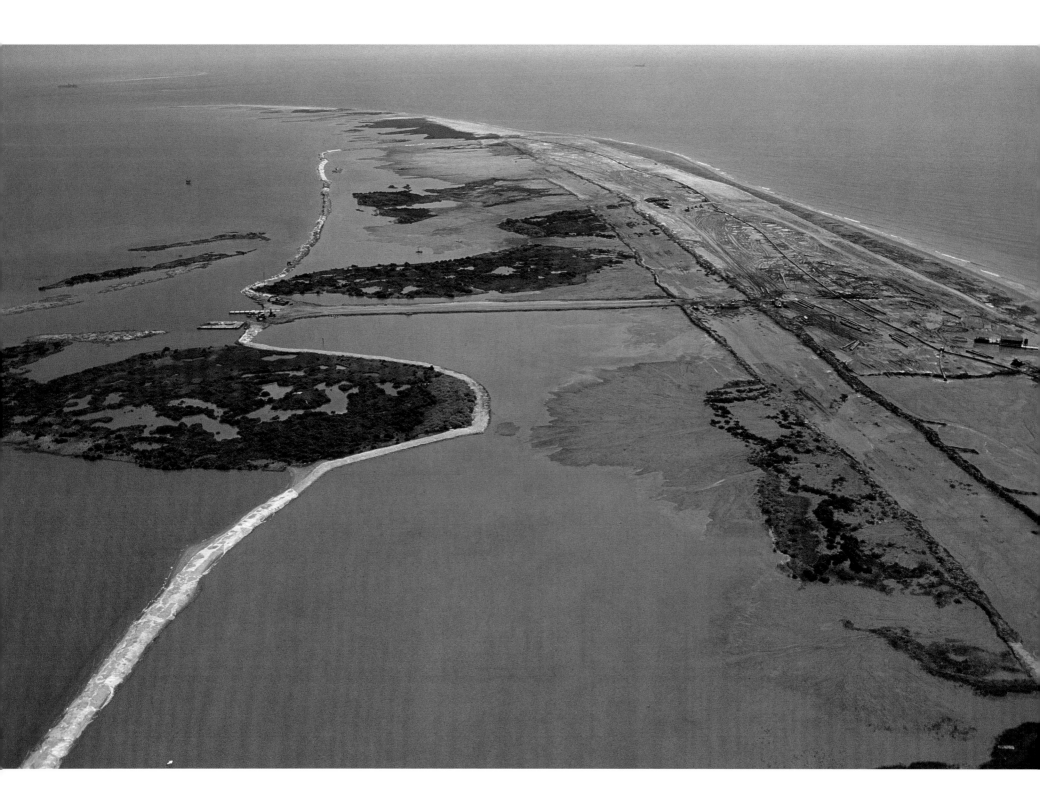

7

REBUILDING AMERICA'S WETLAND

Just about a mile off Timbalier Island a dredge sucks sand from the ocean bottom and shoots it through a pipeline hundreds of yards away, where bulldozers spread it around, rebuilding the barrier island.

On a hot summer's day, dozens of volunteers walk across an area newly filled with dredged mud and sand, poking holes in the muck to plant marsh grasses that will help hold the fine-grained silt in place.

As the river rises, an attendant opens the gates that allow muddy Mississippi River water flow into the marshes that have been cut off from the annual floods by the levee system. Here, restoration officials have learned that the most effective methods of restoration often mimic Mother Nature. In some

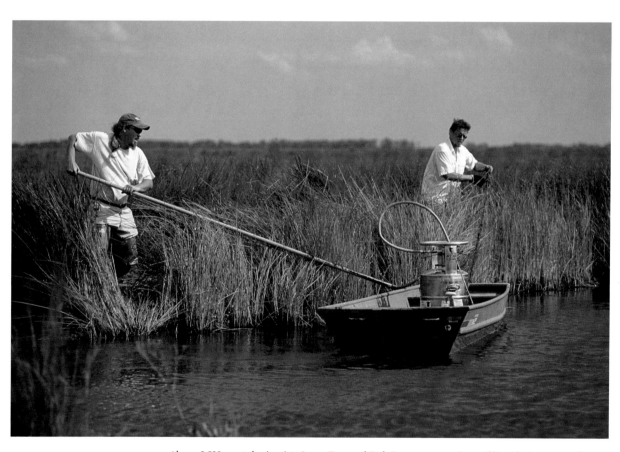

Left: Timbalier Island is rebuilt under a project sponsored by the U.S. Environmental Protection Agency. Workers first dug dikes to contain 3.6 million cubic yards of dredged sand and silt pulled from the Gulf of Mexico's bottom just a few miles offshore and pumped into the diked areas. The project was designed to build 118 acres of dune, 33 acres of berms, and 197 acres of shallow-water marsh on the leeward side of the island. The price tag is $17 million. More than 73,000 containers of eight different species of plants were also to be planted once the island is rebuilt.

Above: LSU coastal scientists Jason Day and Rob Lane use a canister of liquid nitrogen to freeze the soil in plots where they are studying how much sediment has been deposited into the marsh in a year in an area near Lafitte called "The Pen." The area was cleared decades ago for farmland but then subsided and is now a rectangular pond. By better understanding the environment, scientists like Day and Lane can help design projects that will restore wetlands already lost.

Quin Kinler of the Natural Resource Conservation Service climbs atop a rock revetment placed against a shoreline to help reduce wave and boat-wake erosion. Often, such rock dikes slowly sink into the soft soils that make up most of coastal Louisiana.

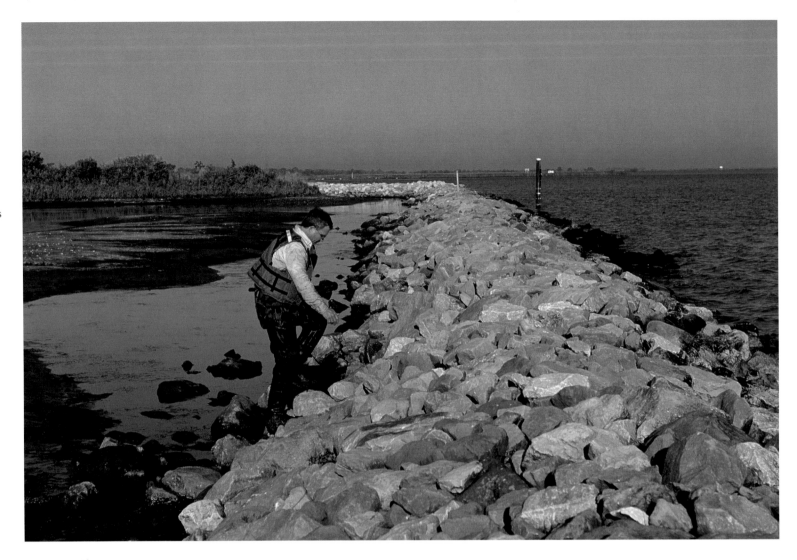

cases, waves waste their energy on rock dikes rather than gobbling the fragile marsh behind the broken stone barriers.

Since 1990, a federal and state task force has spent more than $500 million on restoration projects, learning what works and what doesn't. Some of the land lost can be restored, helping rebuild fisheries, continuing to protect infrastructure, increasing habitat for birds, and adding some extra hurricane protection for 2 million people.

Meanwhile, research on how best to restore lost wetlands continues, and techniques are refined from real experience each year. Science looks not only at how to recreate wetlands but also how to help the wildlife that lives there. Rockefeller Wildlife Refuge in Southwest Louisiana, which has lost eight thousand acres to

erosion, is a center for cutting-edge research. Eggs and other materials from Rockefeller are sent all over the world to help researchers learn more about how to manage alligators.

Educating the next generation is a vital part of ensuring the protection of coastal Louisiana. It is this idea that inspired the State of Louisiana to launch the largest public education effort in its history, aimed at informing the nation and the world about the impact of the state's coastal wetland loss. America's WET-LAND: Campaign to Save Coastal Louisiana is supported by a growing cadre of world, national, and state conservation and environmental organizations and has drawn private support from businesses that see wetlands protection as a key to economic growth. These diverse groups understand that we cannot afford to lose

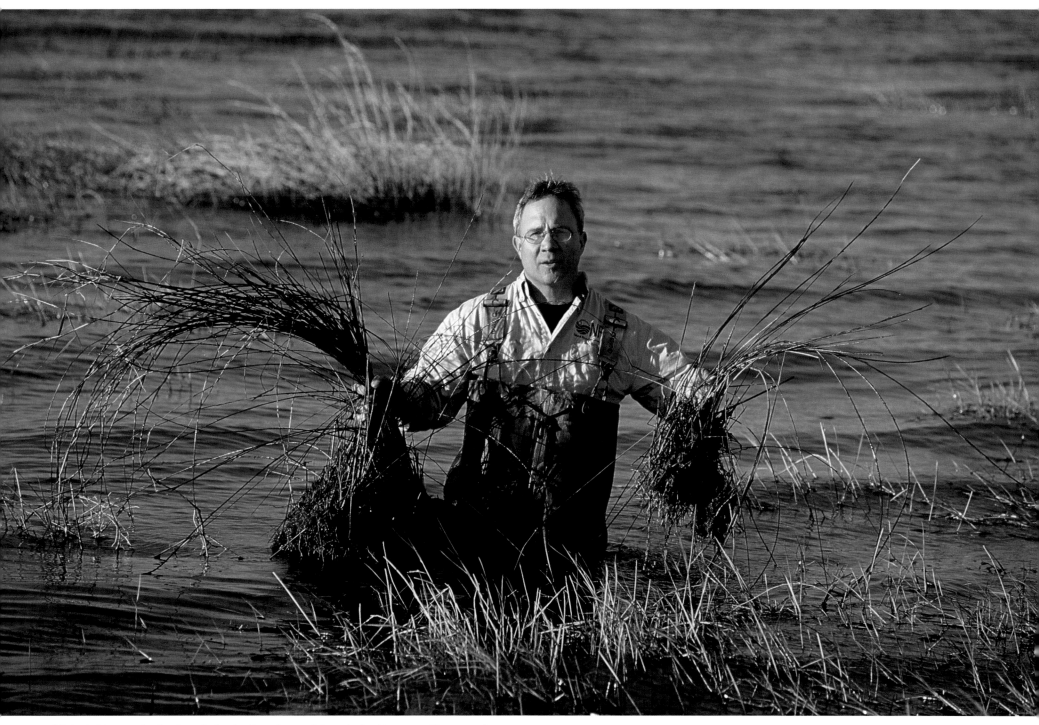

Kinler holds up a chunk of marsh that has been battered from the land by waves. The agency is trying to save a "land bridge," or strip of low-lying marsh, between two bayous that continue to widen. As the bayous become small lakes, wind can create larger waves to slam ashore and gobble up more shoreline.

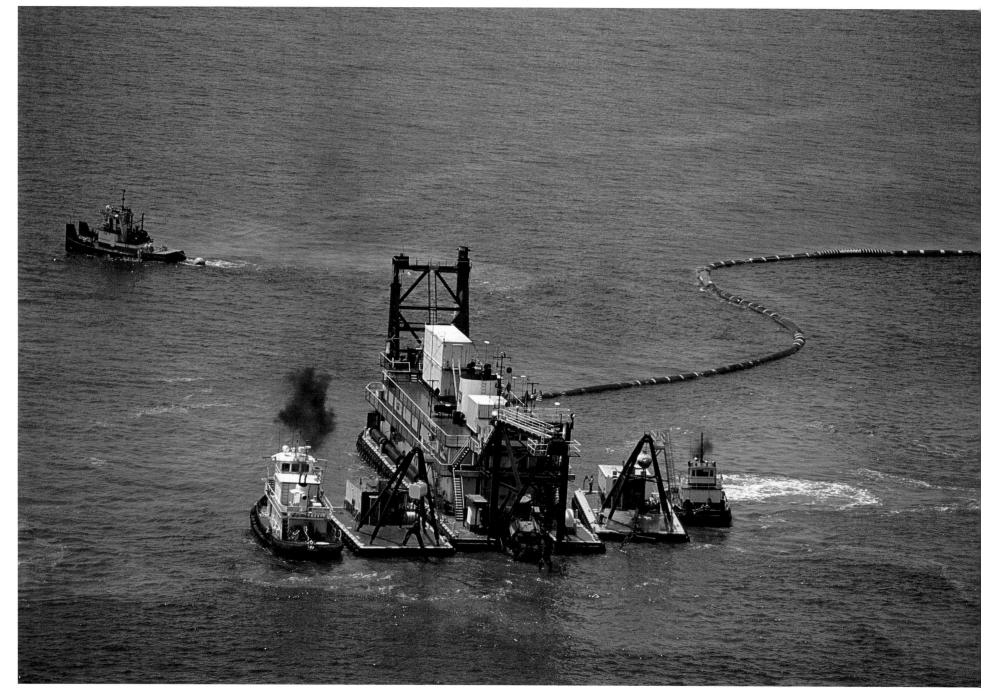

The Dredge *Tom James* sucks as much as 2,500 cubic yards of sand per hour from the seafloor of the Gulf of Mexico and shoots it through up to three miles of pipe to be deposited on nearby Timbalier Island. The island helps protect Terrebonne Bay and provides an important fish habitat.

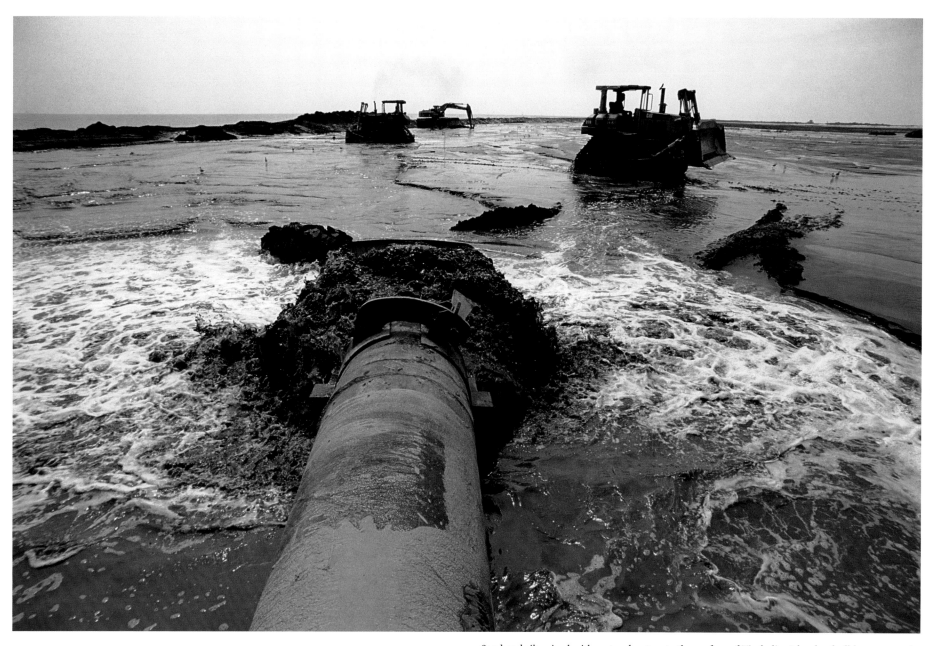

Sand and silt mixed with water shoot onto the surface of Timbalier Island as bulldozers spread out the new material, slowly building up the island and a dune system on the 2.1-mile-long island.

this national treasure. Every citizen has an opportunity to help ensure that future generations can benefit from the beauty and resources of this unique and delicate ecosystem. We can all educate family and friends about the value of these wetlands, the importance of what is at risk, and the efforts under way to save and restore this place called America's Wetland.

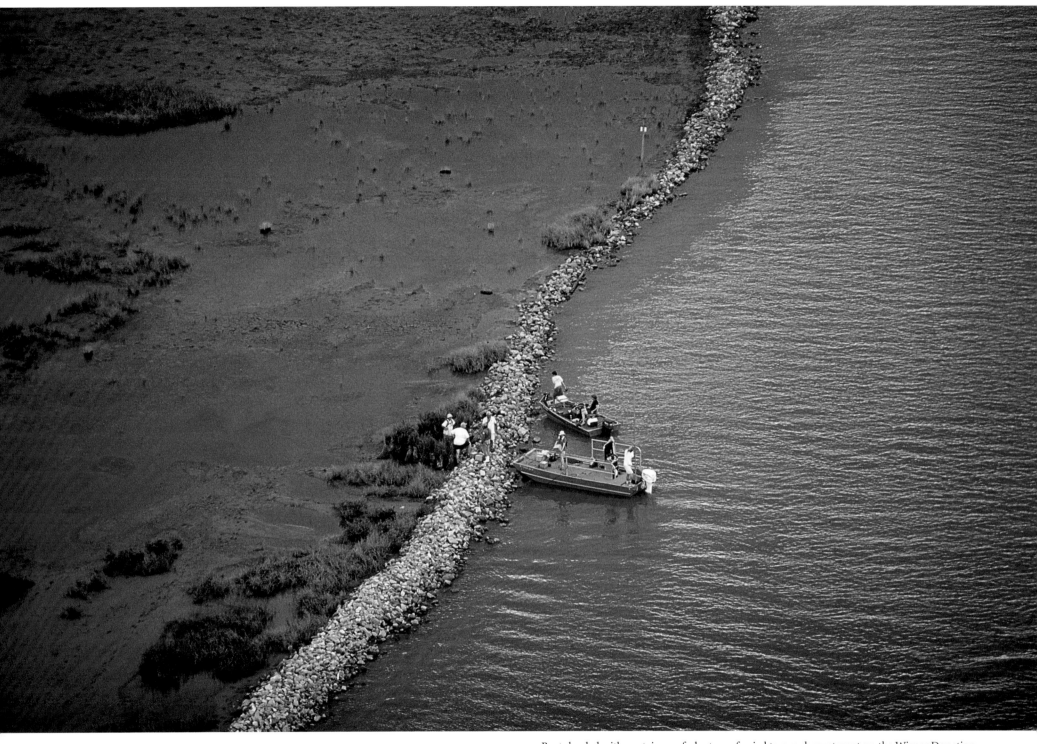

Boats loaded with containers of plants are ferried to a rock revetment on the Wisner Donation tract in Fourchon. Volunteers will plant thousands of plants in a two-thousand-acre area reclaimed by dredging.

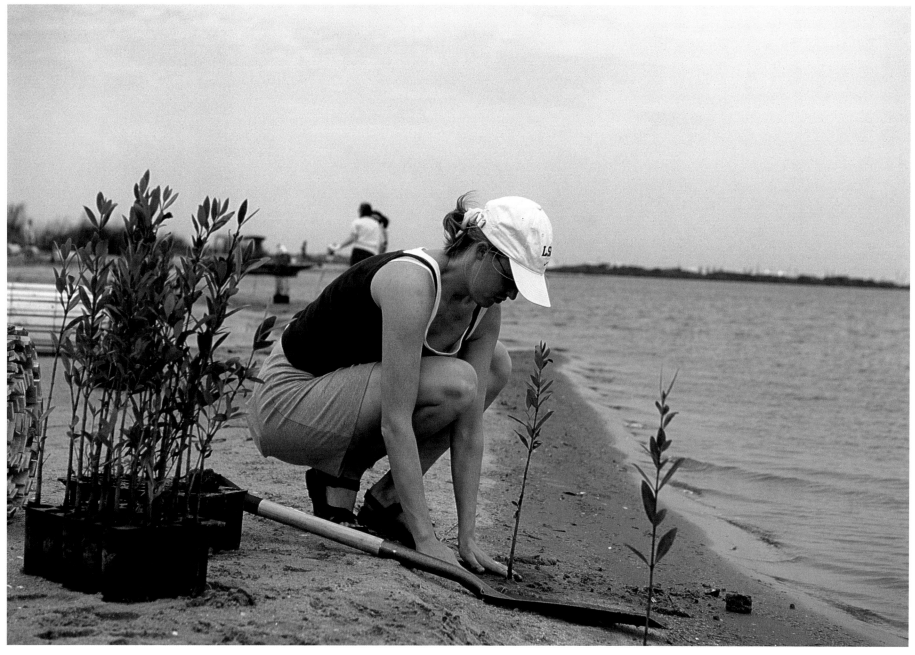
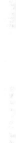

Cheryl Broadnax of the National Oceanic and Atmospheric Administration's Restoration Center, plants a mangrove tree on a tract of land in Fourchon owned by the Wisner Foundation of New Orleans. Sediments were pumped into an area that had turned from marsh into water, and the mangroves and other plants will help the newly restored land stay in place.

The Wisner Foundation is a land trust that provides money to several New Orleans institutions. Partners in this project include the Barataria-Terrebonne National Estuary Program, ChevronTexaco, the Coalition to Restore Coastal Louisiana, the Greater Lafourche Port Commission, the Natural Resources Conservation Service's Plant Materials Center in Galliano, Restore America's Estuaries, and the University of New Orleans. All contributed funds or volunteers to carry out the $700,000 effort to restore about two thousand acres of fragile land between the Gulf of Mexico and Port Fourchon.

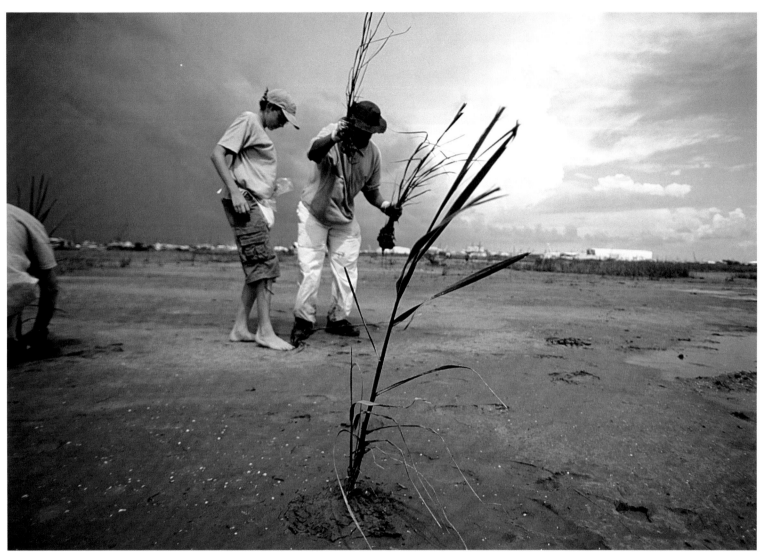

Ben Hartman of Baton Rouge uses his foot to close a hole where he just placed a packet of fertilizer that will help these cord grass plugs grow and rebuild a marsh that had subsided. The marsh is near the public boat launch in Fourchon.

A crew uses an auger to dig a hole in the sand to place a fence post deep into the ground in an effort to start building dunes that will better repel storms. The fences gather windblown sand much like snow fences in other parts of the country.

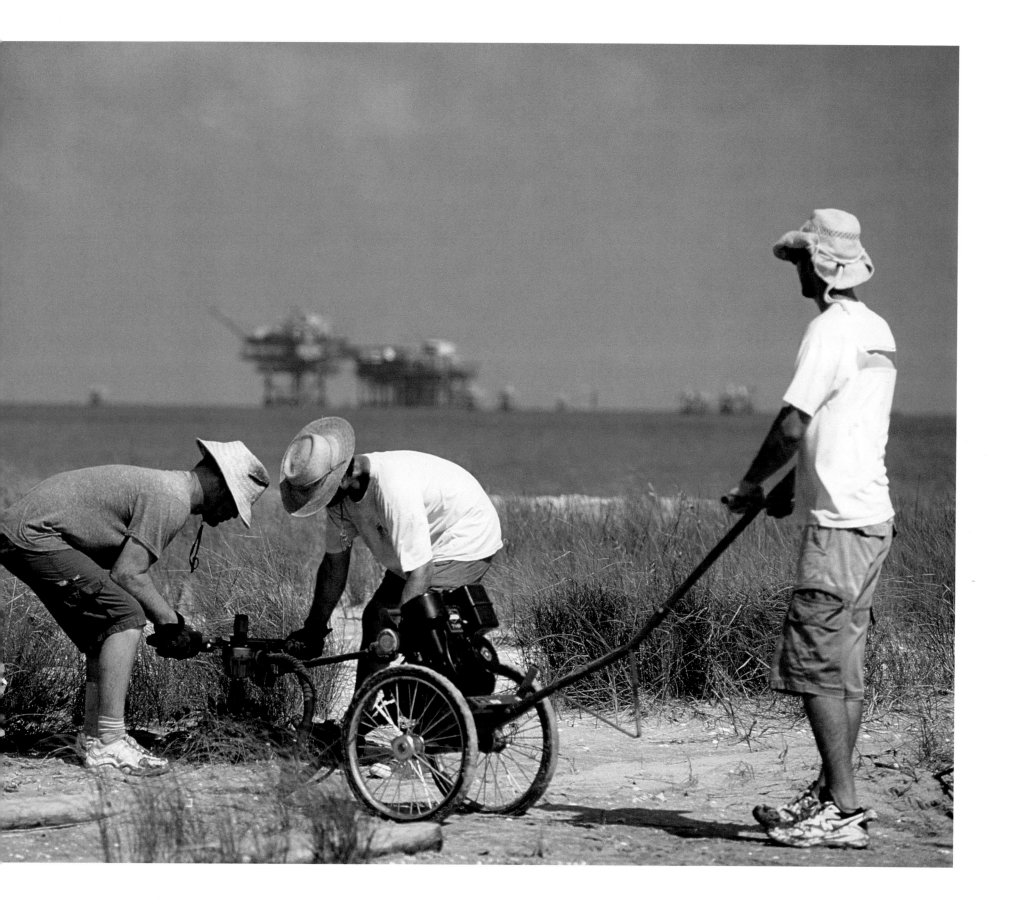

Chris Wells and Pat O'Neil of the U.S. Geological Survey's National Wetlands Research Center study the habitat of Raccoon Island, a barrier island remnant important both as a bird rookery and fish nursery.

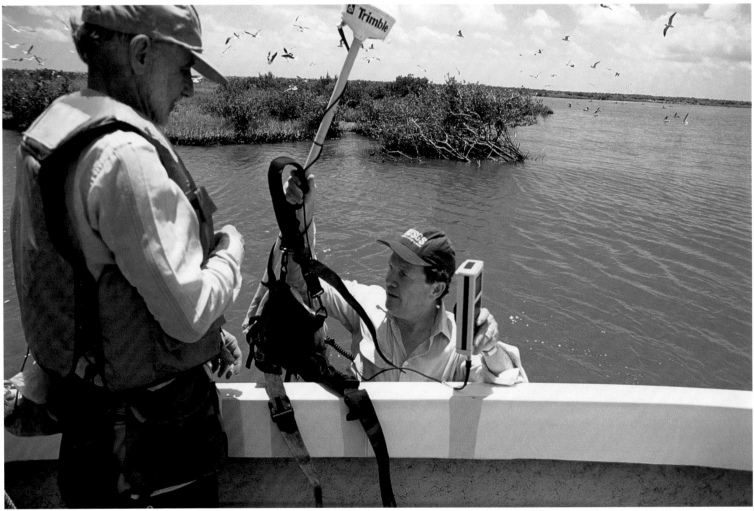

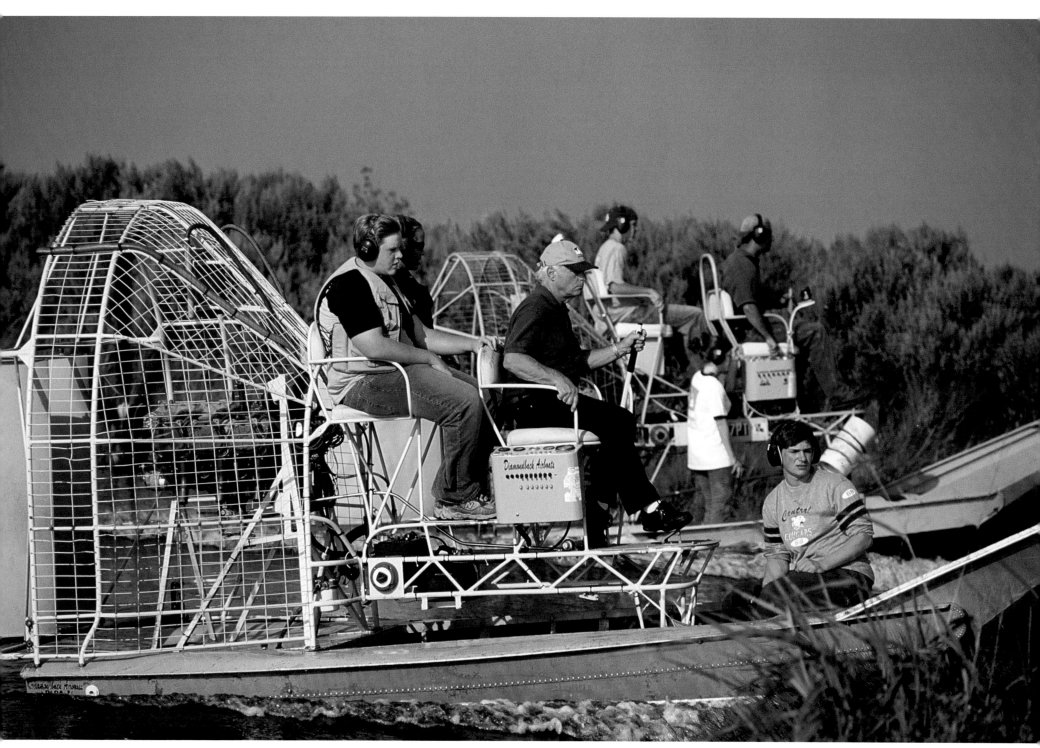

Airboats are often the best way to travel through the shallow marshes in coastal Louisiana. Here, students participating in a summer education program are transported through the marshes to see alligators and other wildlife up close while learning about Louisiana's wetlands loss.

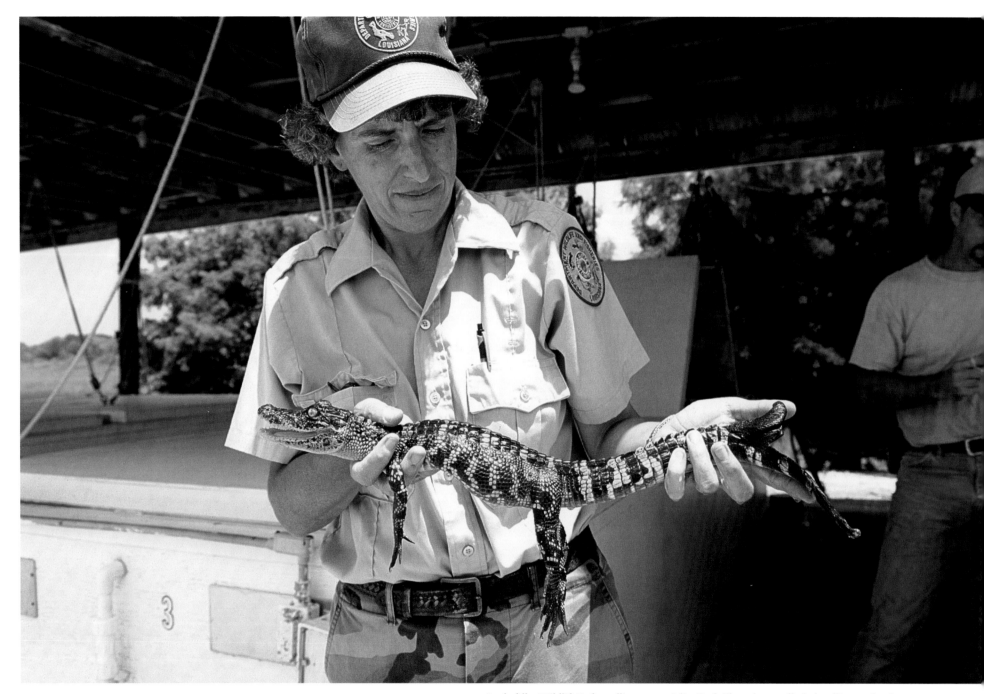

Rockefeller Wildlife Refuge alligator specialist Ruth Elsey shows off a baby alligator that has a split tail.

Elsey also prepares some alligator embryos for a researcher in Japan. The Rockefeller National Wildlife Refuge conducts research and assists other alligator researchers around the nation and the world.

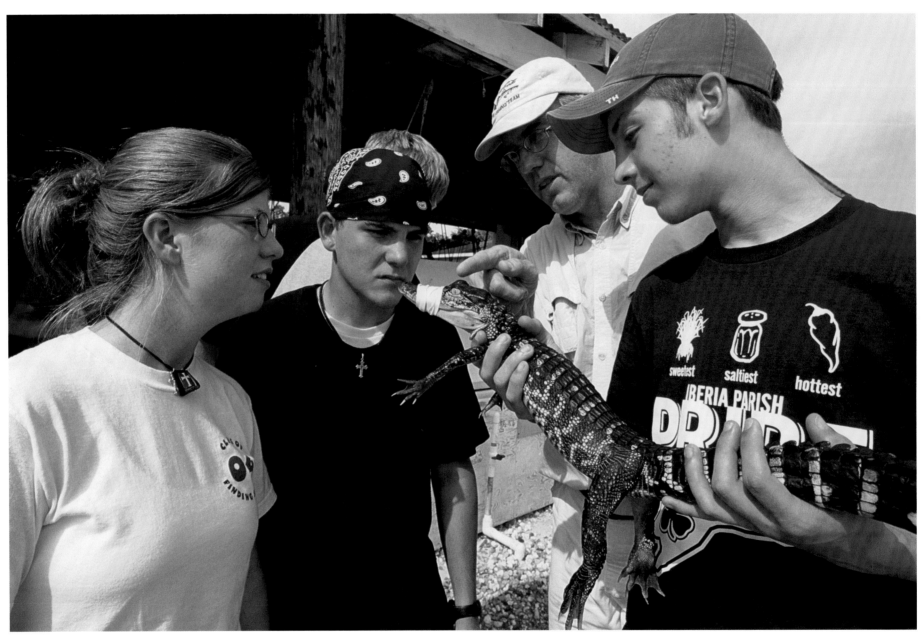

LSU Agricultural Center educator Mark Shirley points out an aspect of this baby alligator for high school students participating in a summer program to learn more about science, wildlife, and the wetlands. From left to right: Christine Cole and Jean Paul Pellerin of St. Mary Parish, Shirley, and Quinn Sarkies of Iberia Parish. The program is called Marsh Maneuvers.

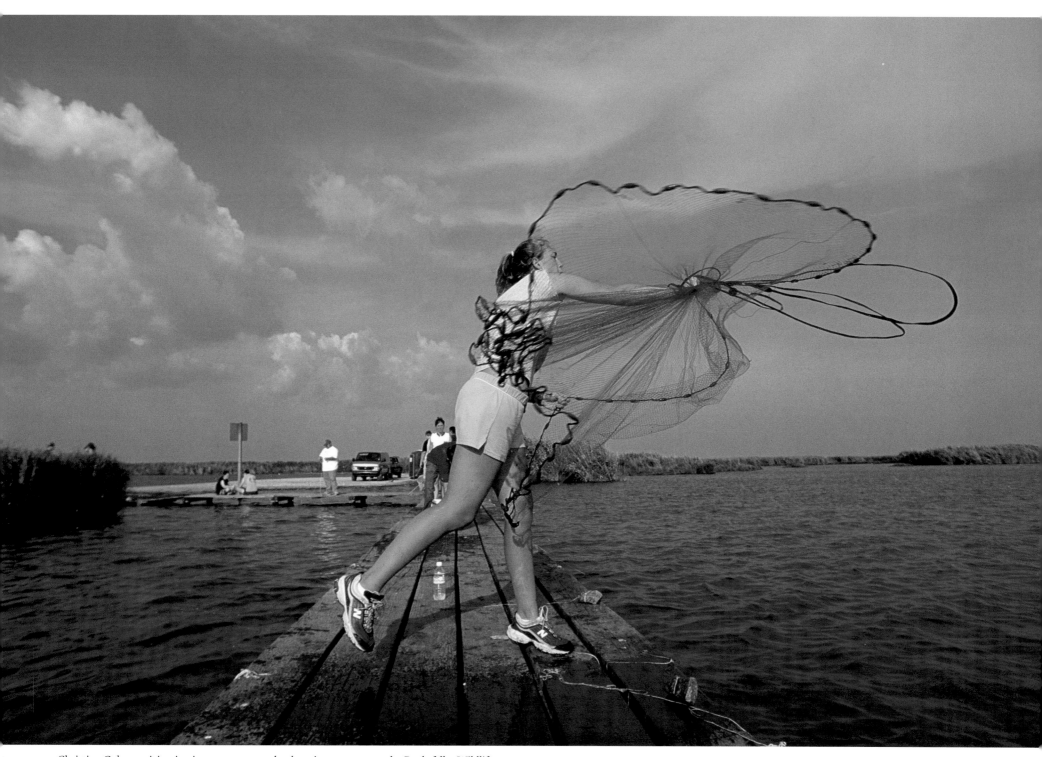

Christine Cole, participating in a summer youth education program at the Rockefeller Wildlife
Refuge, practices casting a net used for catching minnows and other bait fish.

Dinah Maygarden runs the Coastal Wetlands Education Program at the University of New Orleans, which provides opportunities for precollege students and teachers to learn through field experiences about the fragile coastal systems close to their homes. The program produces interpretive materials for public distribution and daylong field trips for middle and high school students and a summer program for high school students.

The summer program brings together a diverse group of mostly minority students to focus on coastal issues for two to three weeks. A major focus is on the rapidly eroding shoreline and the barrier islands, with visits to the barrier islands, trips to learn methods of measurement for quantifying changes on the shoreline and other scientific experiments. "This program sparks the curiosity of these young people and creates a foundation on which to build future layers of earth and environmental science learning," Maygarden said. "Our long-term goal is to stimulate a lifelong interest in earth and environmental sciences."

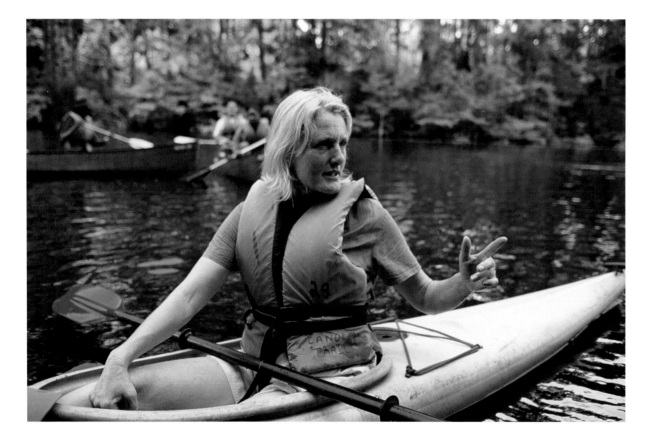

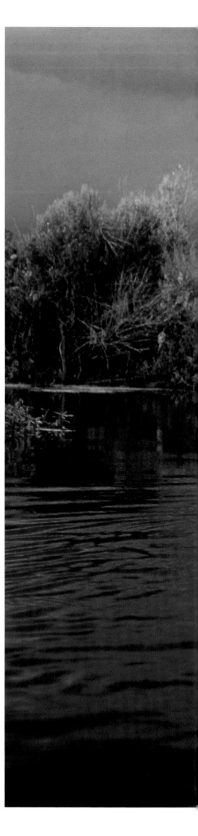

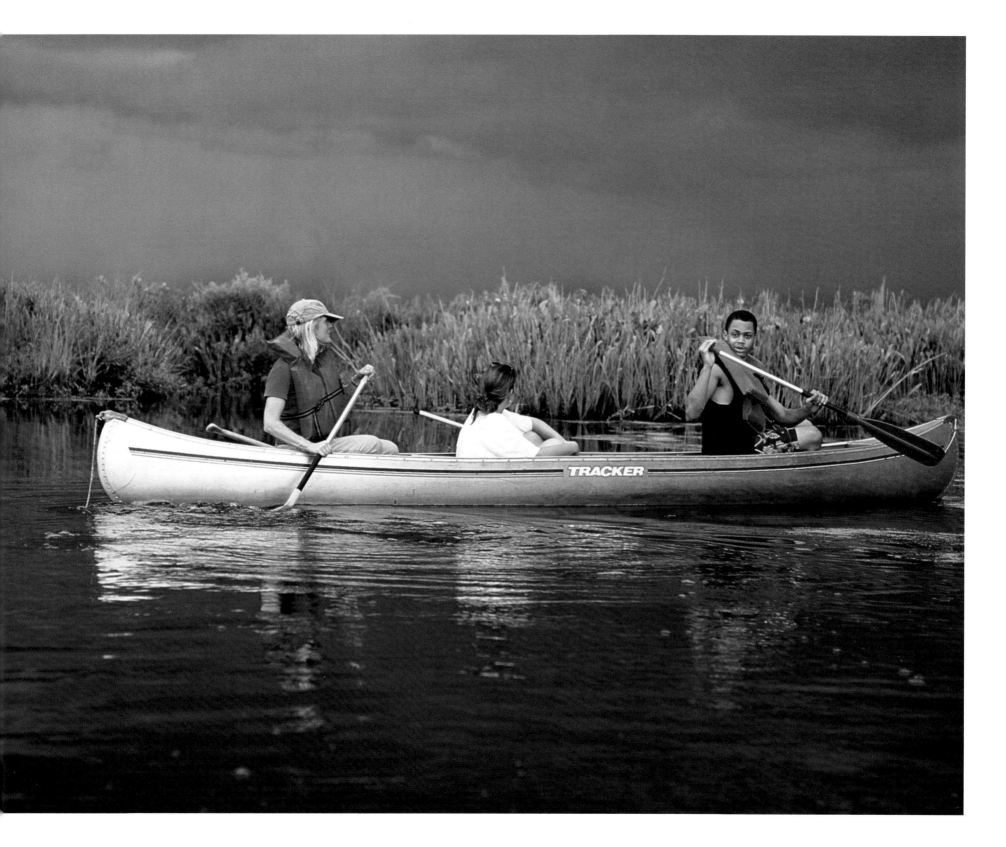

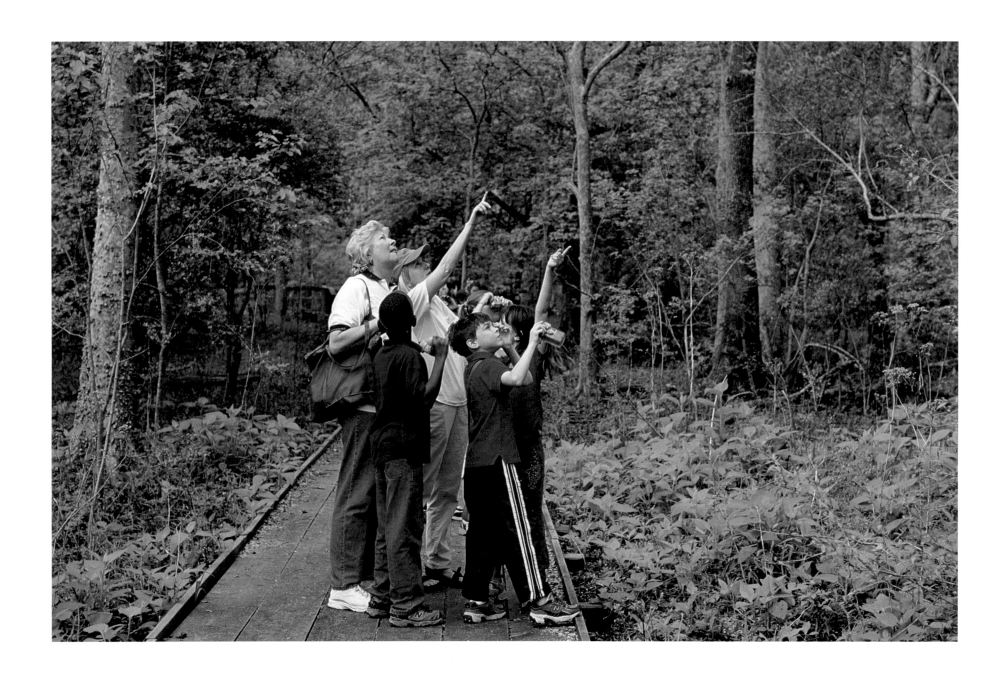

For more information or to become involved in coastal restoration in Louisiana contact:

America's WETLAND Campaign
P.O. Box 44249
Baton Rouge, LA 70804-4249
866-4WETLAND
www.americaswetland.com
e-mail: americaswetland@mcopr.com

Barataria-Terrebonne National Estuary
 Program
Nicholls State University
P.O. Box 2663
Thibodaux, LA 70310
800-259-0869
www.btnep.org

Coalition to Restore Coastal Louisiana
746 Main Street, B101
Baton Rouge, LA 70802
225-344-6555
888-LA-COAST
www.crcl.org
e-mail: coalition@crcl.org

Coastal Restoration and Enhancement
 through Science and Technology
 (CREST)
1143 Energy, Coast, and Environment
 Building
Louisiana State University
Baton Rouge, LA 70803
225-578-0069
www.gulfcrest.org

Coastal Wetlands Planning, Protection,
 and Restoration Act
USGS National Wetlands Research Center
700 Cajundome Boulevard
Lafayette, LA 70506
337-266-8623
www.lacoast.gov

Governor's Office of Coastal Activities
Capitol Annex
1051 North 3rd Street, Suite 138
Baton Rouge, LA 70804
225-342-3968
www.goca.state.la.us
e-mail:goca@gov.state.la.us

Lake Pontchartrain Basin Foundation
P.O. Box 6965
Metairie, LA 70009
504-836-2215
www.saveourlake.org
e-mail: lpbfinfo@saveourlake.org

Louisiana Coastal Area Ecosystem
 Restoration
U.S. Army Corps of Engineers, New
 Orleans District
P.O. Box 60267
New Orleans, LA 70160-0267
504-862-2587
www.lca.gov

Louisiana Department of Natural
 Resources
P.O. Box 94396
Baton Rouge, LA 70804-9396
225-342-4500
dnr.louisiana.gov

Louisiana State University Coastal Studies
 Institute
www.csi.lsu.edu

Louisiana State University School of the
 Coast and Environment
www.cceer.lsu.edu

Louisiana Wildlife Federation, Inc.
P.O. Box 65239
Audubon Station
Baton Rouge, LA 70896-5239
225-344-6707
www.lawildlifefed.org
e-mail: lwf@lawildlifefed.org

The Nature Conservancy–Louisiana
P.O. Box 1497
Covington, LA 70434
985-809-1414
www.nature.org

Parishes Against Coastal Erosion (PACE)
1221 Elmwood Park Boulevard, Suite 703
Jefferson, LA 70123
504-736-6440
www.paceonline.org

University of New Orleans Coastal
 Research Laboratory
www.coastal.uno.edu